1670

1666

between home and heaven

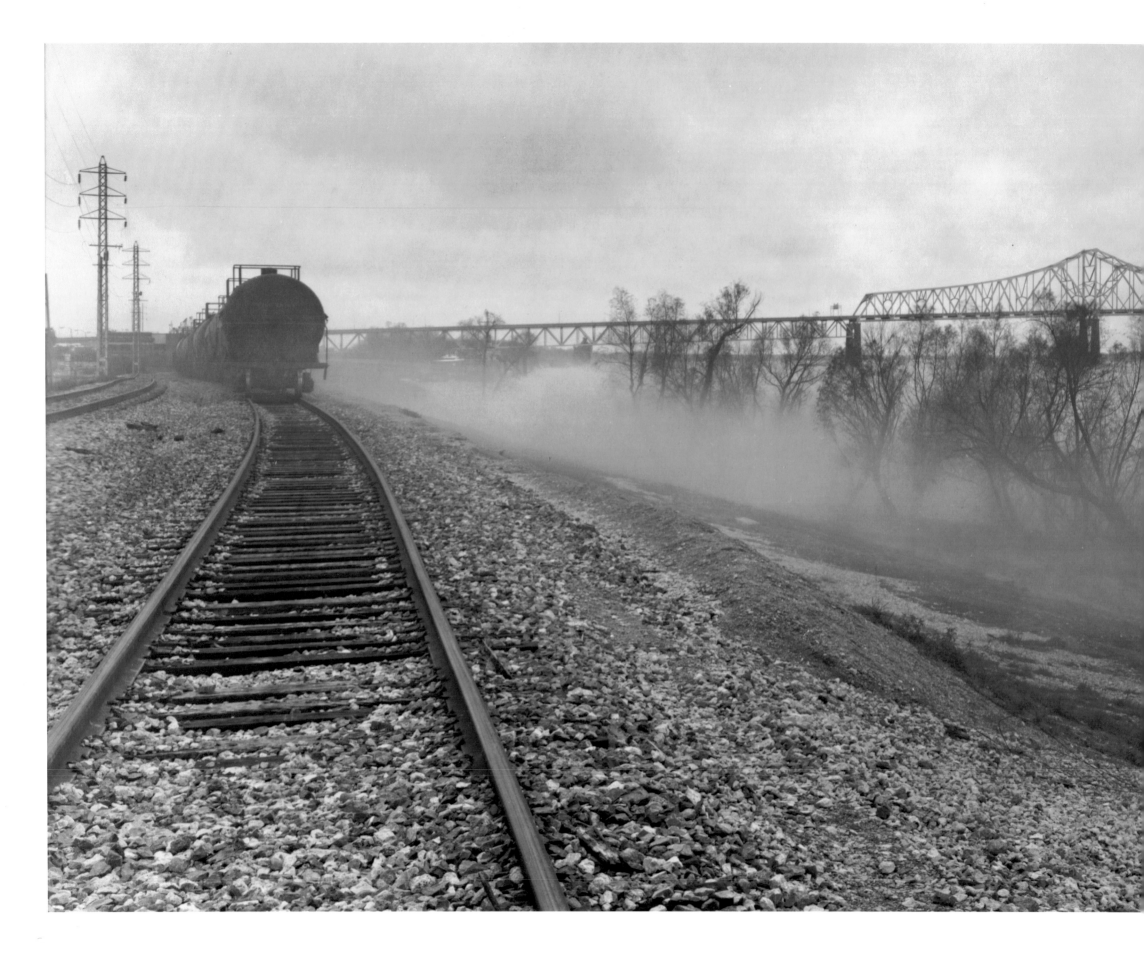

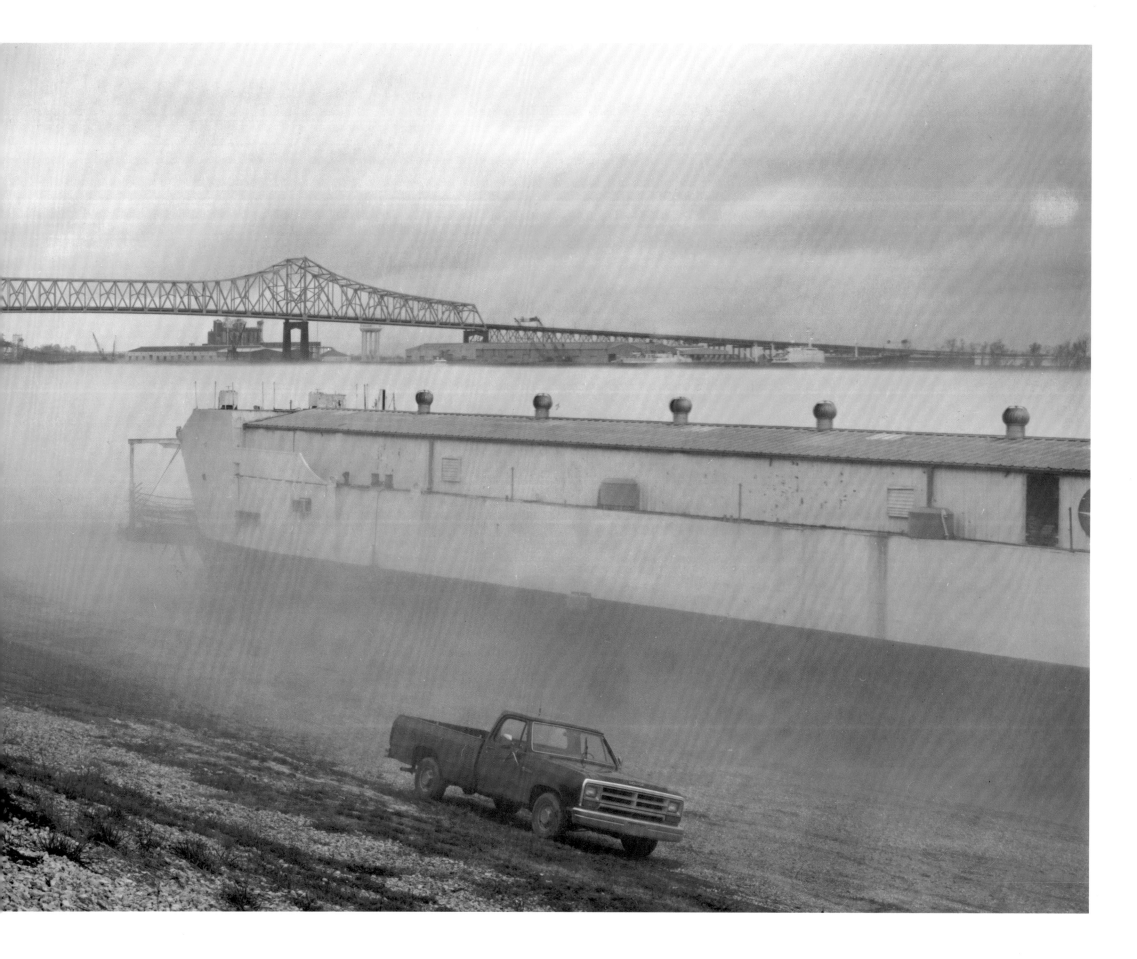

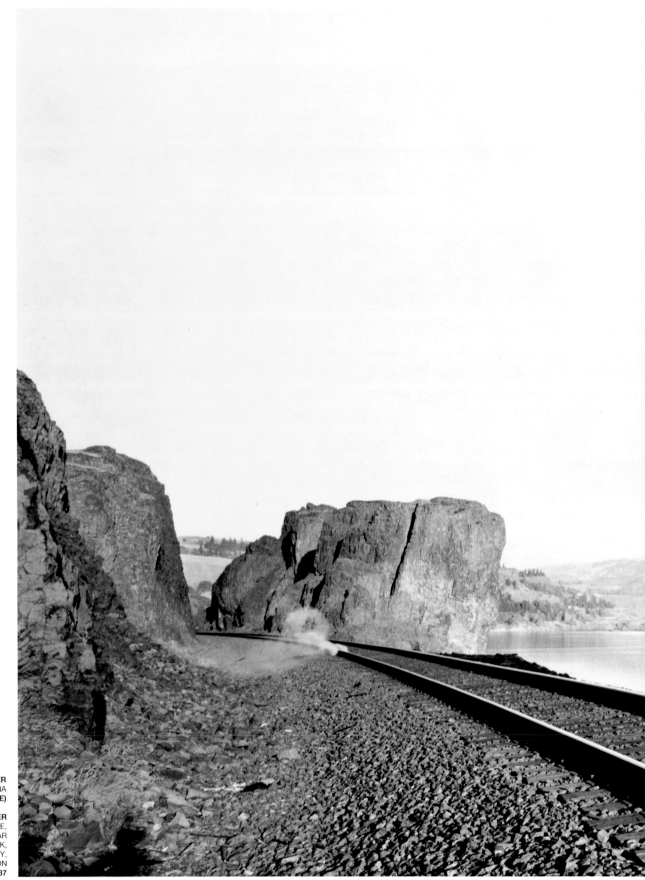

**1. LOIS CONNER**
BATON ROUGE, LOUISIANA
1988 (PRECEDING PAGE)

**2. TERRY TOEDTEMEIER**
BURNING RAILROAD TIE,
BURLINGTON CUT NEAR
CATHERINE CREEK,
KLICKITAT COUNTY,
WASHINGTON
1987

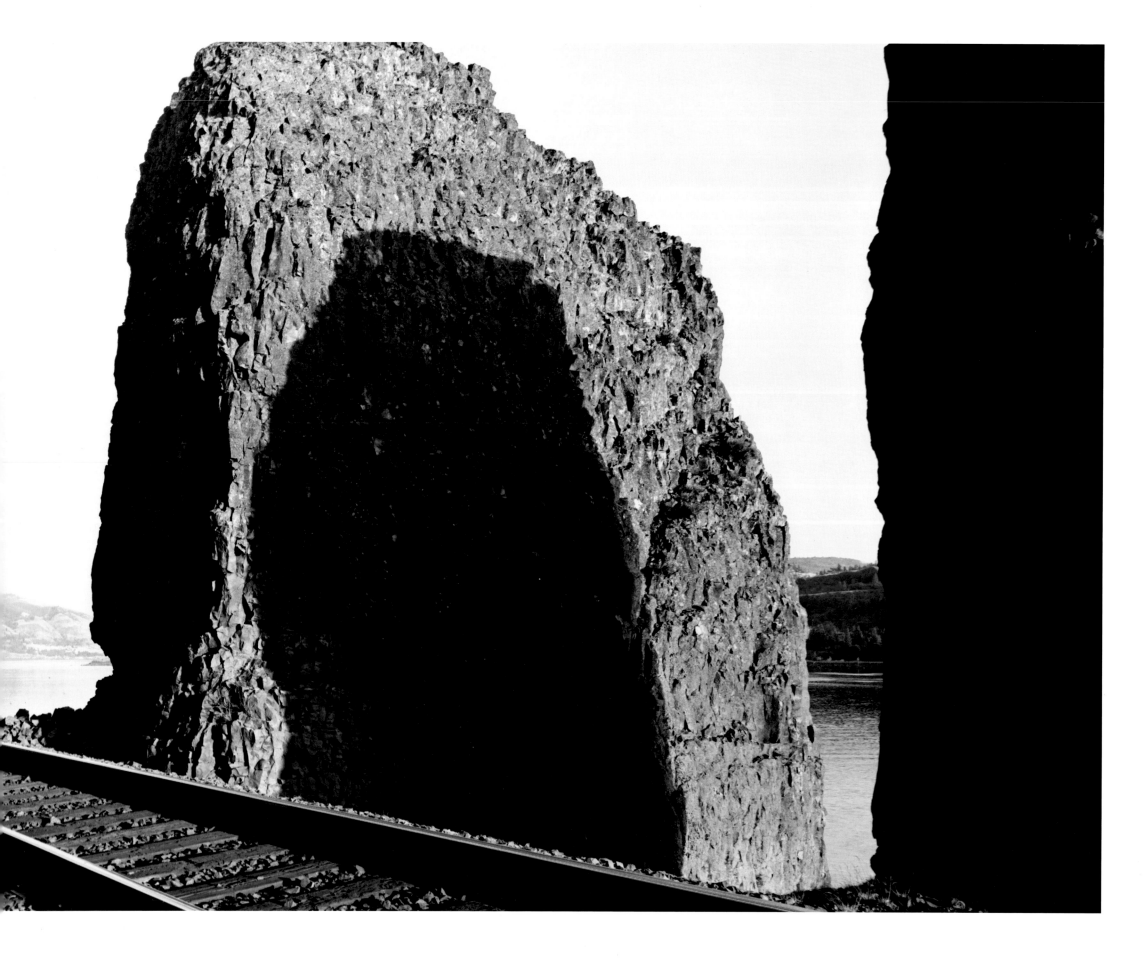

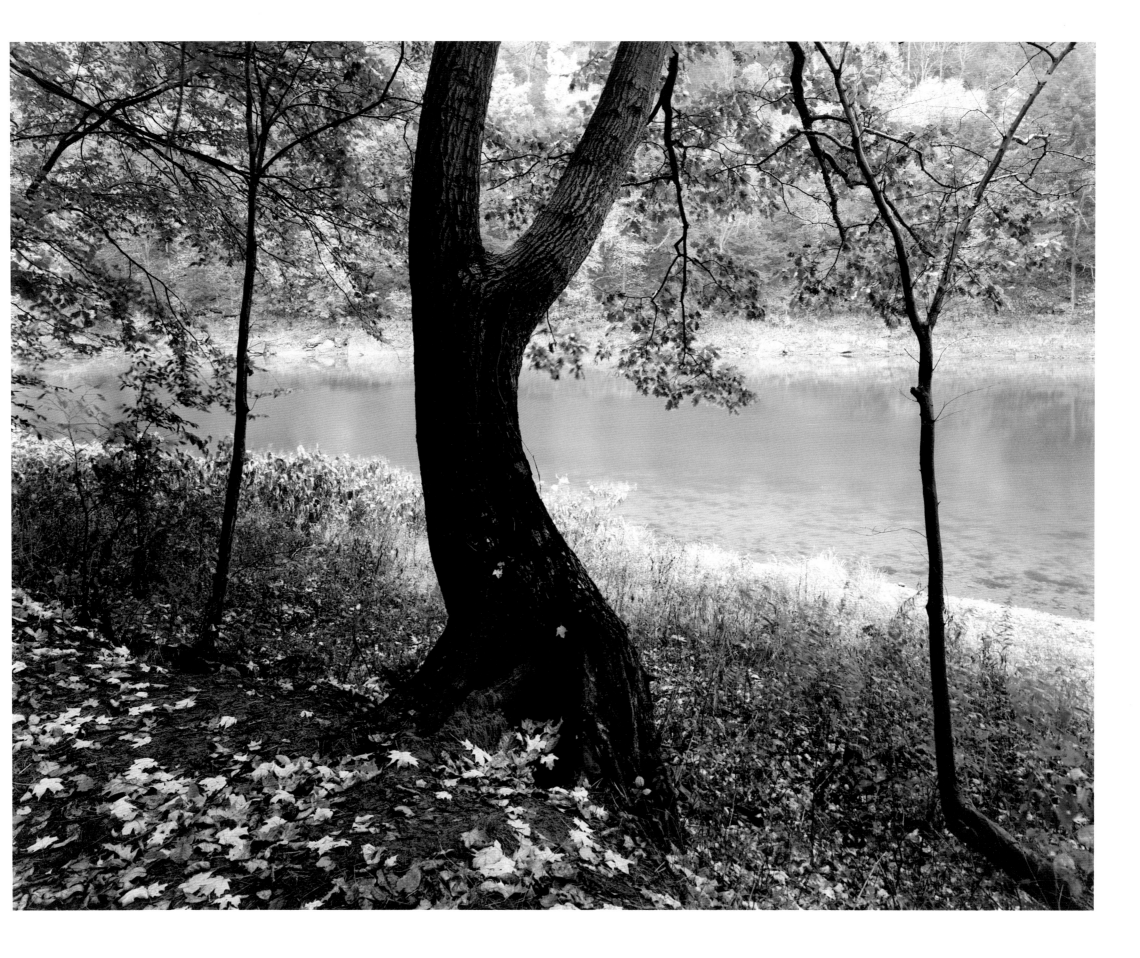

# between home and heaven
# contemporary american landscape photography

from the
consolidated natural gas company foundation collection
of the
national museum of american art
smithsonian institution

essays by
merry a. foresta, stephen jay gould
karal ann marling

national museum of american art
smithsonian institution
washington, d.c.
in association with
the university of new mexico press
albuquerque, new mexico

THIS PUBLICATION IS MADE POSSIBLE THROUGH THE GENEROUS SUPPORT OF
THE CONSOLIDATED NATURAL GAS COMPANY FOUNDATION.

PUBLISHED ON THE OCCASION OF THE EXHIBITION
*BETWEEN HOME AND HEAVEN: CONTEMPORARY AMERICAN LANDSCAPE PHOTOGRAPHY*
CURATED BY MERRY A. FORESTA

NATIONAL MUSEUM OF AMERICAN ART, SMITHSONIAN INSTITUTION, WASHINGTON, D.C., 6 MARCH—28 JUNE 1992
THE CARNEGIE MUSEUM OF ART, PITTSBURGH, PENNSYLVANIA, 14 AUGUST—11 OCTOBER 1992
NEW ORLEANS MUSEUM OF ART, 6 FEBRUARY—28 MARCH 1993
THE NEW YORK STATE MUSEUM, ALBANY, NEW YORK, 1 MAY—28 JUNE 1993

FIRST PUBLISHED IN THE UNITED STATES OF AMERICA
BY THE NATIONAL MUSEUM OF AMERICAN ART, SMITHSONIAN INSTITUTION, WASHINGTON, D.C.,
IN ASSOCIATION WITH THE UNIVERSITY OF NEW MEXICO PRESS,
1720 LOMAS BOULEVARD, NE, ALBUQUERQUE, NEW MEXICO 87131.

PROJECT DIRECTOR: STEVE DIETZ; EDITOR: TERENCE WINCH;
EDITORIAL ASSISTANT: DEBORAH THOMAS; PRODUCTION ASSISTANCE: STEVE BELL;
TRITONE SEPARATIONS: ROBERT HENNESSEY;
DESIGN ASSOCIATES: ELENA ZAHARAKOS, NAOMI WINEGRAD; TYPESET BY BG COMPOSITION, BALTIMORE. MARYLAND;
PRINTED BY LITHO SPECIALITES, ST. PAUL, MINNESOTA; BOUND BY NICKLESTONE, NASHVILLE, TENNESSEE
BOOK DESIGN: YOLANDA CUOMO

FRONT AND BACK COVERS: GUS FOSTER, *CUT WHEAT* (DETAIL; SEE PL. 58)

ISBN 0-8263-1363-9 (CLOTH) ISBN 0-8263-1364-7 (PAPER) ISBN 0-937311-04-9 (SLIP CASE)

LIBRARY OF CONGRESS CATALOG NUMBER 91-33448

LIBRARY OF CONGRESS CATALOGING-IN-PUBLICATION DATA
NATIONAL MUSEUM OF AMERICAN ART (U.S.)
BETWEEN HOME AND HEAVEN : CONTEMPORARY AMERICAN LANDSCAPE PHOTOGRAPHY
FROM THE CONSOLIDATED NATURAL GAS COMPANY COLLECTION OF THE NATIONAL MUSEUM OF AMERICAN ART,
SMITHSONIAN INSTITUTION / ESSAYS BY MERRY A. FORESTA, STEPHEN JAY GOULD, KARAL ANN MARLING.
P.   CM. CATALOG OF AN NMAA EXHIBITION OPENING MAR. 1992.
INCLUDES BIBLIOGRAPHICAL REFERENCES.
ISBN 0-8263-1363-9 (HC) : $50.00 —ISBN 0-8263-1364-7 (SC) : $35.00 —ISBN 0-937311-04-9 (SLIP CASE)
1. LANDSCAPE PHOTOGRAPHY—UNITED STATES—EXHIBITIONS. 2. NATIONAL MUSEUM
OF AMERICAN ART (U.S.)—EXHIBITIONS. I. FORESTA, MERRY A.
II. GOULD, STEPHEN JAY. III. MARLING, KARAL ANN. IV. CONSOLIDATED
NATURAL GAS COMPANY. V. TITLE. VI. TITLE: CONSOLIDATED NATURAL GAS COMPANY
COLLECTION OF THE NATIONAL MUSEUM OF AMERICAN ART, SMITHSONIAN INSTITUTION. TR660.5.N37  1992
779'.3673'0973074753—DC20  91-33448 CIP

THE NATIONAL MUSEUM OF AMERICAN ART, SMITHSONIAN INSTITUTION,
IS DEDICATED TO THE PRESERVATION, EXHIBITION, AND STUDY OF THE VISUAL ARTS IN AMERICA.
THE MUSEUM, WHOSE PUBLICATIONS PROGRAM ALSO INCLUDES
THE QUARTERLY JOURNAL *AMERICAN ART*, HAS EXTENSIVE RESEARCH RESOURCES:
THE DATABASES OF THE INVENTORIES OF AMERICAN PAINTING AND SCULPTURE,
SEVERAL IMAGE ARCHIVES, AND A VARIETY OF FELLOWSHIPS FOR SCHOLARS.  THE RENWICK GALLERY,
ONE OF THE NATION'S PREMIER CRAFT MUSEUMS, IS PART OF NMAA.
FOR MORE INFORMATION OR A CATALOGUE OF PUBLICATIONS,
WRITE: OFFICE OF PUBLICATIONS, NATIONAL MUSEUM OF AMERICAN ART, SMITHSONIAN
INSTITUTION, WASHINGTON, D.C. 20560.

**5. JOE MALONEY**
CAMP DELAWARE,
NEW YORK STATE, **1986**

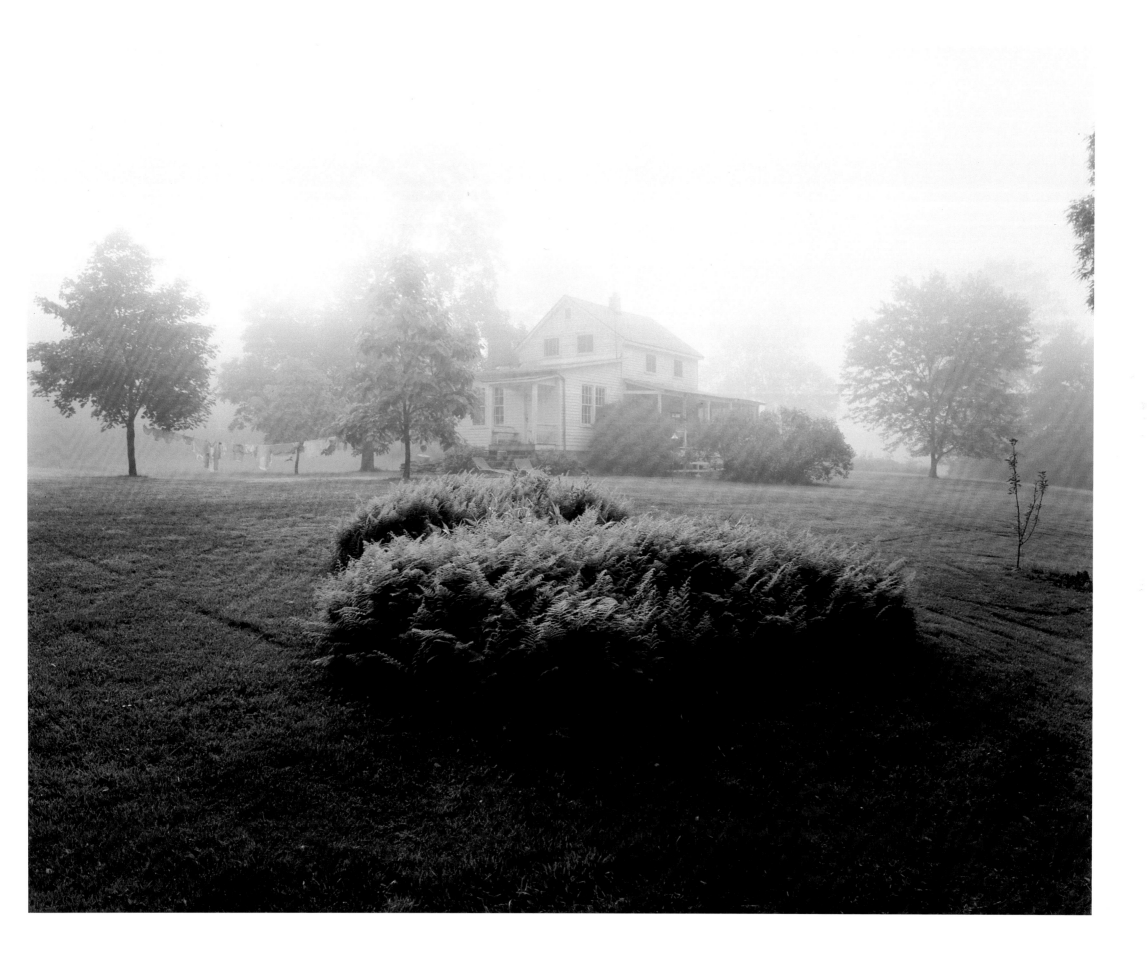

6. STUART D. KLIPPER, STORM OVER BONNEVILLE RACEWAY, UTAH **(FROM THE SERIES THE WORLD IN A FEW STATES)**, 1990

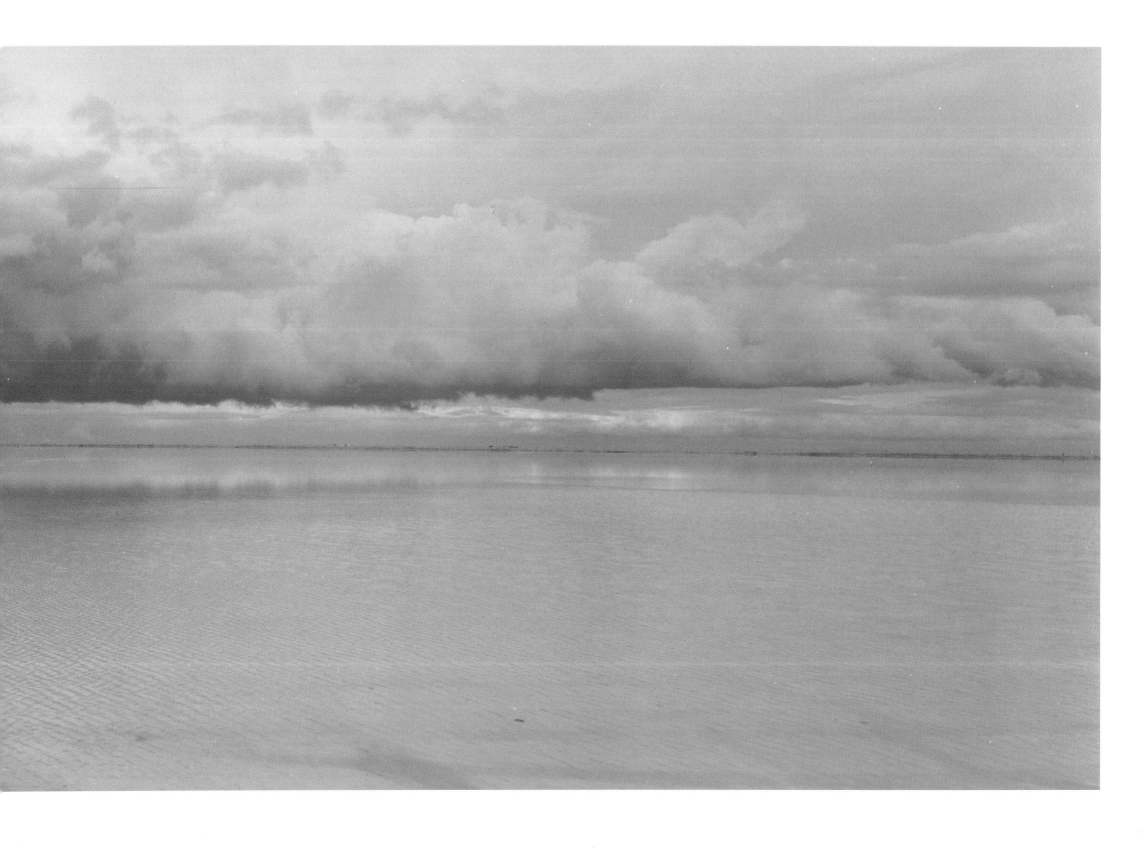

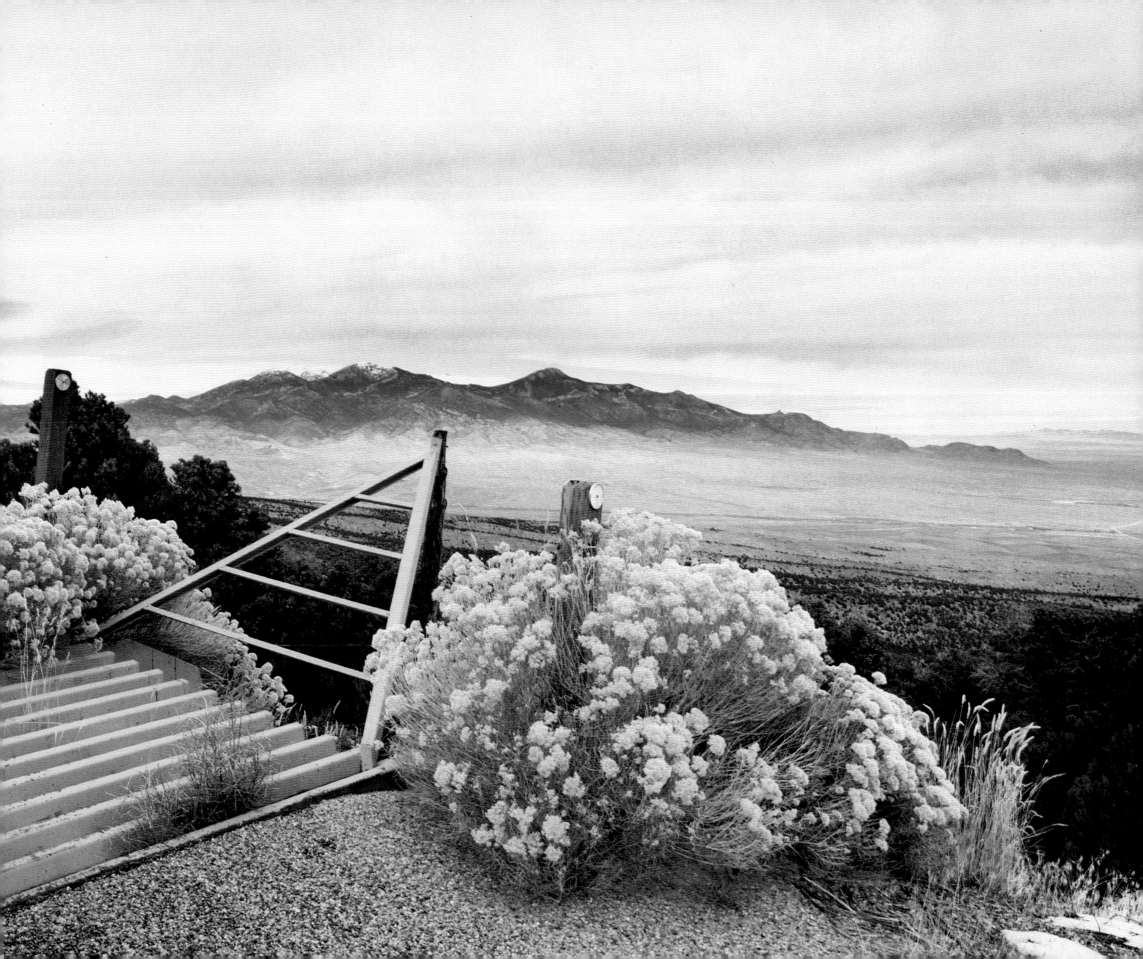

**8. RICHARD ARENTZ**
RED MAPLE IN WIND, **1988**

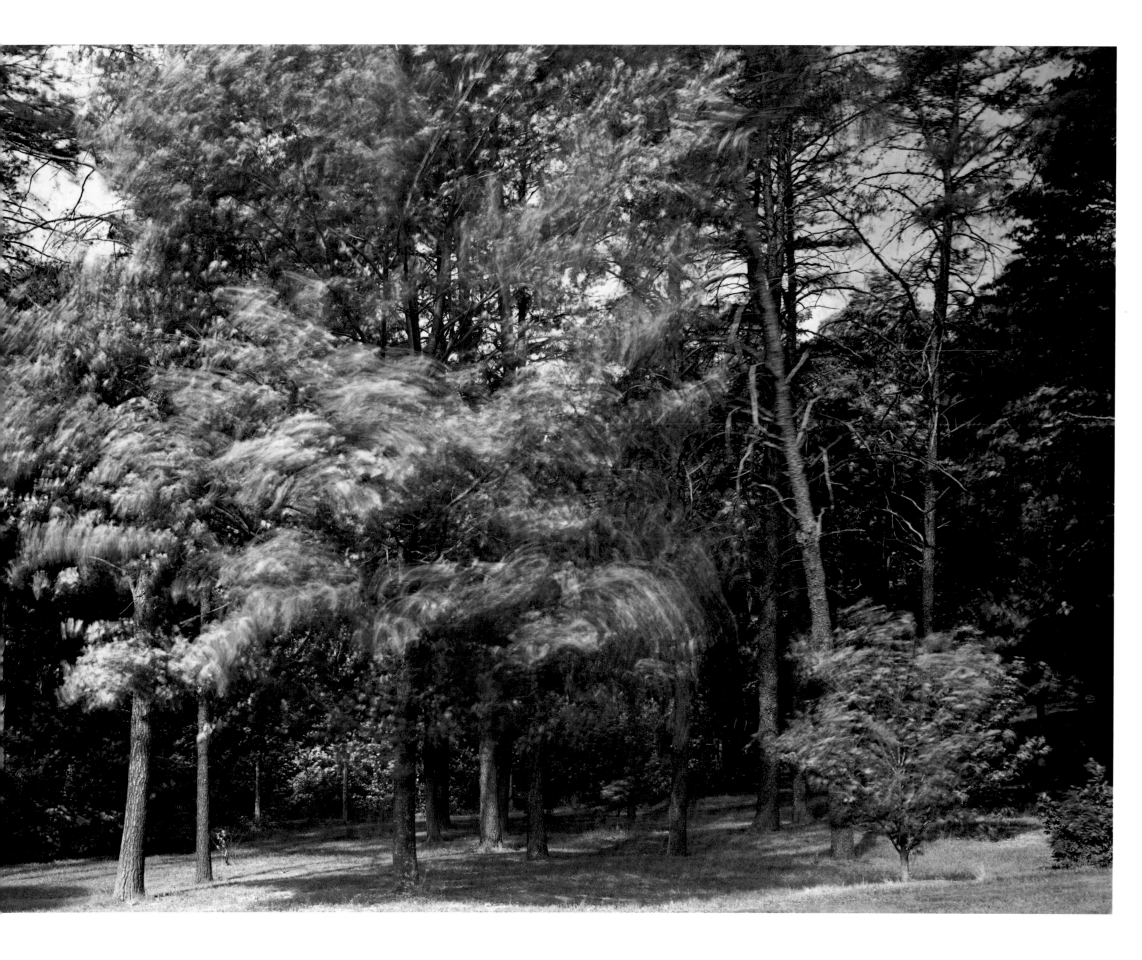

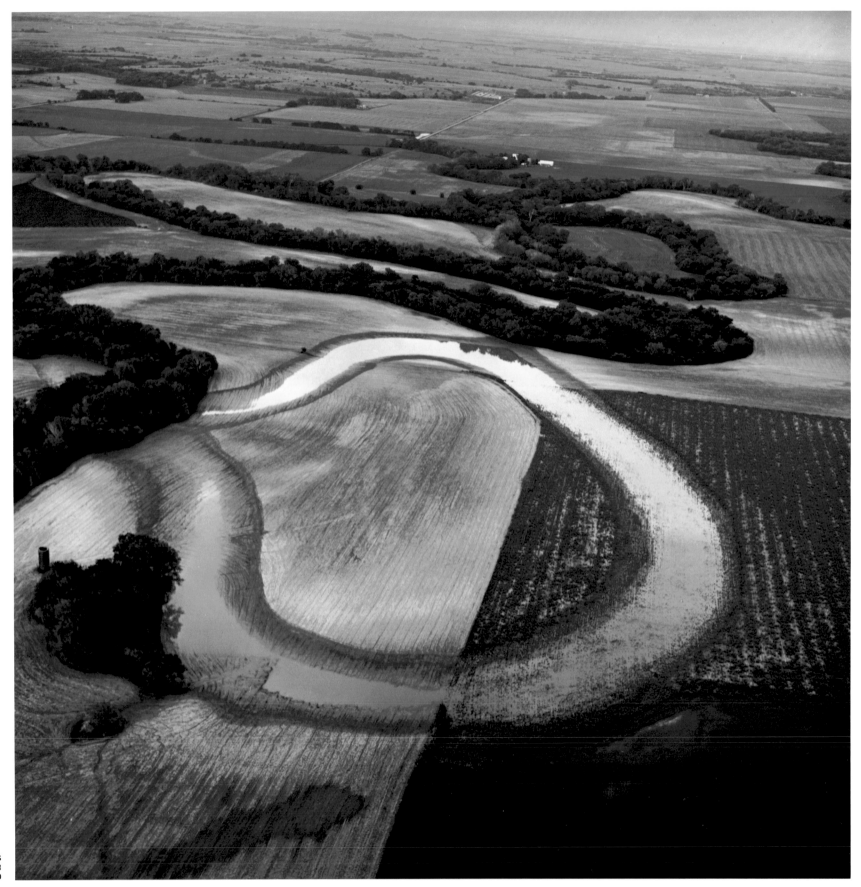

**9. TERRY EVANS**
SOLOMON RIVER
OXBOW, **1990**

# contents

## preface

The landscapes in this book reveal the intimate coexistence of nature and culture in late twentieth-century America. They could not have been made a century ago, or even a generation ago, before we knew how urgently we must reconcile our longstanding affair with the environment in which we all live. This affair, like most love affairs, is part passion, understanding, regret, sympathy, and hope. Although many of the photographers represented here draw on traditions of the past, all are informed by a new understanding of the many ways we depend on nature to be a sustaining resource, a mystery beyond human comprehension, and a physical record of our actions.

Individually, the photographs presented in this book and in the accompanying exhibition testify to the intense responses of American artists to the land, which has often been considered our nation's special endowment—a magnificent natural treasure that seemed to early Americans to be divine compensation for our lack of ancient cultures and classical heroes. Collectively, the photographs show the thoughtfulness with which we approach the challenge of cohabiting with nature in a complex age.

The museum is deeply grateful to the Consolidated Natural Gas Company Foundation for the opportunity to collect and present this major collection. With the foundation's support over four years, Merry A. Foresta met with artists from every corner of America, selecting and acquiring more than three hundred photographs. The CNG Foundation has provided a model for successful public/private partnerships, offering generous multi-year support for a program of collecting, research, exhibition, and publication. They asked only one consideration—that every aspect of the project reflect our highest professional standards.

I warmly thank Mr. George A. Davidson, Jr., Chairman and CEO of the Consolidated Natural Gas Company, and Mr. Ray N. Ivey, Vice President and Executive Director, CNG Foundation, for their complete confidence in the National Museum of American Art. Their commitment to this exhibition and book has made it possible for us to present an extraordinary record of our contemporary involvement with the land. Still more important, their establishment of a collection at the museum will give future generations insight into our attitudes and responses when these contemporary works have become part of history.

Elizabeth Broun
Director

## acknowledgments

Over the past decade, photographers' answers to the question of how we use the land have been diverse and challenging. Our use of the land is a subject that cuts across stylistic, regional, and critical categories; it is as much a historical consideration as contemporary concern. When the Consolidated Natural Gas Company agreed to work with the National Museum of American Art to assemble a collection of significant contemporary American photography, few themes seemed as pervasive or as pertinent as that of the landscape.

The pictures reproduced in *Between Home and Heaven* have been assembled to survey the character of contemporary developments in landscape. Surveys, like landscapes, are about limits, however, and assume that the character of the whole is richer than the sum of its parts. Not every landscape photographer of merit is represented here; the sustained projects that many photographers have undertaken must be represented by only a few pictures. Only two-dimensional photographic work has been included. The work accomplished by such project artists as Manual (Suzanne Bloom and Ed Hill) and Louis DeSoto, who combine photography with a range of different media (such as electronic images and video), had to be regrettably omitted.

Once thought of as irrelevant—in the 1950s Henri-Cartier Bresson exclaimed, "Now, in this moment, this crisis, with the world maybe going to pieces—to photograph a landscape!"—landscape has been recast by today's photographers as a subject of potent necessity.

My greatest thanks are to the Consolidated Natural Gas Company, whose initial generosity made this collection and exhibition possible. In particular, the support and encouragement of Beverly Jones, Vice President for Government Affairs, and Ray N. Ivey, Vice President and Executive Director of the CNG Foundation, was early, constant, and gratifying.

By discussing their work with me at length, alerting me to the work of others, and providing a variety of valuable suggestions, the artists represented here have been of enormous help. Their expertise and commitment to their subject have been an inspiration. For her thoughtful advice, I am also grateful to Ellen Manchester, Co-Director of the Water in the West Project; for his assistance in providing taped material from "The Political Landscape Conference," I thank James Baker of the Anderson Ranch Art Center.

At the NMAA, I am grateful in particular to several individuals who helped with the organization of the exhibition and this publication. Interns Elizabeth Peck and Mark Bauman and curatorial assistant Lara Scott deserve special mention. For her unflagging dedication and dependable thoroughness, my assistant Christine Donnelly deserves her own sentence. In the Office of Publications, I especially thank senior editor Terence Winch and editorial assistant Deborah Thomas. Steve Dietz, Chief of Publications, is responsible for the beautiful execution of this catalogue; his advice and criticism on all aspects of the project were always welcome.

For his ideas, support, and constant encouragement, I dedicate my part in this complex group effort to S.J. Staniski.

Merry A. Foresta
Curator

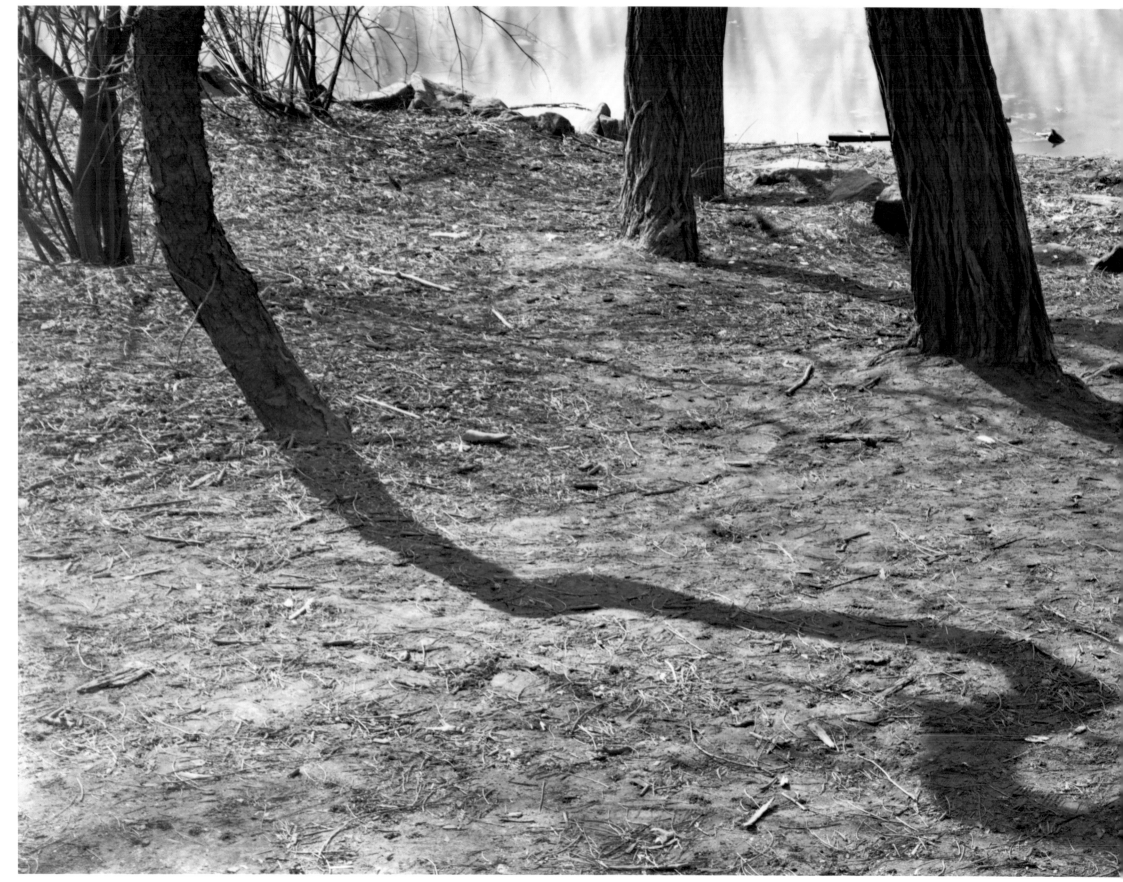

**10. LOIS CONNER,** CENTRAL PARK, NEW YORK CITY, **1988**

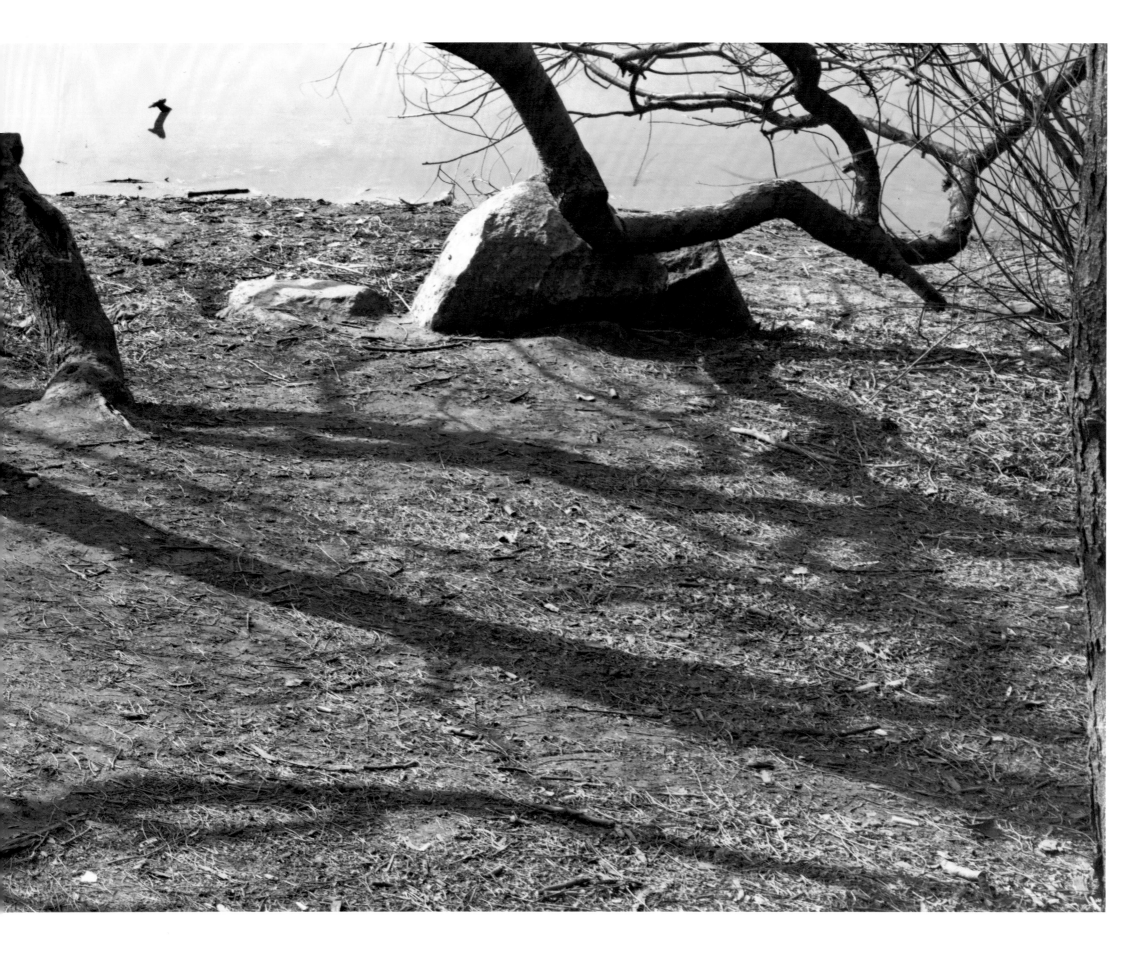

**11. ROBERT GLENN KETCHUM**
"THE VOYAGE OF LIFE"/HOMAGE
TO THOMAS COLE, **1984**

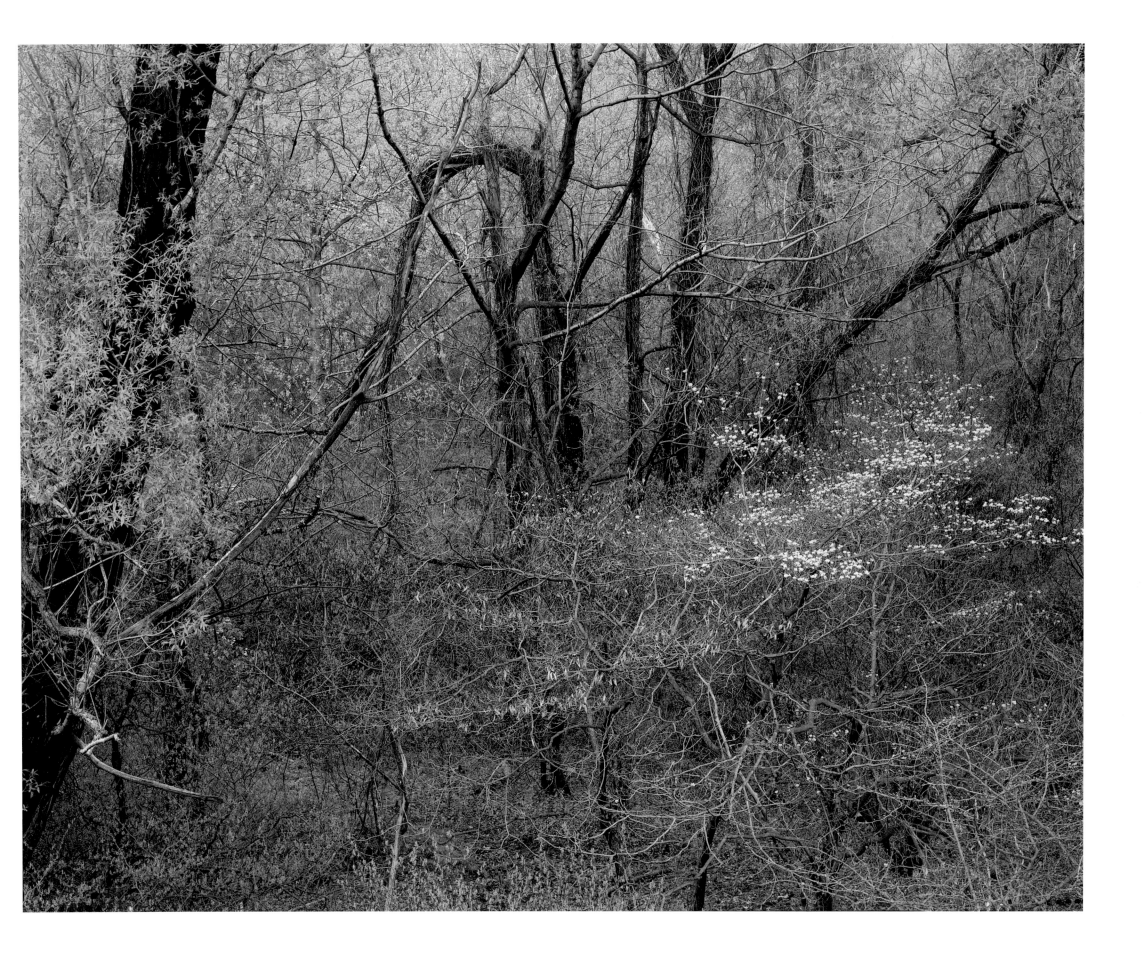

12. **ELLEN BROOKS**, UNTITLED (COURSE I), 1989

We did not think of the great open plains, the beautiful rolling hills, and winding streams with tangled growth as "wild." Only to the white man was nature a "wilderness" and only to him was the land "infested" with "wild" animals and "savage" people. To us it was tame. Earth was bountiful and we were surrounded with the blessings of the Great Mystery. Not until the hairy man from the east came and with brutal frenzy heaped injustices upon us and the families we loved was it "wild" for us. When the very animals of the forest began fleeing from his approach, then it was for us the "Wild West" began.

The white man does not understand the Indian for the reason that he does not understand America. He is too far removed from its formative processes. The roots of the tree of his life have not yet grasped the rock and soil. The white man is still troubled with primitive fears; he still has in his consciousness the perils of this frontier continent, some of its vastness not yet having yielded to his questing footsteps and inquiring eyes. He shudders still with the memory of the loss of his forefathers upon its scorching deserts and forbidding mountain-tops. The man from Europe is still a foreigner and an alien. And he still hates the man who questioned his path across the continent. But in the Indian the spirit of the land is still vested; it will be until other men are able to divine and meet its rhythm. Men must be born and reborn to belong. Their bodies must be formed of the dust of their forefathers bones.

*Luther Standing Bear, Lakota (from his autobiography published in 1933)*

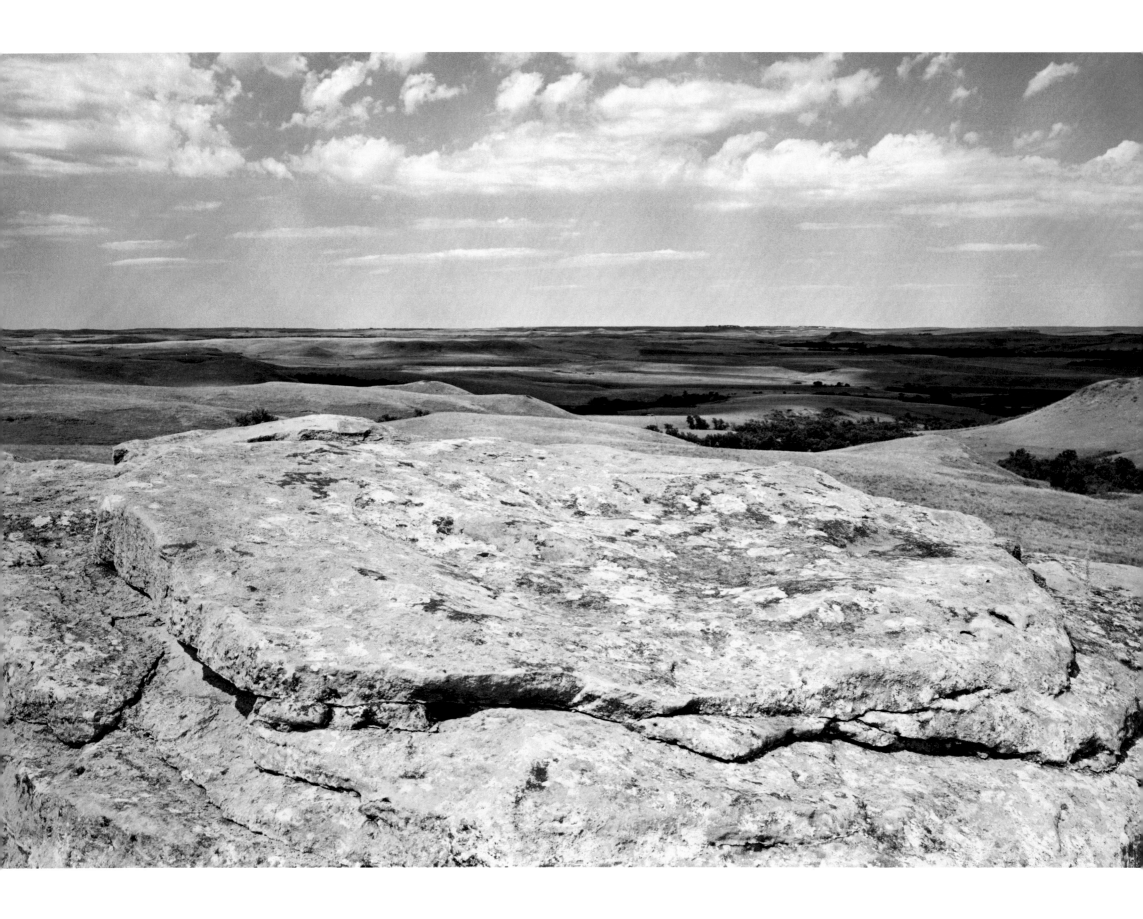

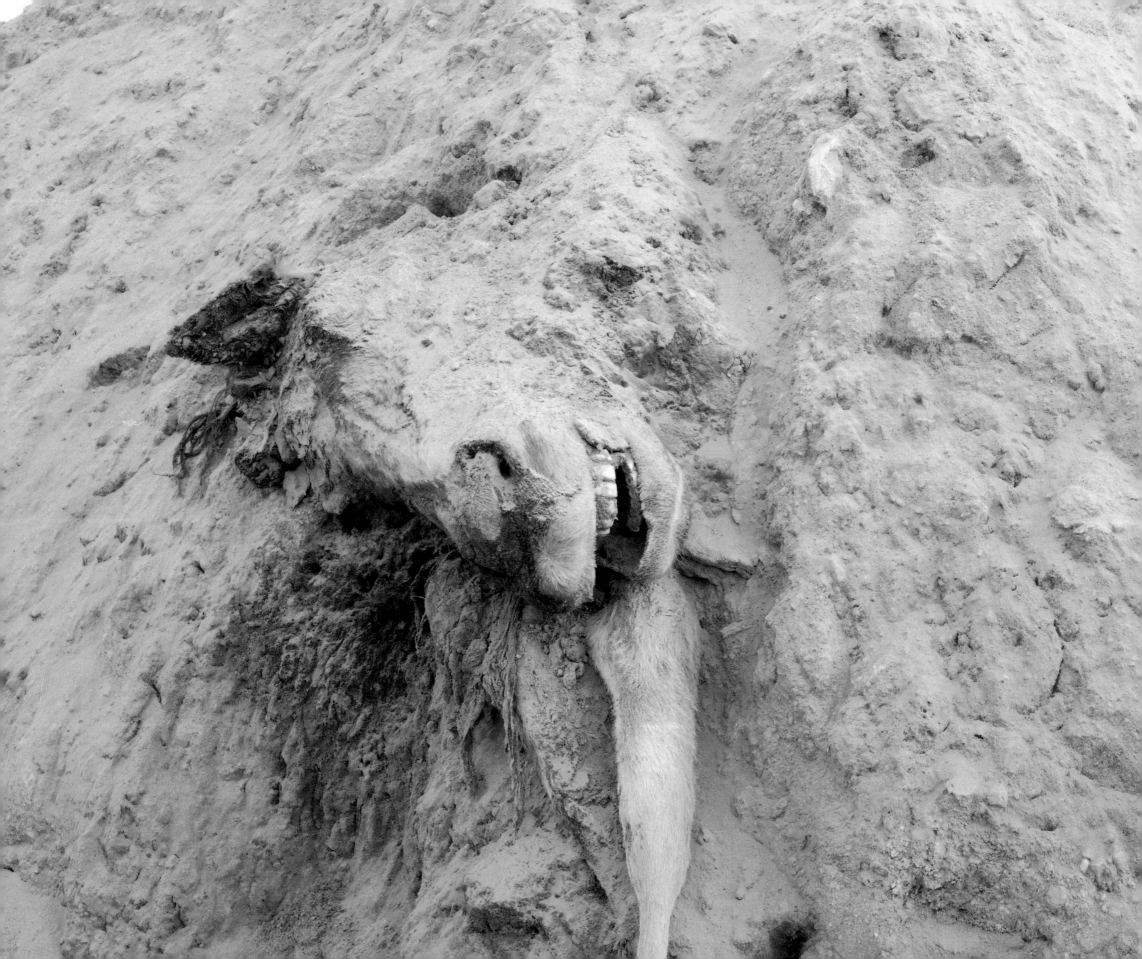

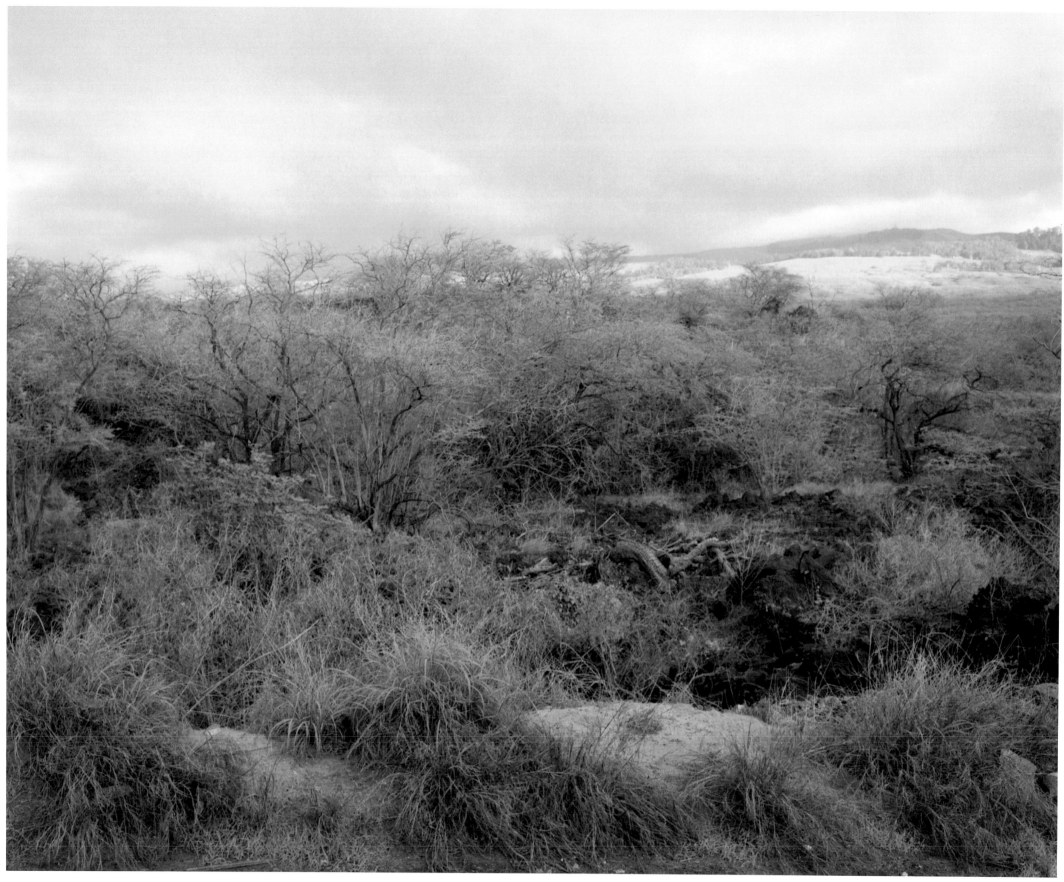

15. **FRANK DIPERNA**, MAKENA FIELD, MAUI, HAWAII, 1988

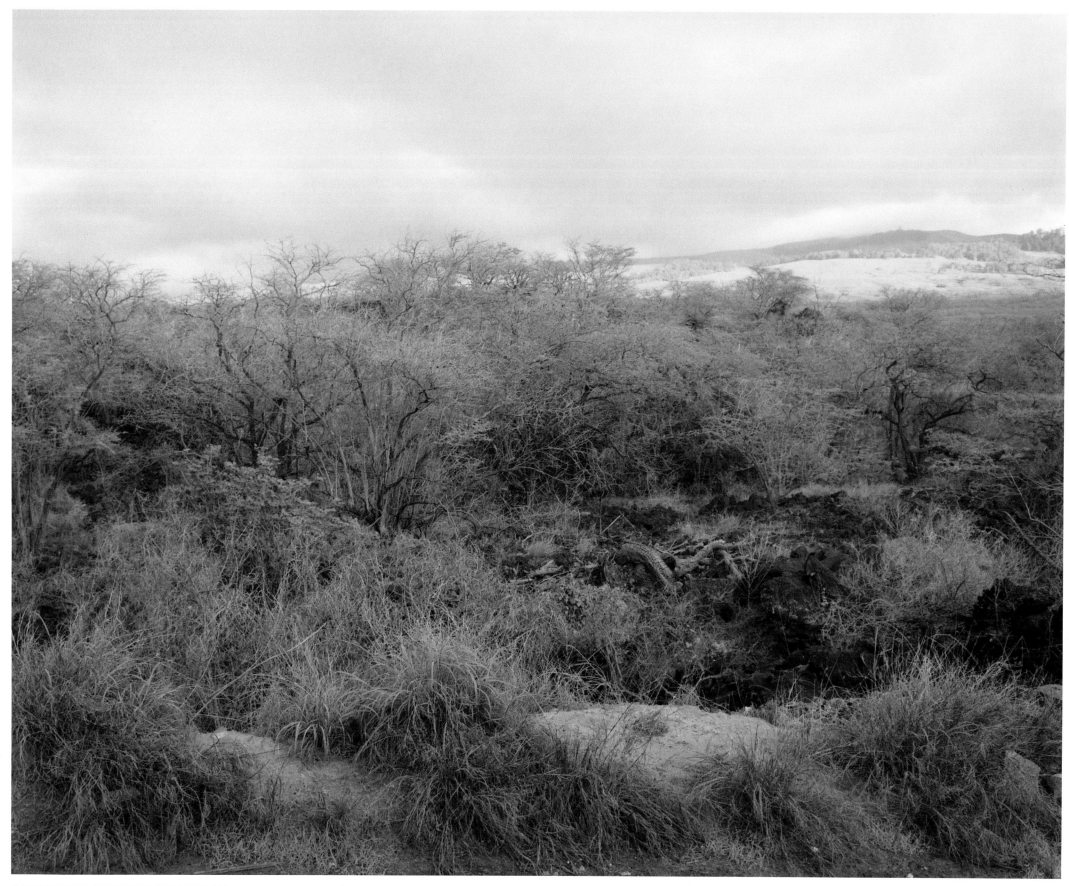

**15. FRANK DIPERNA**, MAKENA FIELD, MAUI, HAWAII, 1988

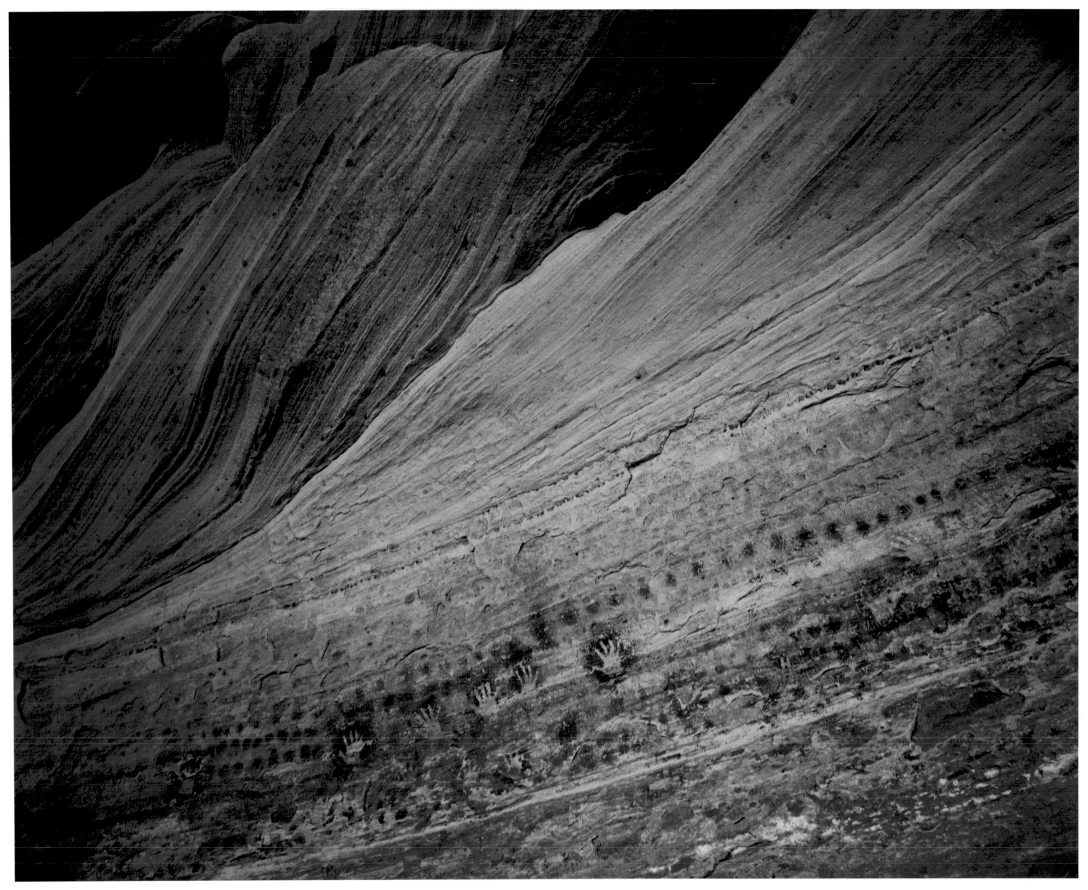

16. **LINDA CONNOR,** DOTS AND HANDS, FOURTEEN WINDOW RUIN BLUFF, UTAH, **1987**

**17. LINDA CONNOR,** PRE-HISTORIC MAZE, COLORADO RIVER, CALIFORNIA, **1986**

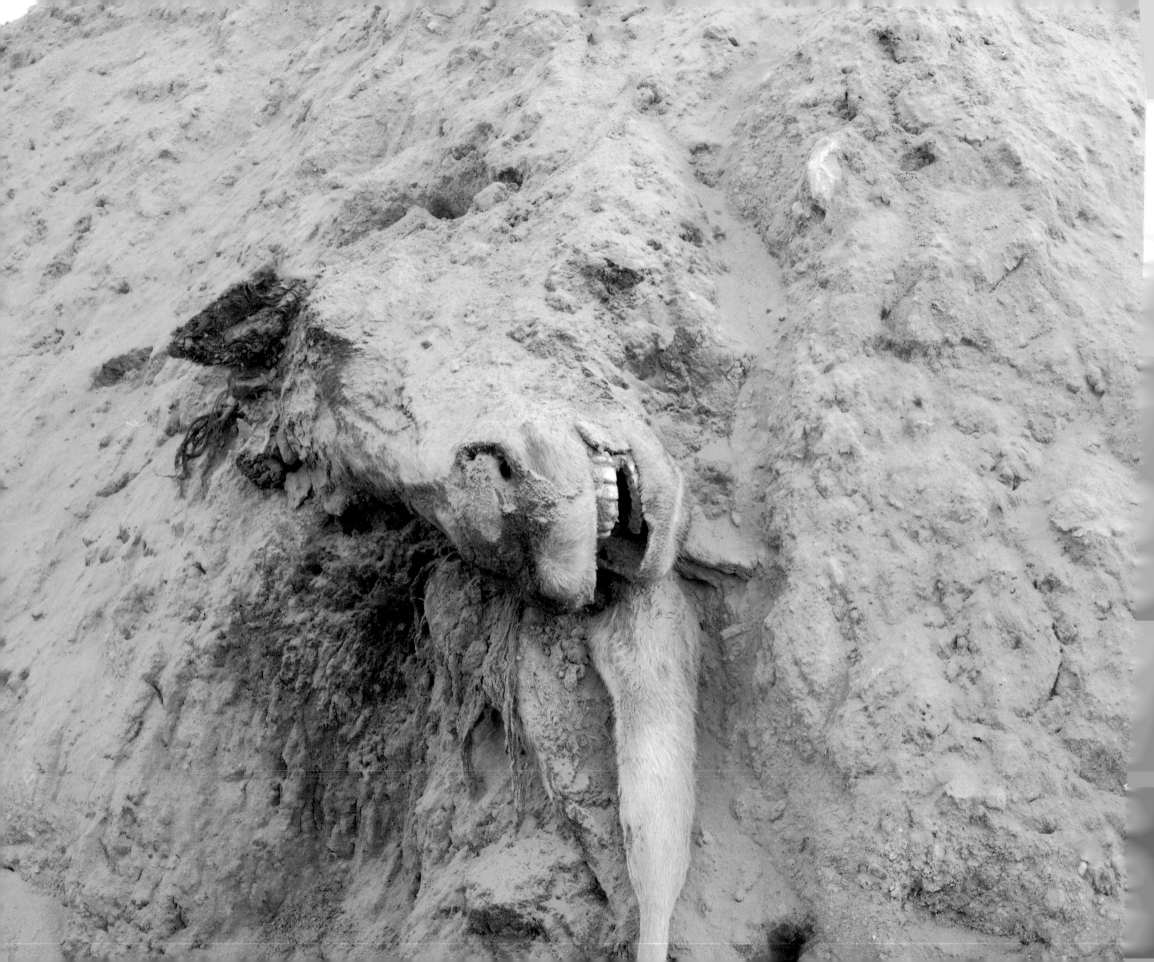

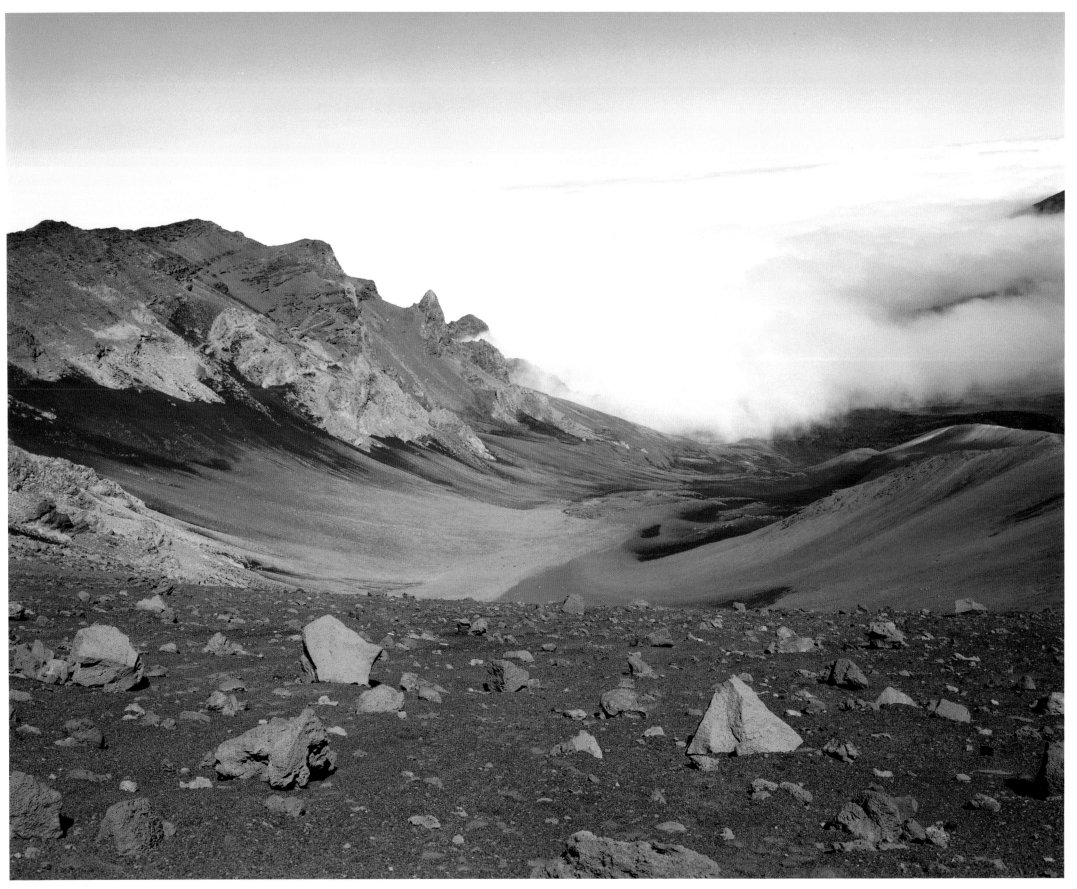

**20. FRANK DIPERNA,** HALEAKALA, MAUI, HAWAII, **1987**

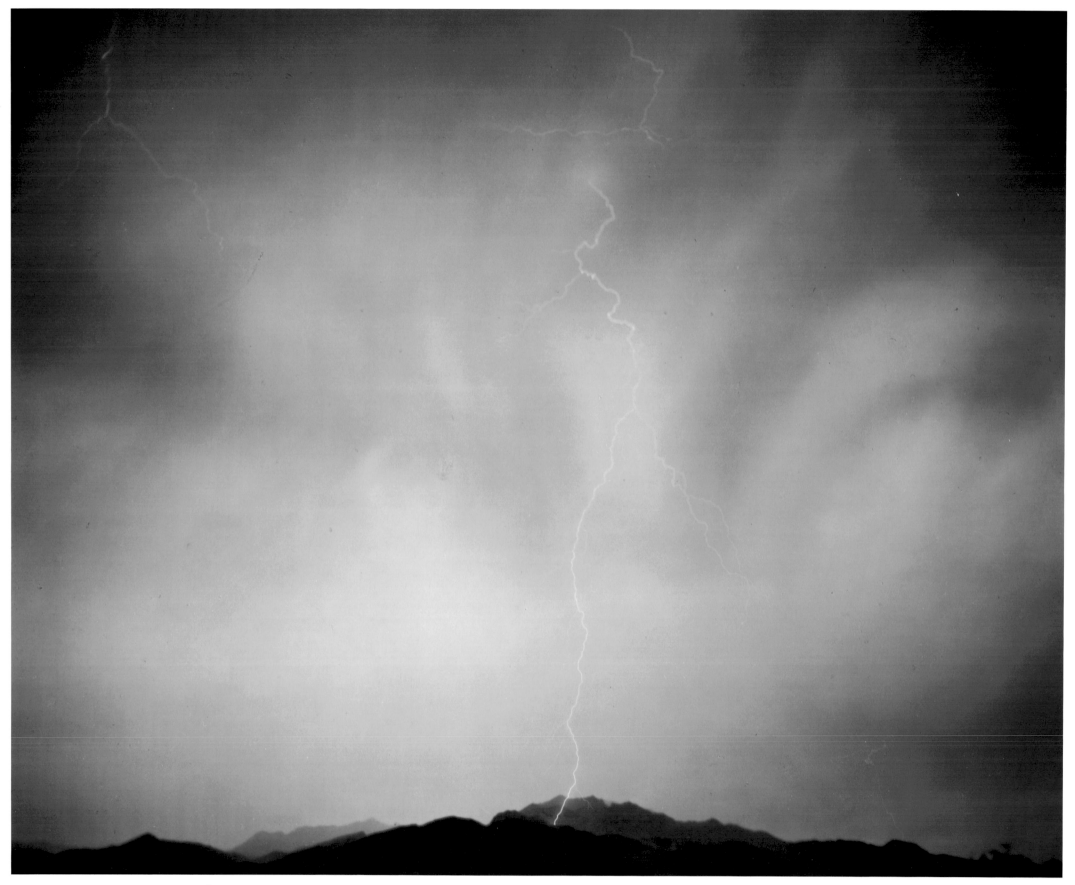

**19. LINDA CONNOR,** LIGHTNING NEVADA, **1976**

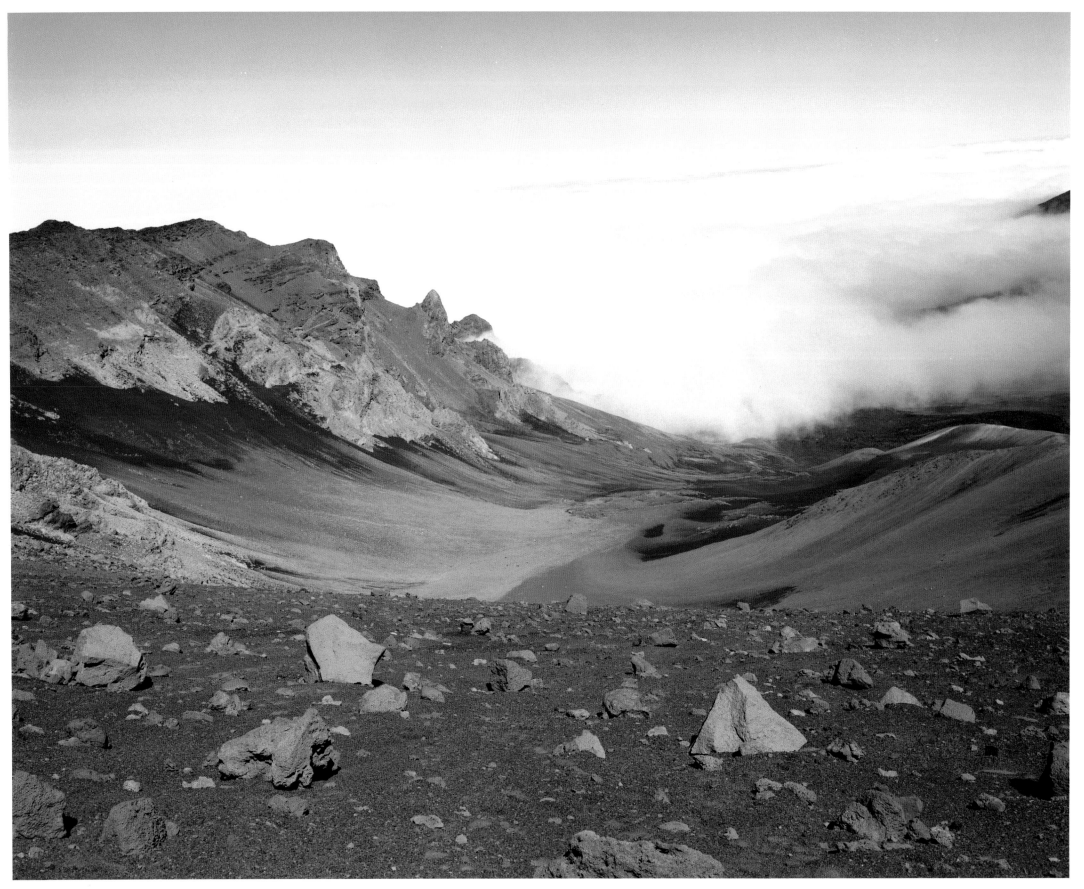

**20. FRANK DIPERNA,** HALEAKALA, MAUI, HAWAII, **1987**

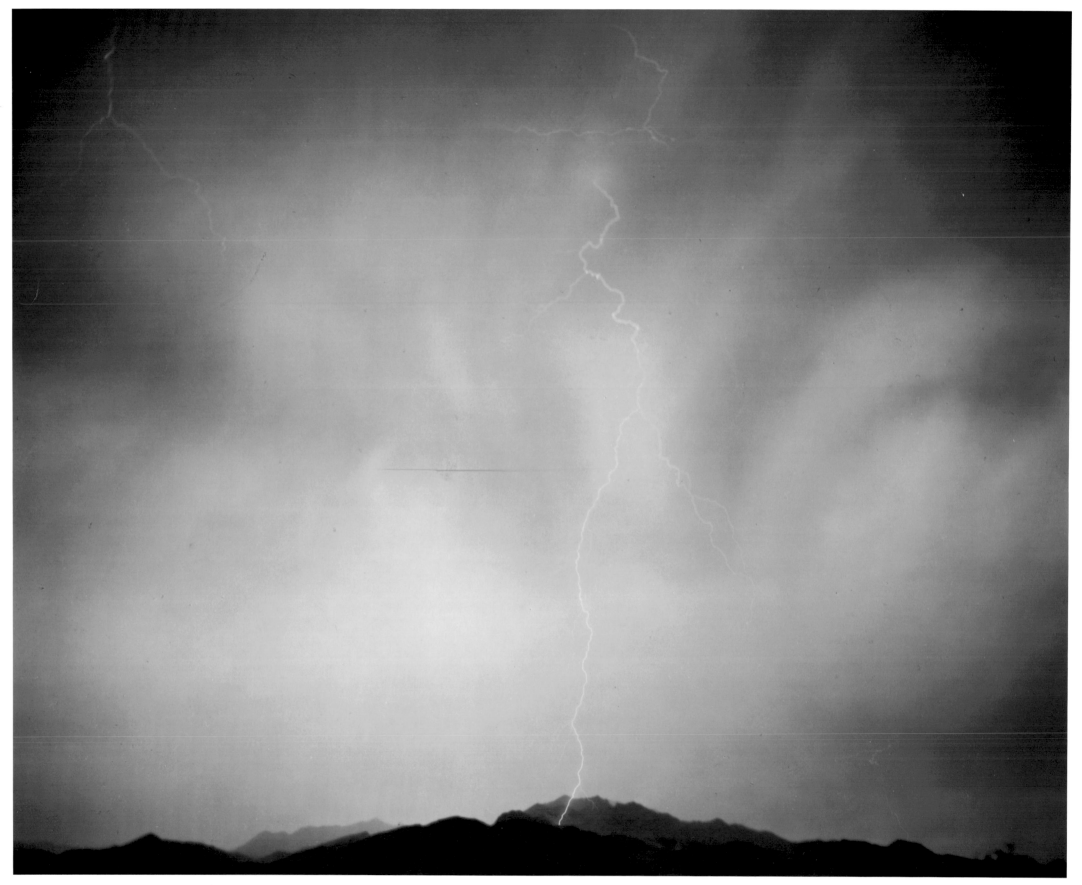

**19. LINDA CONNOR,** LIGHTNING NEVADA, **1976**

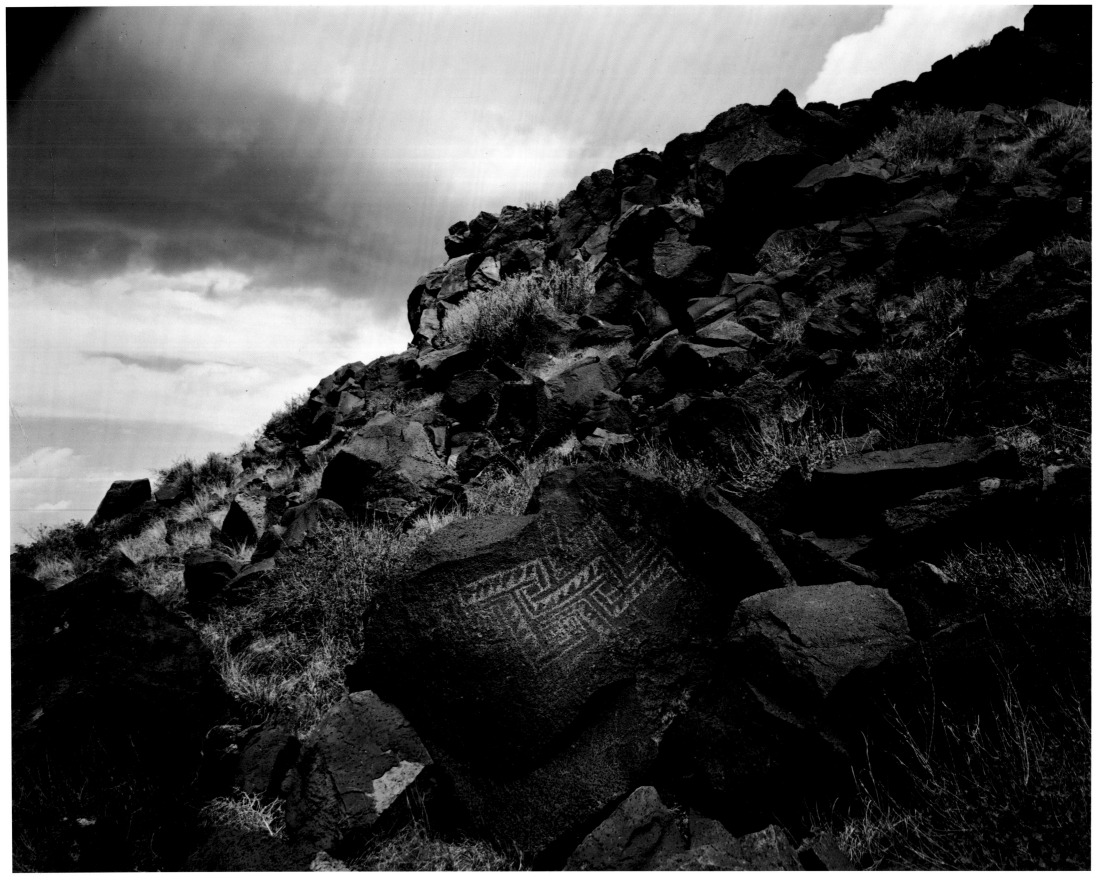

**18. LINDA CONNOR,** DESIGN PETROGLYPH, WUPATKI, ARIZONA, **1989**

# between home and heaven
## contemporary american landscape photography

**merry a. foresta**

"All these islands are very beautiful," wrote Columbus, describing his first landfall, "and distinguished by a diversity of scenery ... surpass[ing] anything that would be believed by one who had not seen it."[1] This statement is perhaps the last time America was described without reference to the aesthetic legacy that has, ever since Columbus, linked national and cultural identity with a picture of the land. Nature as Thomas Cole's or Ralph Waldo Emerson's primordial wilderness, Thomas Jefferson's garden, Walt Whitman's or Albert Bierstadt's original Paradise, Dorothy's Kansas-Oz, or Thomas Pynchon's Vineland—literature and art have projected a range of religious, moral, philosophical, and social ideas onto the American landscape.

In the late twentieth century, landscape—whether "as close as your own backyard," or "paradise on earth"—lies somewhere between the ideals of home and heaven. Echoing the older traditions of Arcadia and Utopia, this double vision of landscape promises either a return to an edenic past or innovation that will make us a paradise in the future. Photographers today chart the territory somewhere between: between society's need to make its home on earth and the hope that such a home can be heaven on earth. Taken together, the pictures in this book speak for a view of landscape as it moves away from awed response to a wary, respectful look at the land.

Not since the middle of the nineteenth century has the question of what we are doing with our land been so central to interpretation by a generation of photographers. Back then, the photography of William Henry Jackson, Timothy O'Sullivan, Carleton E. Watkins, and others—with its ability to note the particularities of place as well as the atmospheric fullness of space—was distinguished for its ability to portray the American myth of the land. The problem of how to find meaning in a New World landscape empty of civilization was in part solved by a photographic version of nature remarkable because it seemed able to produce simultaneously an informative document and a pleasing picture. With the meaning of landscape today intimately affected by the culture that inhabits the camera's geological subject, photography is again engaged in a serious attempt to realize a new aesthetic in nature.

Most of the earliest landscape photography in America was concerned with tasks other than merely presenting vistas in the European romantic tradition. As early as 1845, only six years after the invention of the daguerreotype was announced to a Parisian audience, the Langenheim brothers of Philadelphia used the new process to produce "significant American views"; their later stereographs of the same images satisfied an eagerness for domestic views of wilderness spaces. Reduced to the scale of the middle-class Victorian parlor, nature could be sampled by a new species of explorer—the arm-chair tourist. But as the Langenheims' five-panel panorama of Niagara Falls shows us, the wilderness was already marked with the signs of progress (fig. 1). From the Canadian side, we look across to the United States, where nature already shares space with industry. Moving through the picture, we not only enjoy the astonishing magnificence of the falls, but also something else. We enter the panorama along with the visitors in the wagon on the left, on an image of nature subdued by the intervention of human industry, but exit in the last panel with an image of the wagon now headed toward the unoccupied distance. By the last panel it has been made clear where the wagon and the as yet unsettled landscape are headed.

Most nineteenth-century landscape photographers were engaged in very specific documentary tasks for a variety of public and private clients. Best known to us are the photographs made by those men who traveled with the geological survey teams following the Civil War. These photographers and others were also hired by the railroads, mining companies, Indian expeditions, or real estate developers. Photographs from the frontier settlements of the mid-nineteenth century feature the development of the land, not the empty spaces of majestic views. It is human scale rather than nature's being measured. The images are of cleared land and towns in the process of construction (fig. 2). Aside from a few eastern intellectuals, who shared with the transcendentalists an idealistic sense of nature

as a direct link to God, "most of those who dwelt in newly settled regions," as critic and photographer Deborah Bright points out, "were hostile to precisely those aspects the literati found ennobling—the solitude and the savages."[2]

The so-called "cult of wilderness" grew out of pragmatic concerns combined with a romantic urge on the part of its adherents to preserve what was being rapidly used up by the final decades of the nineteenth century—land and space (i.e., nature itself). To generate interest in the cause of protection, photographers and painters alike were enlisted to augment the pictorial record. Sold as stereographs for the mass market and picture albums for Victorian parlors, pictures of giant trees, spouting geysers, balancing rocks, and breathtaking gorges were by then familiar staples of the popular picture trade (fig. 3).

The notion that we can no longer respond to images with any degree of innocence—thanks to television and *Life* magazine, more of us have "visited" the surface of the moon than Niagara Falls—has become basic to late twentieth-century thought (fig. 4). That end of innocence, along with a new emphasis on the politics and spirituality of landscape, sets recent work apart from most modernist landscapes. Contemporary photography successfully mediates between two opposing tendencies in landscape: the desire to record nature versus the desire to construct reality out of pictorial illusion. In the form of a photograph, the open spaces of nature combine with the controlled, compact environment of the camera and the darkroom studio. The promise of the earliest camera obscura— the lens-pierced darkened room that made possible the capture of a picture formed by natural light—continues to suggest the mix of scientific precision and poetic idea integral to landscape photography. Like a natural boundary, the frame of the photograph arranges our view. Inside and outside are reconciled. Meaning becomes something inherent in the subject rather than an effect of composition—a idea to be contemplated rather than a space to be entered.

Looking afresh at the cultural meanings of landscapes, contemporary photographers practice a genre bound neither by style nor technique. For their definitive *Landscape as Photograph*, Estelle Jussim and Elizabeth Lindquist-Cock isolated eight different approaches—from artistic, genre, and pure form to politics and propaganda—to account for the

ideologies that implicitly or explicitly shape the aesthetic, moral, and political outcomes of the practice of landscape photography.[3] Photographers trained in subjects such as geology as well as art have further extended the boundaries of recent landscapes by bringing to their work an interest in social and ecological issues. Their talk may just as easily be of ecosystems as f-stops.

For photographers, the present challenge lies in making photographs that address the myths of landscape in ways that make sense out of contemporary experience. Feminists, as well as artists whose identities are rooted in different cultures, approach the issue of meaning in landscape from perspectives that have not been part of the traditional discourse. Terms like "virgin territory" and "Mother Nature" are being reconsidered; the concepts of frontier, wilderness, and exploration are being reviewed. The crisis of modernism ultimately involves our precarious relationship with nature: the used-up quality of heroic aesthetic formulas suggests the depletion and exploitation of natural resources.

Most of the artists represented in this book continue to use traditional materials and methods for their images, making old approaches work for new subjects. Others rely on more experimental techniques—creating pictures from preexisting images, for example, or otherwise affecting the place photographed. Some construct their landscape environments to be photographed in the studio. What all these artists share with us, however, is a new orientation to the subject of nature, one tied to the cycles of contemporary life. Their chosen landscape is typically a living and working milieu in which each train of discourse—critical analysis and practice—feeds and enriches the other.

Consider two landscapes. One by Mark Klett recalls nineteenth-century geological survey photography, while the other by John Divola looks like the documentation of a sculpture-in-progress. Majestic views and lumpy models ordinarily have little in common, yet both these pictures raise questions regarding the meaning of "natural" and "artificial," revealing the interconnections between nature and art. Between them they describe the range of vision available to contemporary photographers who have chosen to rethink the landscape genre.

The subject of Mark Klett's five-panel panorama is described by its title, *Around Toroweap Point, Just Before and After*

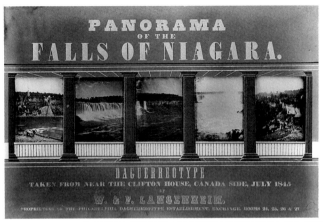

FIG. 1. LANGENHEIM BROTHERS, *PANORAMA OF THE FALLS OF NIAGARA*, 1845. FIVE-PANEL DAGUERREOTYPE PANORAMA.

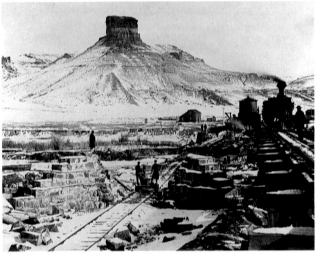

FIG. 2. ANDREW JOSEPH RUSSELL, *TEMPORARY AND PERMANENT BRIDGES AND CITADEL ROCK, GREEN RIVER*, 1868. ALBUMEN PRINT.

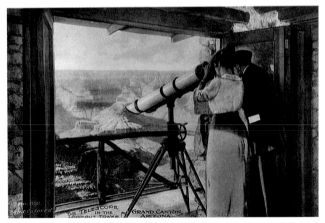

FIG. 3. THE TELESCOPE IN THE LOOKOUT TOWER, GRAND CANYON, ARIZONA, CA. 1910. POSTCARD.

*Sunset Beginning and Ending with Views by J. K. Hillers Over 100 Years Ago, Grand Canyon* (pl. 21). In five frames Klett has encompassed a bend in the Colorado River. The first frame, featuring an upriver view, and the last, a downriver shot, re-create views made by John K. Hillers, who worked as photographer for the Hayden survey of the Yellowstone in 1872. Over a hundred years later, during the time of a sunset, Klett made additional exposures, carrying his camera several hundred yards to include the view in between. Some part of each picture is repeated in the next, just as the contemporary image includes pictures made a century before.

Divola's four-part landscape, *Cyclone on the Beach,* is entirely invented (pl. 38). The temporal rhythm of dawn to dusk is described by the painted stars of the final frame and by the progression of lengthening shadows, the result of well-placed studio lights. The cyclone is nothing but a papier-mâché and chicken wire model held up by strings, the beach a painted studio backdrop. The entire situation is artificial—who has ever heard of a prairie cyclone landing on a beach or posing for a series of photographs? Indeed, no force of nature ever looked so tame.

Cyclones, the cosmos, the atmosphere—traditionally these elements are part of the stormy vocabulary of the sublime. Divola's late twentieth-century example, however, suggests the drama of lost order and direction that results from the fragmentation of contemporary experience. Though it is not the traditional highly charged effect preferred by Thomas Cole or Frederic Church (fig. 5), Divola's landscape, with an aura of hand-made intimacy that lends emotional weight to the not ordinary scene, remains a subject of transcendent possibilities. Ours is often an irrational world of machine-generated images in which natural truths are displaced by man-made fictions. The material and the spiritual are often confused. The world we experience, usually through an elaborate range of media—including photography—is often theatrical, even magical.

Both Klett and Divola's landscapes concern distance. First, there is the distance implied by the passing of time. Like a time-release nature study, Divola's image unfolds over an entire day. Bracketing his own contemporary views with Hiller's from the nineteenth century, Klett constructs a seamless continuum from first view to last. Klett uses his hat to mark the landscape.

Beyond indicating human scale, the hat adds the photographer and the photograph to a timeline that began with the formation of the rock (fig. 6). The striations of the canyonside recount a geological time of many thousands of years, while Klett's quotation of Hiller's nineteenth-century photographs questions the progress of a century: what is different, how much is the same?

The second kind of distance lies between the picture and the motivation to make the picture—the distance between real experience and the coded iconography that represents it, the distance of the photograph from the circumstances and substance of which it is an impression. For Divola, a mere record can never capture heartfelt experience. And while he aspires to an emphatic revelation of the artifice, he is equally insistent about working the iconography of the art. Klett's images also admit the difference between beauty and information. Models are sculpted, paint drips, Polaroid film leaves its mark; the land no longer serves as a conceptual vacation from human issues. In the collision of limits lies a truer reunion between humans and their environment.

As the work of Klett, Divola, and others makes clear, a new brand of romanticism—part pastoral, part irony—marks much of contemporary landscape photography. After a century and a half of photography, we cannot look at pictures of the Grand Canyon with the same astonishment as did nineteenth-century viewers. Our situation practically demands cyclones on the beach.

However diminished or tame the landscape may have become, the impulse towards the pastoral—the retreat to nature in the face of society's increasing power and complexity—has been a persistent force in America art. "It is the suddenness and finality of change—the recent past all at once a green colonial memory," that triggers artists' attention.[4] In a space age capable of sending back to earth an image of the entire planet, any move "closer" to nature involves a landscape that inescapably bears the marks of human intervention.

For artists, the revelations of the technological age, as in Rachel Carson's *Silent Spring* (1963) or Alan Toffler's *Future Shock* (1970), increasingly prompted an emphasis on the politics and spirituality of landscape. The discussion of land in terms of politics, economics, and culture—continued in books such as Roderick Nash's *Wilderness and the American Mind* and William

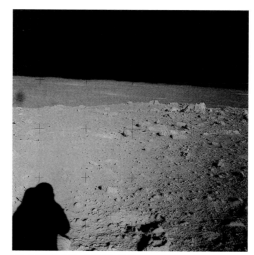

FIG. 4. APOLLO 14 MISSION, 1971.

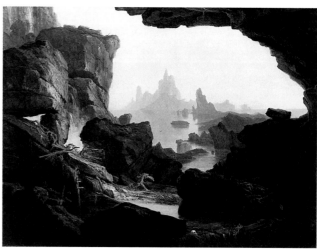

FIG. 5. THOMAS COLE, *THE SUBSIDING OF THE WATERS OF THE DELUGE*, 1829. OIL ON CANVAS. 35 3/4 X 47 5/8 IN.

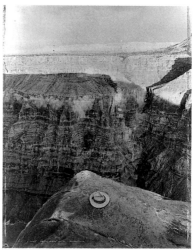

FIG. 6. MARK KLETT, *AROUND TOROWEAP POINT #2*, 1986 (SEE PL. 21).

McKibbin's *End of Nature*—revised the traditional view of the landscape. Photography, capable of description that includes both technical and cultural interpretation, could mingle opposing impressions of the "natural" view. The camera, itself a machine in the garden (to use Leo Marx's metaphor), facilitated a move from the "natural" landscape to the cultural landscape.

In the 1960s, issues of meaning and interpretations of landscape photography began to be identified. Those artists whose brand of conceptual art used the land as both medium and subject relied on photography to document their artistic activities. The "roads to a view" that earthworks artist Robert Smithson advocated were excursions to land and waterworks of tremendous scale that few gallery-goers needed to make (fig. 7). His *Non Sites* (made by Smithson in 1968, these works take earth material from a specific site and present it in visually neutral bins accompanied by documentary maps) addressed the tamed wilderness, the "non spaces"—superhighways, airports, parking lots—of twentieth-century civilization. Documentation of these earthworks, along with those of the related happenings or performances, were more "framable" and thus viewable and were more and more regarded as artworks themselves.

As the landscape itself began to seem more fragile, the camera in the landscape seemed a gentler machine than the bulldozer. The popularization of views by Ansel Adams, Eliot Porter, and others by the Sierra Club and other environmental organizations matched the rise of appreciation for landscapes in museums and galleries. "The Photographer and the American Landscape," a 1963 Museum of Modern Art exhibition curated by John Szarkowski, presented nineteenth- and twentieth-century work by artists ranging from Timothy O'Sullivan to Art Sinsabaugh. Mapping a modernist trail, the curator cited the growing limitations of the American wilderness as subject; the wilderness had become merely "those remaining fragments of the American landscape that recall the original site."[5]

During the 1970s, curators and critics undertook a significant reconsideration of landscape photography. In historian Peter Hales's words, photography moved from a position of "embarrassed popular step-child" in the art world to "one of seriousness, even centrality."[6] During a decade that reverberated with images of the Vietnam War and the nation's Bicentennial celebration, photography struggled to define itself around issues of style that described an actual, physical subject. "New documentary" photographers—Diane Arbus, Gary Winnogrand, Danny Lyon, and Larry Clark among them—had reinterpreted traditional documentary genres in the 1960s to picture more personal, difficult truths. These artists probed the difference between what a picture is of and what it is about. The authenticity of character produced by Diane Arbus's photographs of society's misfits challenged the stricter, formal boundaries of landscape photography.

A 1975 exhibition called "New Topographics: Photographs of a Man-Altered Landscape," at the International Museum of Photography, featured work characterized by a more rigorous intention.[7] Photographs by Robert Adams, Lewis Baltz, Bernd and Hilda Becher, Joe Deal, Frank Goelke, Nicholas Nixon, John Schott, Stephen Shore, and Henry Wessel, Jr. pictured few people while insisting on architectural and other signs of human presence (fig. 8). The show, comprised of works by a generation of artists who came of age in the period of postwar American prosperity (then just beginning to disintegrate), demonstrated how the vernacularity of shopping malls, tract housing, motels, and industrial parks, seen juxtaposed with glimpses of mountains, desert, and sky, is a record of progress (or perhaps the failure of progress).

The photographers' pointedly "artless" photographic strategy, by which they refused to extol nature over civilization, stood in sharp contrast to the popular vision of the wilderness, as exemplified by photographers such as Ansel Adams. Continuing a modernist emphasis on the expressive possibilities of natural forms (practiced earlier in the century by Alfred Stieglitz, Edward Weston, Minor White, Ansel Adams and others), the modernists' dramatic, sensuous views of natural wonders almost entirely avoid any references to society (fig. 9). In these epic photographs, marked by technical perfection, mountains rise up, birch trees glisten, mists sputter as waterfalls crash, and brooks gurgle in unpolluted solitude. Such a visionary sense of the redemptive beauty of the wilderness has made these photographs—Ansel Adams's in particular—persuasive promotions for twentieth-century conservation movements.

Scornful of photographers who created images of wilderness by cropping out trash cans, tourists, and telephone poles, the New Topographers championed what they considered to be a

more truthful representation. Seemingly neutral, their photographs evoke the kind of description that "was anthropological rather than critical, scientific rather than artistic."[8] In fact, with references to land-use management, automobile culture, and the leisure habits of contemporary Americans, these photographers joined a contemporary discussion of cultural geography.[9]

Statements by the photographers—"The world is infinitely more interesting than any of my opinions concerning it" (Nixon); "The most extraordinary images might be the most prosaic with a minimum of interference (i.e. personal preference, moral judgment) by the photographer" (Deal); "The ideal photographic document would appear to be without author or art" (Baltz)—underscore the "style-less style" of the photographs.

Still, if documentation requires neutrality, then none of these photographers produced documents. These photographs were as exclusionist as the pristine views of nature they contradicted. The point throughout New Topographics was the contrast between the photographers' reductive style—it is no mistake that many of these images exhibit a surface frontality of closed-in space—and the often meager possibilities of human existence in the spaces they depicted. Conceptually self-conscious, these artists chose stylistic precedents that included the mid-1960s seriality of Ed Ruscha, the vernacular of Pop, as well as nineteenth-century topographical photography. New Topographics, argues Richard Misrach, "not only opened up the possibilities of a photographic critique of our culture's relationship to the environment, it also opened up a critique of landscape photography as well."[10]

Begun in 1977 (initially with support from a Documentary Survey grant of the Visual Arts Program of the National Endowment for the Arts), the Rephotographic Survey Project (RSP) sprang from a far wider conceptual movement in the world of art criticism. The members of this group—including photographers Mark Klett, JoAnn Verburg, and Rick Dingus, photographic historian Ellen Manchester, and mathematics teacher Gordon Bushaw—formed a new kind of collective. Between 1977 and 1979 they repeated more than 120 nineteenth-century photographs by W. H. Jackson, Timothy O'Sullivan, John Hillers, A. J. Russell, and Alexander Gardner. The process was simple in method, arduous in execution: travel to the landscape, find the nineteenth-century view, and make a second view as close as possible to the

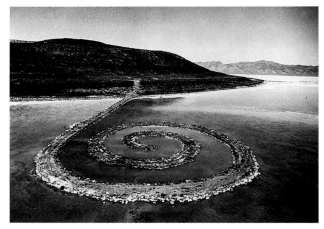

FIG. 7. ROBERT SMITHSON, *SPIRAL JETTY, APRIL 1970* (GREAT SALT LAKE, UTAH). PHOTOGRAPH BY GIANFRANCO GORGONI.

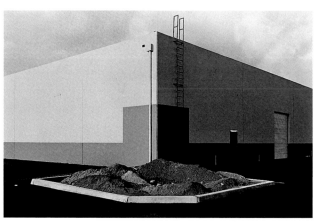

FIG. 8. LEWIS BALTZ, *SOUTH CORNER, RICCAR AMERICA COMPANY, 3184 PULLMAN, COSTA MESA*, 1974.

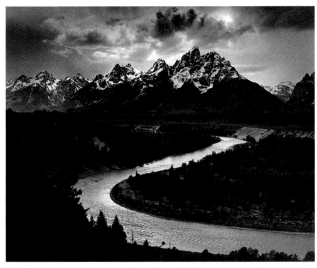

FIG. 9. ANSEL ADAMS, *THE TETONS AND SNAKE RIVER, GRAND TETON NATIONAL PARK, WYOMING*, 1942.

FIG. 10. (TOP) TIMOTHY O'SULLIVAN, *GREEN RIVER BUTTES, GREEN RIVER, WYOMING*, 1872 (U.S. GEOLOGICAL SURVEY), AND MARK KLETT AND GORDON BUSHAW, *CASTLE ROCK, GREEN RIVER, WYOMING*, 1979 (FOR THE REPHOTOGRAPHIC SURVEY PROJECT).

photograph that inspired it. Beyond recognizing that the place no longer looked like the picture, the RSP photographers could compare what was included in the frame with what was left out. Not only did rephotographing provide an imaginative way for artists to experience a hundred years through a very simple comparison, the process also enabled them to examine concepts of originality and individuality. The very subject of landscape gave photographic practice and context new critical territory. If the land itself had been used up, pictures had not.

Published in 1984, *Second View: The Rephotographic Survey Project* paired illustrations of original views with their contemporary copies (fig. 10). The images implied not only the passage of time, but the changes "in the often complex interpretations we make in order to compare similar but different pictures" as well.[11] The publication also suggested nostalgia for a time when photography could make a difference, when the photographer had a particular value—like the cartographer or the geologist—as a member of a survey team. Appropriating the technique of repeat photography, well known to environmental scientists in search of evidence for certain changes in geography, these art school-trained photographers slyly extended the idea of aesthetic comparisons in pseudo-scientific terms.[12] The publication was something of a literal and philosophical "how to" book, with various appendices that explained things such as the "Geometry of a Vantage Point" and "Mathematical Technique for Checking the Accuracy of a New Vantage Point." Though perhaps breaking conceptual ranks, soul-baring confessions, such as that by Dingus on the importance of participation, rang true: "My experience at each site became an interaction.... [It] was both an exchange and interchange, an engaging and a blending, an agreement and an affirmation."

By the early 1980s it seemed unlikely that landscape photography could continue under the guise it had assumed for most of the twentieth century. Almost overnight, a single view of anything came to seem insufficient. The methods introduced by the New Topographers and the RSP proposed aesthetic revelations that could sometimes reach beyond themselves toward areas of moral concern. The ordinary, simple act of describing the landscape suddenly became loaded with responsibility. These developments—along with the admission that a persistent romantic avowal, however dressed in the guise of science, could still preside over a new American cultural landscape—completely

altered contemporary notions about photography.

In complex times, there are many possible ways for an artist to achieve significance. One contemporary path is to enter the urban environment, to embrace the fractured signs, the discontinuity, the utter dissemblance of meaning. An opposite approach is for the artist to search out the meaning of signs in nature, motivated not by the notion of retreat from the urban metropolis, but by the need to find inner significance apart from the self-conscious fabrication of contemporary identity.

Most recent landscape photographers continue to use the formal aspects of beauty as a strategy of persuasion. The beautiful is usually revealed, however, in the less spectacular guise of cultivated fields or the protected preserves of state parks. As described by environmentalist J. B. Jackson, whose writings are often cited by these photographers, a revolution in ways of perceiving the environment "has to operate through ten thousand private decisions...by wishing to astonish a neighbor; by dissatisfaction; by sudden illumination, by patient experimentation."[13]

A frequent point of view in these photographs is one that slightly distances us from the subject. In general avoiding the close-up and the long-range view, these artists instead present a middle ground, offering a meditation on the landscape and its meaning. Quiet images describe a continuity between ancient reverence and contemporary reliance on land as an effective respite from mechanized society (pls. 3, 16). The middle ground offers only a part-time connection to nature, to be sure, but a respectful one nonetheless.

A sharp awareness of the disjunction between experience dominated by sophisticated machines versus a wonder at the deeply felt sense of moral order in nature informs the work of many contemporary artists and scientists. To geographer Denis Cosgrove, the ability of contemporary scientists to describe the world depends on the same sense of unified meaning understood by those widely learned individuals he calls "Renaissance environmentalists," whose philosophy recognized the integral link between humankind and nature. Cosgrove suggests that in a postmodern world, where meaning is often constructed through images, art may lead the way to affirm beauty in, and man's unity with, the world. "Image

and metaphor," he writes, "are conceived not as surface representations of a deeper truth but as a creative intervention in making truth."[14] Geography and photography, both of which attempt to describe and make sense of the natural world and the role and record of people in transforming it, stress as crucial concerns the place of humans in nature and their manipulation of the natural world.

What is at stake in landscape, visually and culturally, are the issues beyond the frame. Cosgrove calls this larger context the "new environmentalism"—the "unity of knowledge combining moral and political with empirical understanding." Mark Klett echoes Cosgrove: "the difficulty is to discover new wilderness values as well as new wilderness places."[15] The effort to reestablish a synchronicity between nature and culture is heartfelt. We're reminded of Klett's hat and Divola's cyclone. No longer mere illustrations, these landscape photographs themselves are subjects of complicated realities, dependent on their audiences. Once engaged, we are asked to participate.

Contemporary panoramas—particularly those made with a circuit camera that rotates—remind us that any representation of space is illusory. In panorama photographs, countless viewpoints are recorded in the form of a long narrow picture, such that a 360-degree event is rendered as if it took place in a straight line. Objects at either end of an image are in reality right next to each other. Those panoramas of more than 360 degrees that actually come around on themselves test our belief that the space pictured is infinite. An image of a New Jersey golf course, itself a planned circuit, reminds us in picturesque terms of the modern impossibility of wilderness (pl. 89).

What is perhaps most compelling for contemporary photographers such as Stuart Klipper or Skeet McAuley—many of whom have chosen the wide-view format in the last few years—are the questions of perception this format raises (pls. 6, 36). The mind's eye does not always conform to the camera's. The possibility of seeing in all directions at once is countered by the illusion of the long static line of the horizon. For the contemporary panoramic photographer, the challenge is how to picture the sweeping expansiveness of an American landscape now cultivated, bridged, and easily traveled. The wide-view format replaces the inadequacy of the single vantage point of the view-camera image with a long picture that, like a movie, is experienced

linearly. The new photography, with its attempts to realize the fantasy of seeing everything all at once, demands new techniques.

Artists who work outside traditional photographic practice have begun to assert a new kind of imaginative control over the landscape. In the past, the basis of the landscape photograph has been its rendering of factual details that connect it with an actual place in nature. Ellen Brooks's photographs, on the other hand, are created from preexisting images chosen from garden magazines. She paints the images to enhance aspects of the landscape and finally rephotographs them through a diffusing screen. In his multimedia process—drawing, painting, and photography—Steel Stillman equally provokes both memory and fantasy. Their work succeeds, however, in giving us an image of artificial beauty still connected with a particular landscape context (pls. 12, 51).

The landscape itself is elusive in Brooks's work. Close inspection brings us face-to-face with the textural patterning of an image, while the image itself dissolves like a mirage. To construe the work's meaning, one cannot avoid comparing the final image with its genealogy of sources. Brooks's screen is a leveler of pictorial language. Stillman's painting and rephotography merges distinctions between media. Whether you photograph real life, source material, or pure pigment, it all reads exactly the same. Such images point to an edge where conventional beauty and photographic reality break down and matters of cultural contexts take over. And at that level, the work begins to strike a note of social commentary.

The landscape is not neutral territory. Ambiguous work, such as John Pfahl's (pl. 34), that depicts factories crowned by toxic smoke with the same sensitivity traditionally afforded cloud-covered mountains are challenges, tightly integrated visual metaphors that play off one another: What effect do power plants have on their environments? What is the place of the sublime in contemporary art photography? Richard Misrach's exploration of the contemporary desert, where he finds ironic beauty in bomb craters and animal carcasses, is not subtle (pls. 14, 57). Attractive, even sumptuous on one level, these pictures of repellent subjects demand that we understand the dynamic between aesthetics and politics. Representation of the land has become an issue in itself, one attached to an agenda of social activity and historical reconsideration of land management. A variety of categories—"public," "political," "economic," and "private" as well as "natural"—have become important markers for both picture-makers and land managers.

Initially setting themselves apart from the context of the art gallery, socially conscious photographers treat their photographs "not as privileged objects but as common cultural artifacts."[16] Written texts, which often accompany the images, may complement, reinforce, even subvert; they are intended to go beyond the meanings offered by the images themselves. It is time, many of these photographers say, to look afresh at the cultural meanings of landscapes in order to confront these issues that transcend individual intuition and technical virtuosity. The sort of question we might ask of the pictured landscape is basic: where are we now?

For some, photography shifts away from a metaphorical model toward a political one distinct from the cultural or social landscape. J.B. Jackson's admonition to scrutinize the land for its secrets is, for some photographers, an ominous challenge. As Richard Misrach sees it, "my experience, particularly pertaining to nuclear toxic issues, is that there is a relationship we have with the land that is, in fact, *invisible*.... Radiation is insidious because it is invisible: you can't see it, feel it, or hear it."[17] Or photograph it. The problematic gap between what we see and what we know is increasingly the issue.

Some images directly challenge the idea that photography can faithfully capture every detail of a given scene. Peter Goin, for example, sees the landscape as a mask. Mimicking the anonymous indifference of a government functionary, he applies industrial lettering to the bottom of images of atomic waste dumps as a foil for the invisible dangers that lurk below the surface (pl. 63). Similarly, Deborah Bright's addition of a terse description of the 1862 Battle of Antietam contrasts the grisly details of battle with her calm, daylit panorama of the site (pl. 88). Juxtaposing peaceful view and text, Bright forces a reevaluation both of historical and artistic ideas of war and beauty.

Landscape photographers have stretched the cultural context of art museums and galleries to include a larger discussion involving teaching, writing, research, and, in some cases,

political action. As a photographer, Bright doesn't consider her involvement with landscape photography as a complete or satisfactory "answer" to the questions she raises in her critical writing; rather, her photography is a "parallel track of practice and exploration." As Robert Dawson puts it, "I can let my photographs, over time, begin to influence and inform me as well."[18] Working on extended photographic projects, those photographers whose subject is the environment propose a certain pragmatic consideration of a beautiful and seductive landscape. Those who portray the spiritual context of a place describe a continuity between ancient reverence and contemporary reliance on the land.

In the larger context of contemporary art-making, the subject of landscape—not merely the view—is connected to a range of sentiment. In photography's very particular practice, landscape offers some hope. "When I first discovered the prairie ecosystem in its undisturbed perfection," Terry Evans writes, "I knew I was observing a profound mystery that was closer to heaven than to home, but that held the key that could unlock home as it was meant to be.... Twelve years later I find myself needing to photograph home as it is on the prairie in all its disturbed, cultivated, inhabited, ingratiated, militarized, raped, and beloved complexity."[19] As photographers continue to act as messengers for the land, their message is necessarily informed by the aesthetics of landscape photography.

Landscape has always been a subject compatible with the medium of photography. The medium distinguished itself early as an important chronicler of the American myth of the land. It could picture the land one struggled to reach and prepare for future generations, the land that promised a better life. The counterpart truth is too often forgotten: that land corrupts as well as inspires, that the burden of land ownership can soon interfere with earlier ideals. It is this recognition of the complex, paradoxical relationship between humankind and the land that has finally allowed artists the freedom to move forward.

NOTES

1. Christopher Columbus, *Four Voyages to the New World*, ed. R.H. Major (New York: Corinth Books, 1961), 5–6.
2. Deborah Bright, "Once Upon a Time in the West," *Afterimage* (December 1984): 16.
3. Estelle Jussim and Elizabeth Lindquist-Cock, *Landscape as Photograph* (New Haven: Yale University Press, 1985).
4. Leo Marx, "The Machine in the Garden," in *The Pilot and the Passenger* (New York: Oxford University Press, 1988), 116.
5. John Szarkowski, *The Photographer and the American Landscape* (New York: The Museum of Modern Art, 1963), 5.
6. Peter B. Hales, "Landscape and Documentary: Questions of Rephotography," *Afterimage* (Summer 1987): 10.
7. See William Jenkins, *New Topographics: Photographs of a Man-Altered Landscape* (Rochester: International Museum of Photography, 1975).
8. Ibid., 8.
9. Deborah Bright points out that architects, planners, and geographers were diligently investigating these issues during the same period and actively involving photographers in their projects. For example, Stephen Shore's photographs were used by Robert Venturi in the U.S. Bicentennial exhibition, "Signs of Life: Symbols in the American City," at the Smithsonian Institution.
10. Misrach, letter to author, 11 December 1990.
11. Mark Klett, Preface, in Klett, Ellen Manchester, et al., *Second View: The Rephotographic Survey Project*. (Albuquerque: University of New Mexico Press, 1984), 2.
12. See Hales, "Landscape and Document," p. 12, for a description of this technique as used by The Rephotographic Survey Project.
13. *Landscape: Selected Writings of J.B. Jackson*, ed. Ervin H. Zube (Amherst: The University of Massachusetts Press, 1970), 49.
14. Denis Cosgrove, "Environmental Thought and Action: Premodern and Post-modern," *Transactions, Institute of British Geographers New Series*, 15, no. 3 (1990). This paper notes certain features of the postmodern debate within geography and in science generally. Specific attention is paid to the uses of mathematics and geometry treated metaphorically, and to the relations between *poesis* (an idealized inspiration) and *techne* (harmonious relationship) as orally distinct but related modes of human interaction with the natural world. The revival in recent years of many features of late Renaissance scientific debates is examined through the work of some feminist and neo-romantic authors.
15. Mark Klett, "A View of the Grand Canyon in Homage to William Bell," in *Myth of The West* (New York: Rizzoli, 1990), 88.
16. Allan Sekula, "Dismantling Modernism, Reinventing Documentary (Notes on the Politics of Representation)," in Nancy Goucher, *Deborah Bright: Textural Landscapes* (Binghamton, NY: University Art Gallery, State University of New York, 1988).
17. Misrach, letter to author, December 1990.
18. Robert Dawson, letter to author, February 1991.
19. Terry Evans, letter to author, September 1990.

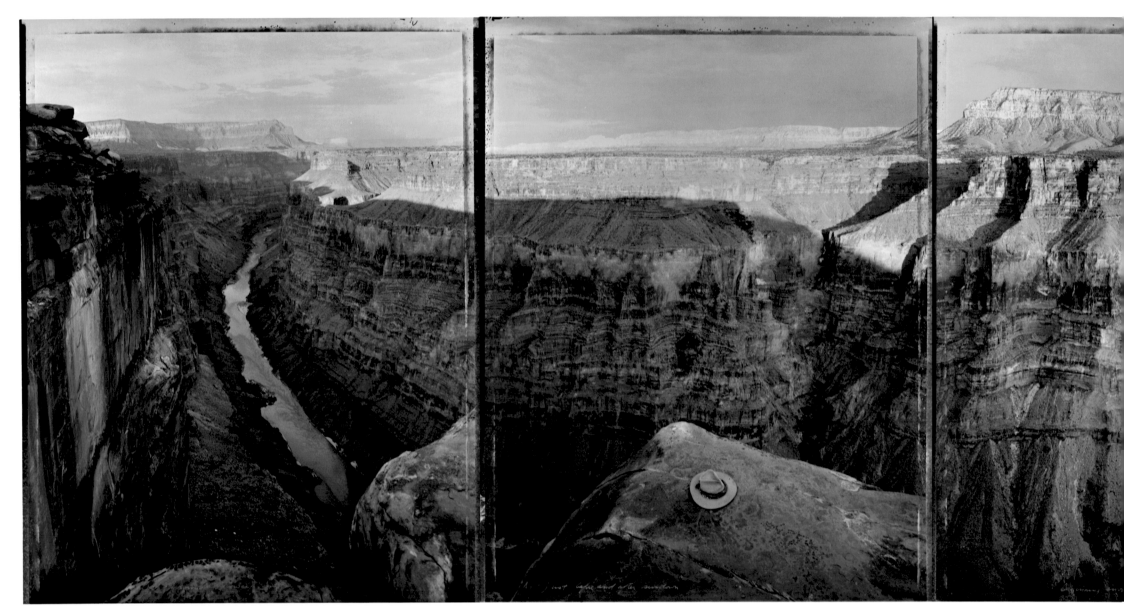

**21. MARK KLETT**
AROUND TOROWEAP
POINT, JUST BEFORE
AND AFTER SUNDOWN,
BEGINNING AND
ENDING WITH VIEWS
BY J.K. HILLERS,
OVER 100 YEARS
AGO, GRAND
CANYON, **1986**

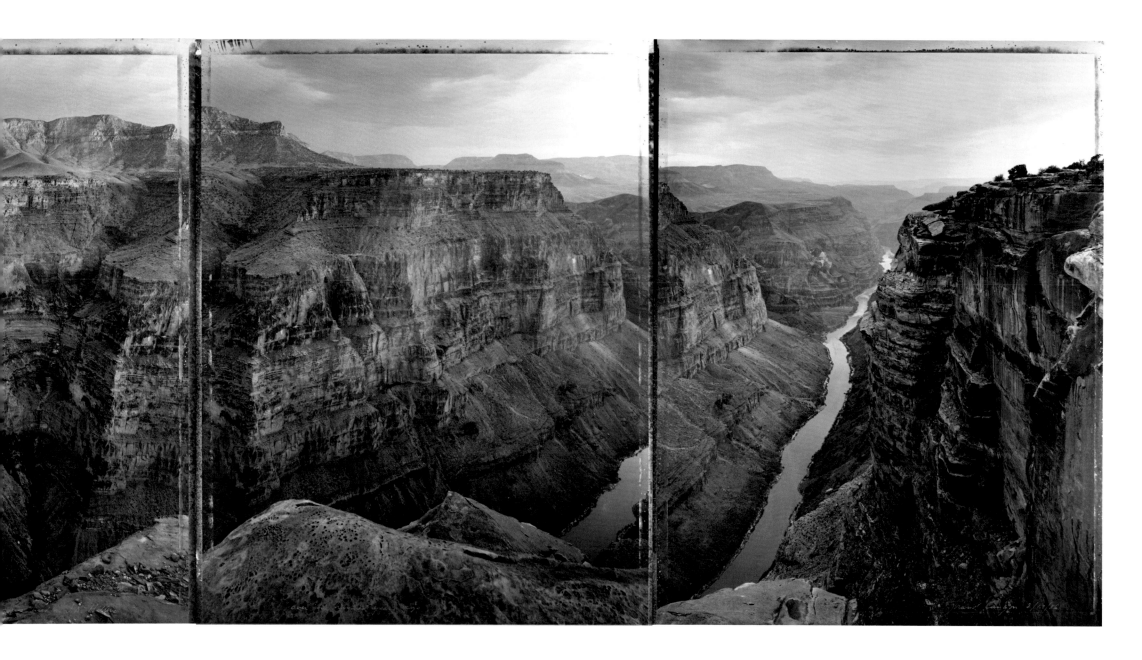

**22. VICTOR LANDWEBER**
KEANE WONDER MINE, DEATH
VALLEY, CA—RICHEST SITE OF
THE WESTERN FUNERAL RANGE,
PRODUCING $1,000,000 IN GOLD
AND SILVER BETWEEN 1908
AND 1916, **1987**

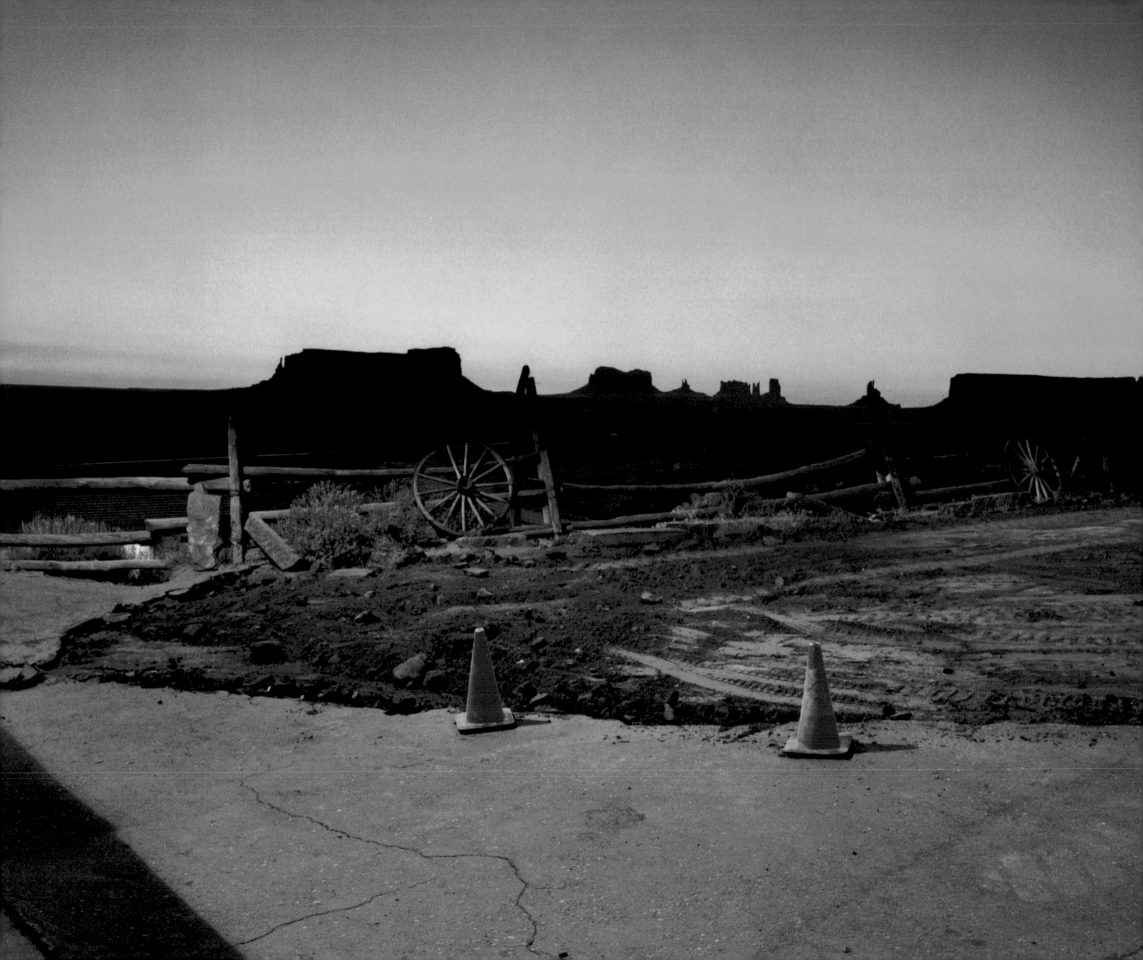

**23. LEN JENSHEL**
GOULDINGS LODGE,
MONUMENT VALLEY,
UTAH, **1987**

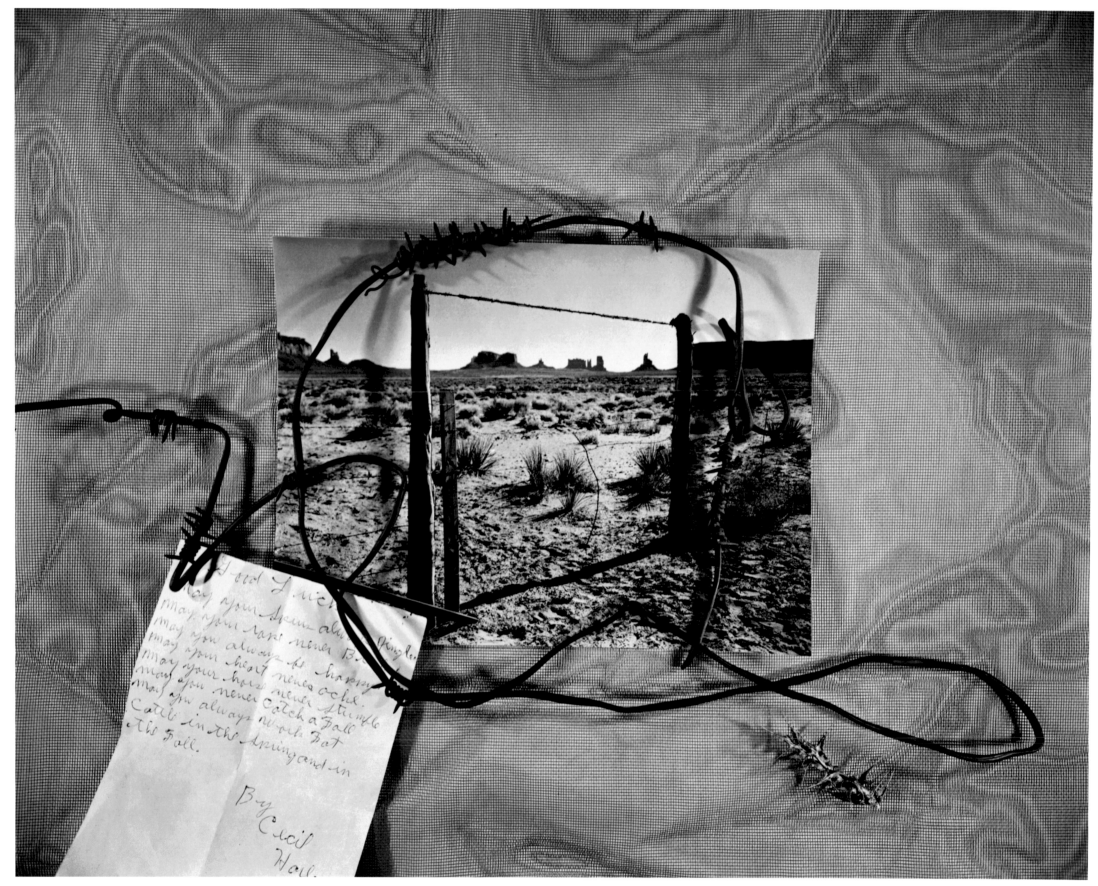

24. MERIDEL RUBENSTEIN, UNTITLED (GOOD LUCK), 1982

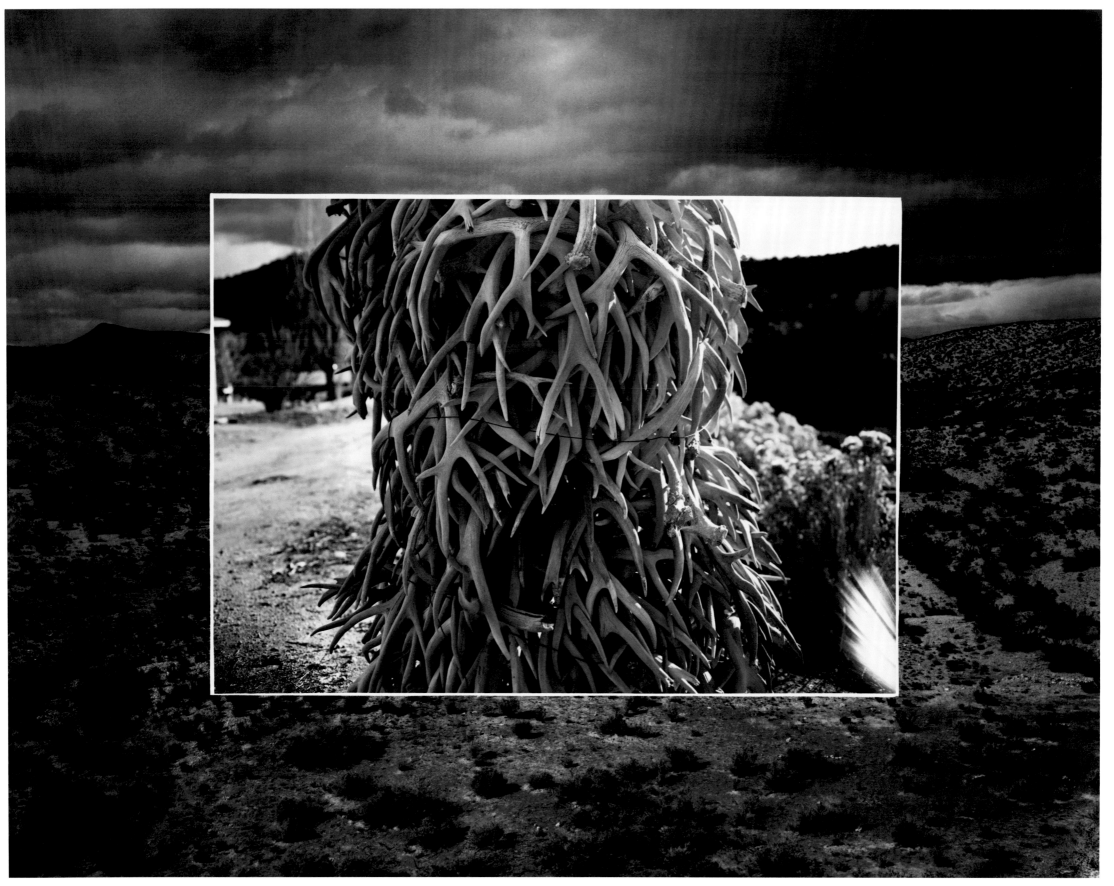

**26. RICK DINGUS**
JOURNEY WITHIN, NEAR
SAN YSIDRO, NM, **1986**

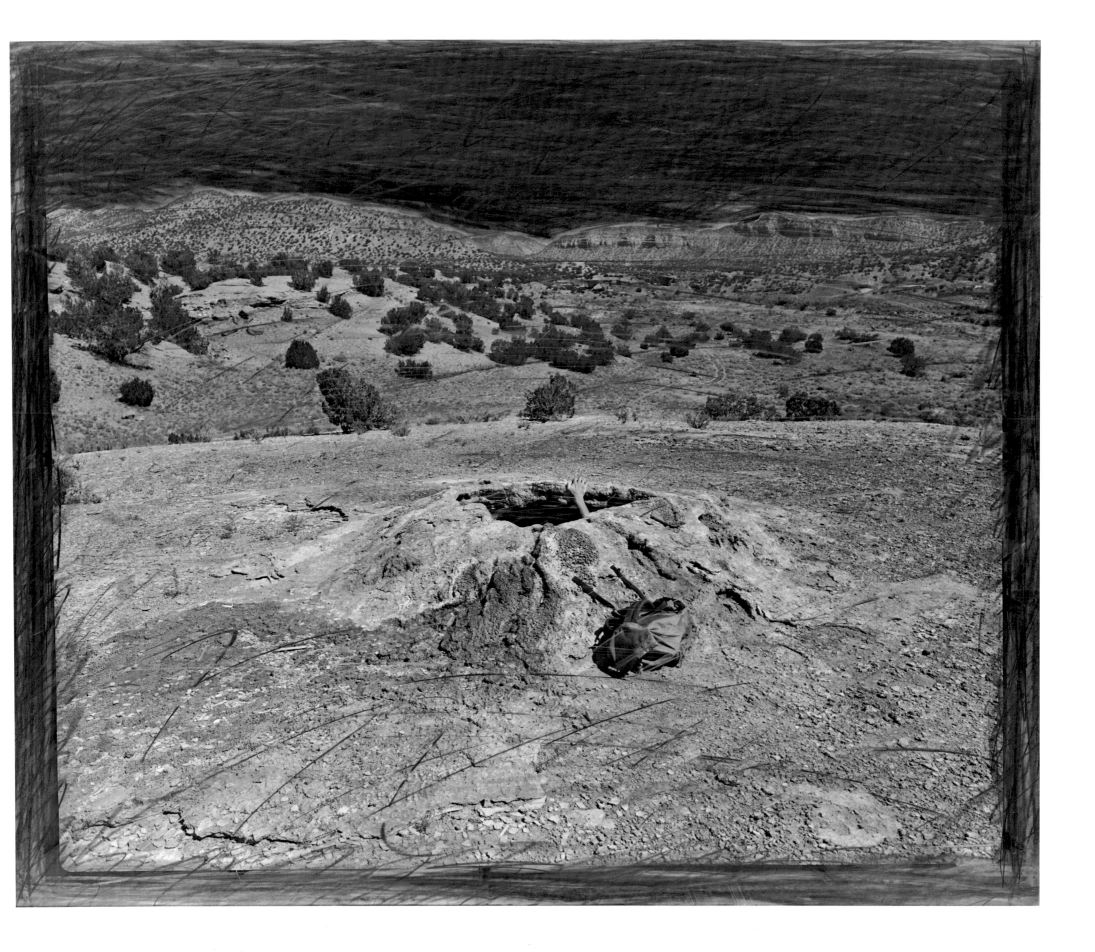

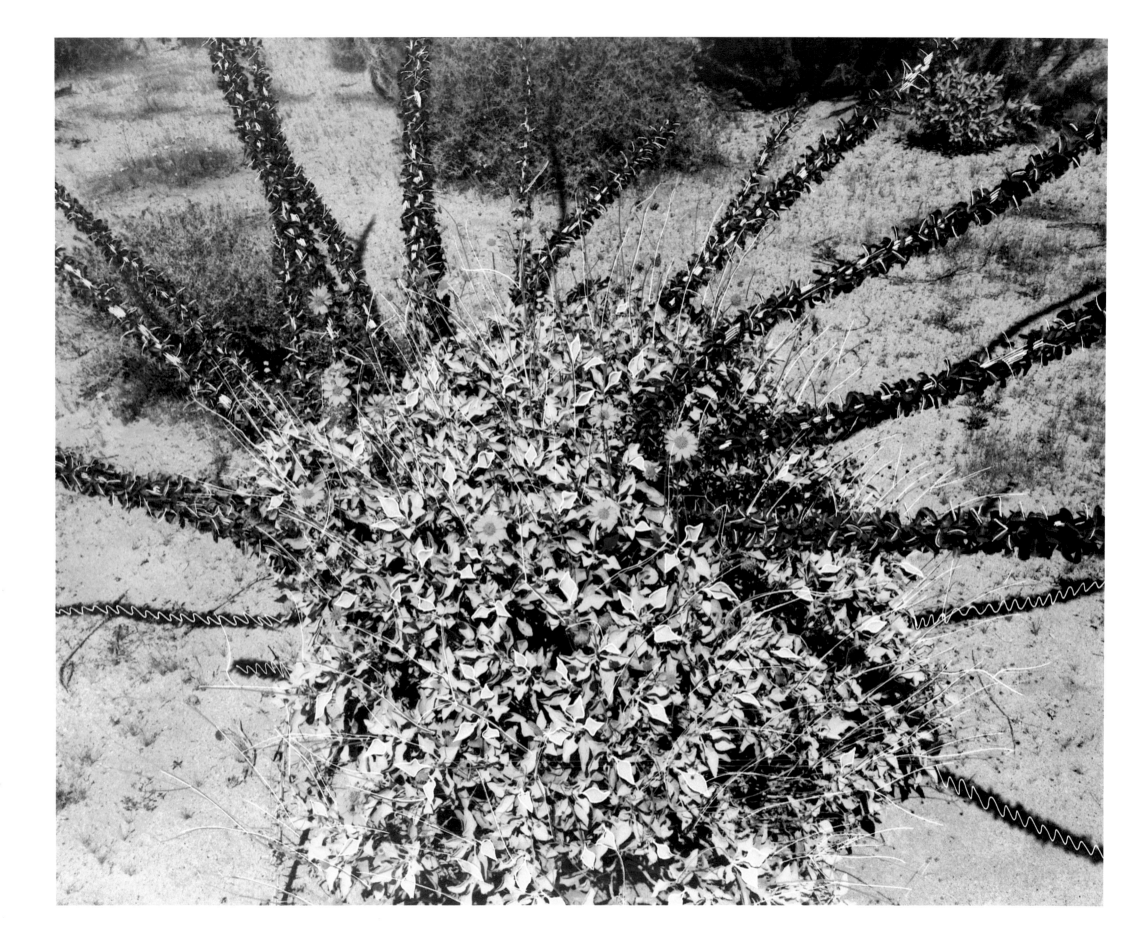

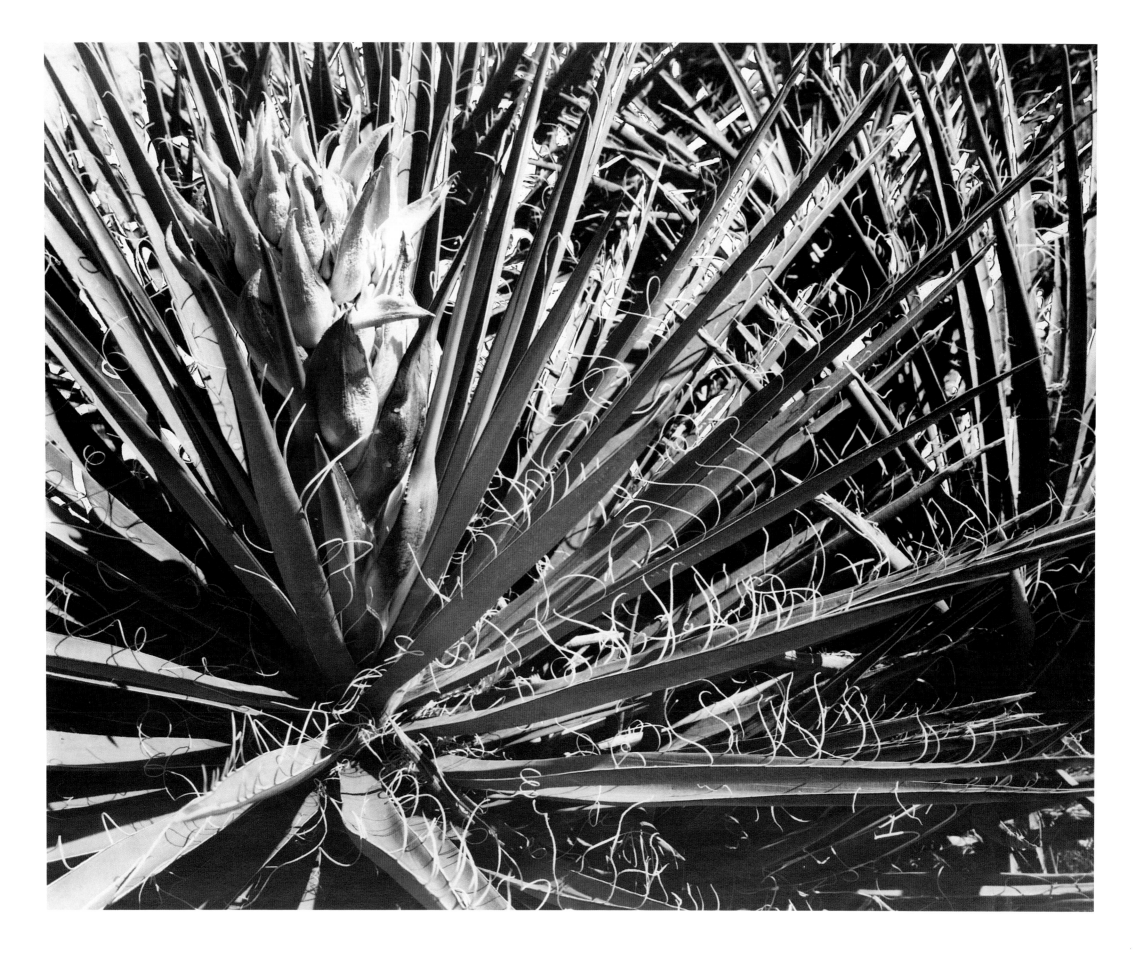

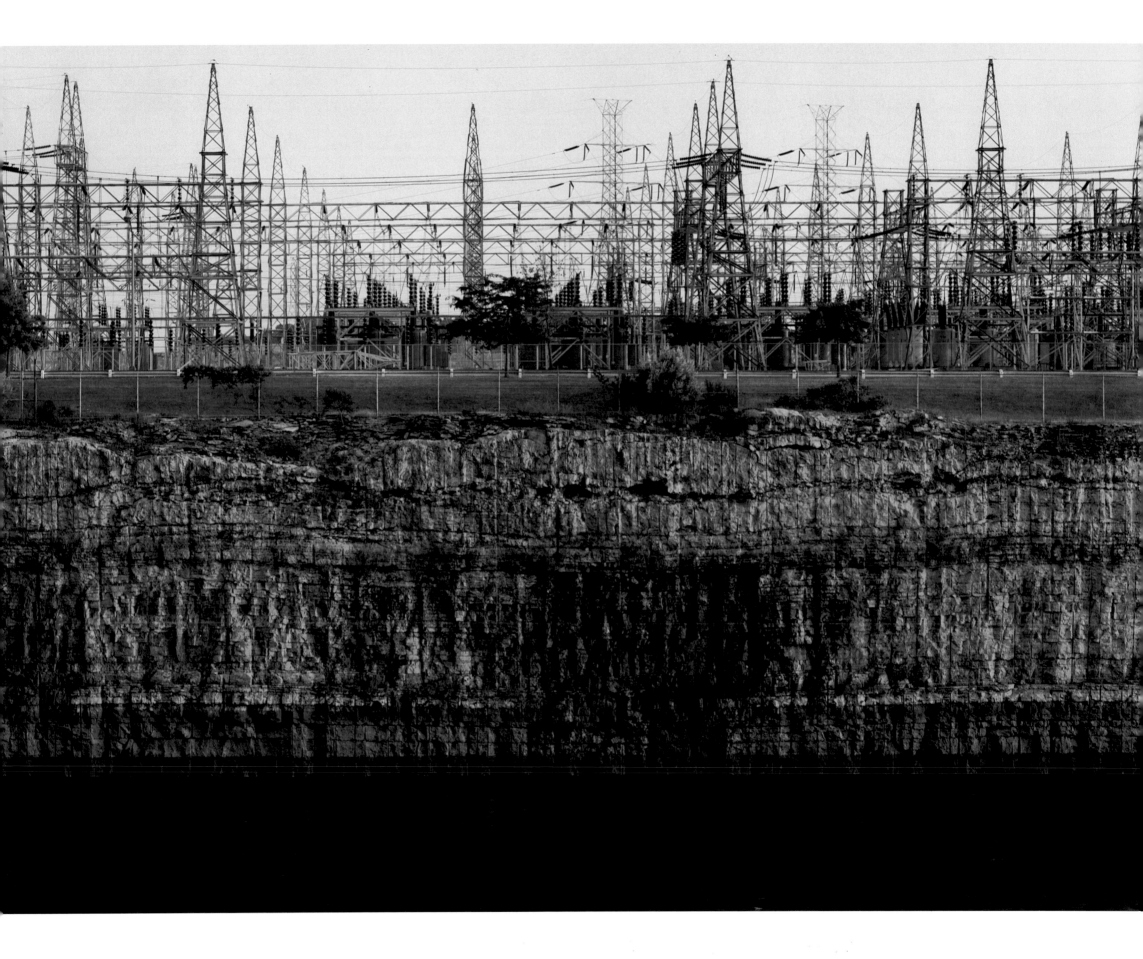

**31. JOHN PFAHL**
NIAGARA POWER PROJECT,
NIAGARA FALLS, NEW
YORK, **1981 (LEFT)**

**32. ANTHONY
LOUIS HERNANDEZ**
"SHOOTING SITES" ANGELES
NATIONAL FOREST, **1988**

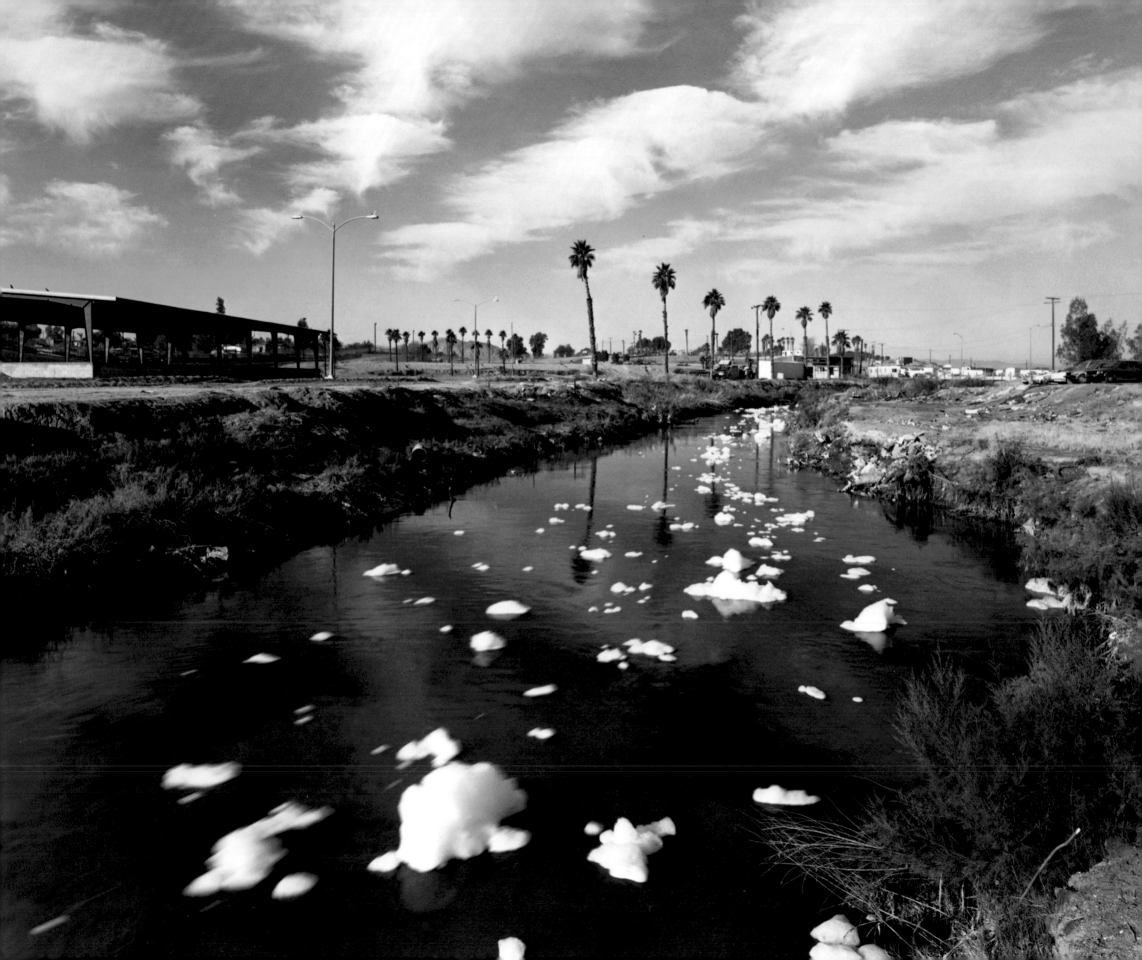

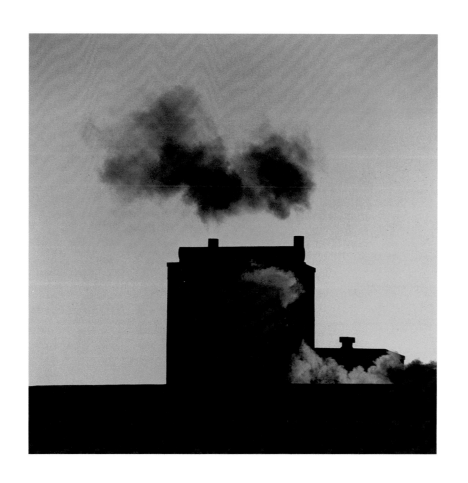

**33. ROBERT DAWSON**
POLLUTED NEW RIVER,
CALEXICO, CALIFORNIA
**(FROM THE CALIFORNIA**
**TOXICS PROJECT), 1989**

**34. JOHN PFAHL**
 GOODYEAR #5,
NIAGARA FALLS,
NY, 1989
**(THIS PAGE)**

**35. ROBBERT FLICK**
AT PINNACLES (SV186)
1990

**36. SKEET MCAULEY,** ALASKA PIPELINE, **1990**

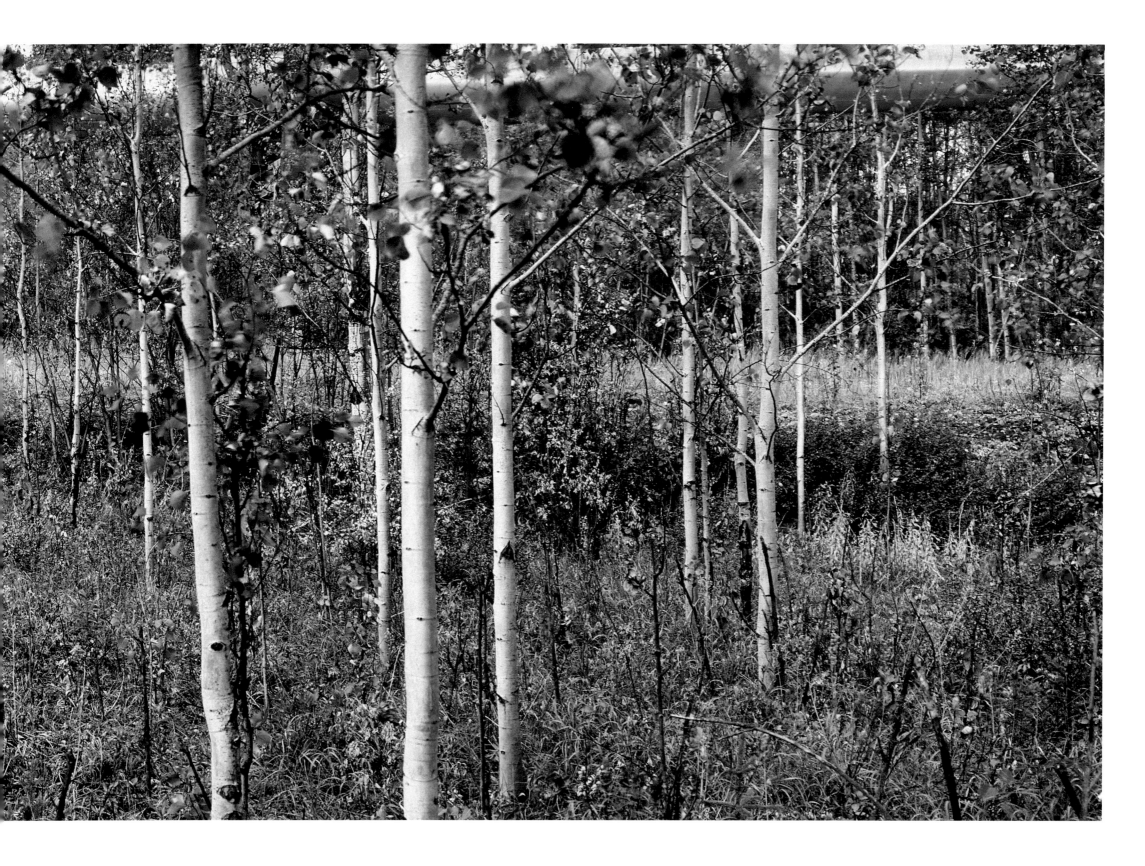

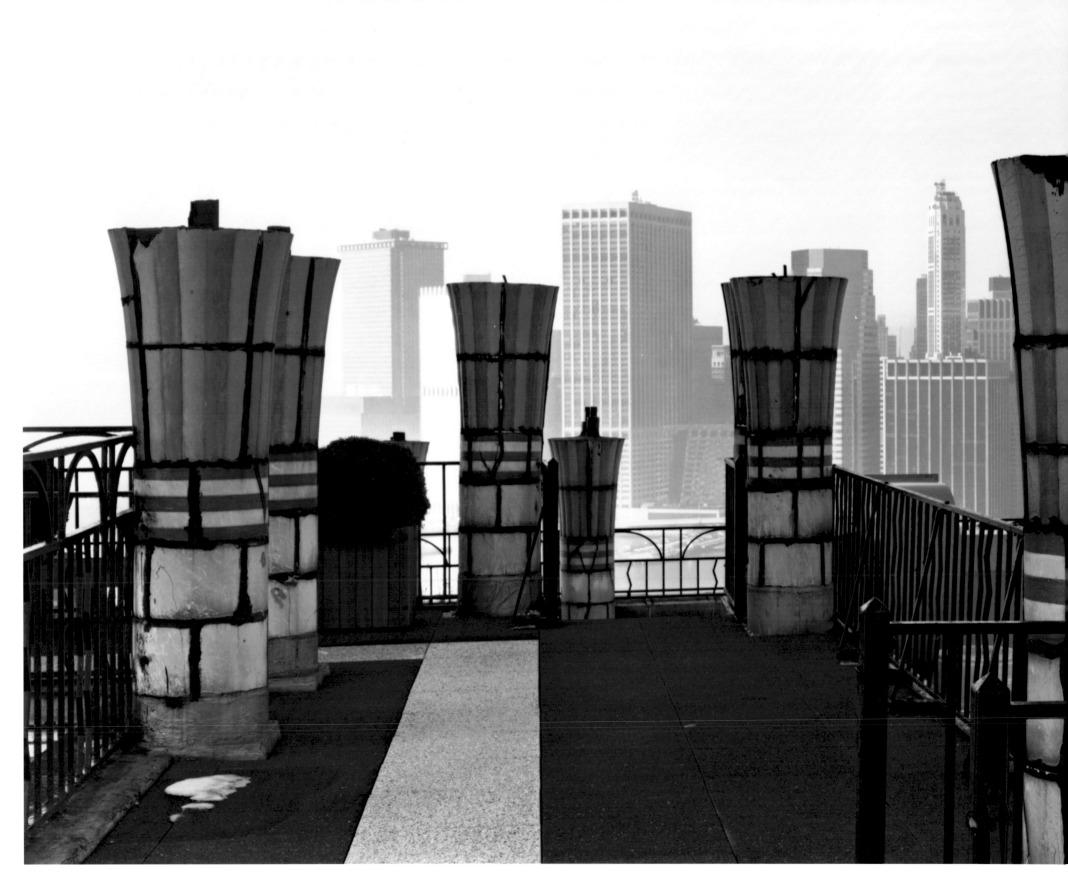

**37. LOIS CONNER,** ST. GEORGE'S HOTEL, BROOKLYN, NEW YORK, **1991**

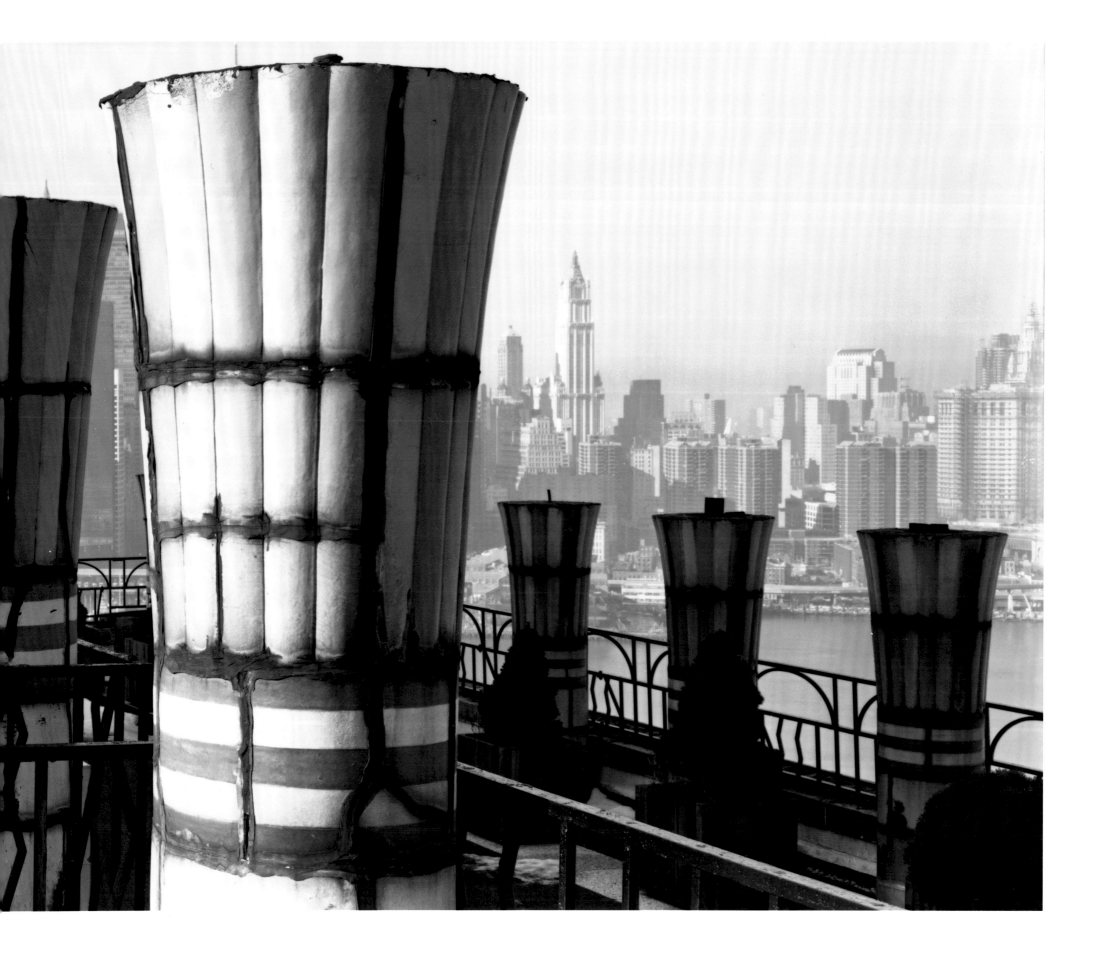

 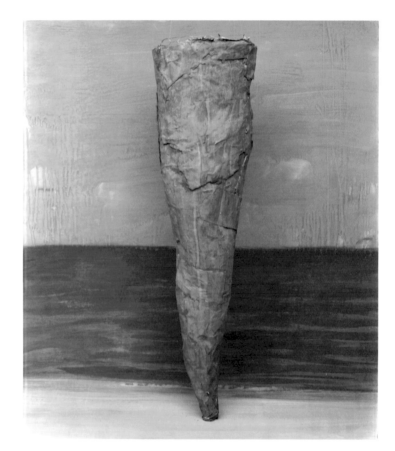

**38. JOHN DIVOLA,** CYCLONE ON THE BEACH, 1987

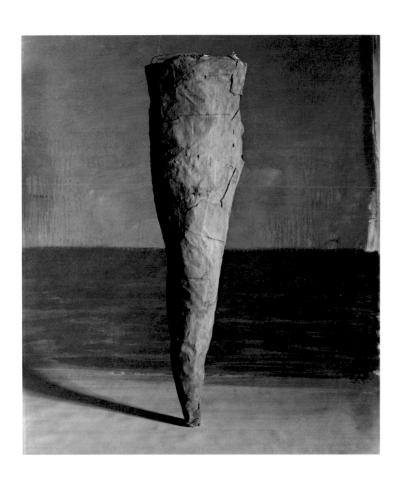 

FIG. 1. MARY PECK, *EVERGLADES 88-2 #4*, 1988.

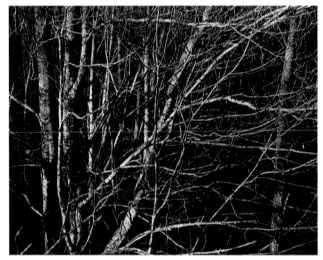

FIG. 2. ROBERT GLENN KETCHUM, *THINGS HAVE A LIFE OF THEIR OWN* (ORDER FROM CHAOS SERIES), 1982.

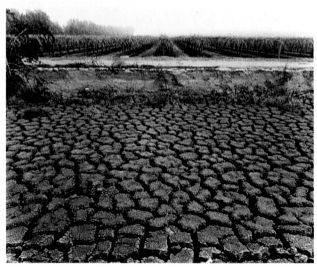

FIG. 3. ROBERT DAWSON, *CRACKED MUD AND VINEYARD NEAR ARVIN, CALIFORNIA* (FROM THE GREAT CENTRAL VALLEY PROJECT), 1985.

# form and scale in nature and culture
# modern landscape as necessary integration

## stephen jay gould

*Introduction: An Outline for Nature and Culture*
We all experience the phenomenon in our personal growth. Something that seemed incredibly large, impossibly far away, or impressively fearful, becomes quite ordinary as we grow bigger, more mobile, and more confident. Uncle Joe's big dog, who once exuded fierce power at immense size, turns out to be just a middling, smelly old cur. The old mine pit contains neither gold nuggets nor secrets of the universe, but only dust, rats, and flies. But with an undeniable gain in comfort and comprehension, we also lose a sense of awe and mystery. The "radiance which was once so bright" must indeed be "taken from my sight."

I am much less likely than most people to endorse any comparison between the growth of individual people and the history of human evolution or culture—for I once wrote a long and turgid book (*Ontogeny and Phylogeny*, Harvard University Press, 1977) to expose the deep fallacy in the most common version of this myth: the idea that we "recapitulate," or pass through the adult stages of our evolutionary history during embryonic development. (The gill slits of an early human embryo do not represent our previous evolutionary existence as a fish.)

Still, knowledge and power do increase in both individual and cultural history, and some metaphorical comparison may be meaningful. Certain features in the history of changing attitudes toward nature in Western culture do seem to fit the childhood sequence of increasing familiarity and encompassment, combined with decreasing respect and mystery.

I see fear of nature in many medieval paintings. Walled cities are rich, familiar, and full of detail. The spaces between are bleak, empty, foreboding, full of danger. Even the rocks look hostile; vegetation is rendered without any loving detail, and includes, here and there, only a blob for a tree. Nature, evidently, was a

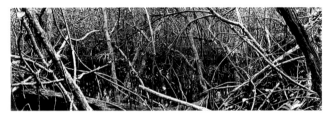

FIG. 1. MARY PECK, *EVERGLADES 88-2 #4*, 1988.

# form and scale in nature and culture
# modern landscape as necessary integration

## stephen jay gould

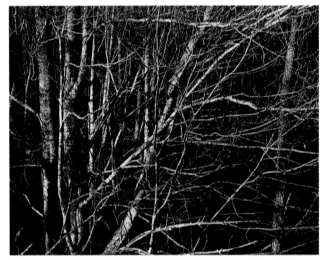

FIG. 2. ROBERT GLENN KETCHUM, *THINGS HAVE A LIFE OF THEIR OWN* (ORDER FROM CHAOS SERIES), 1982.

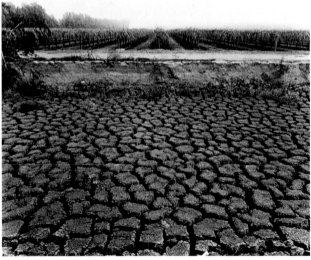

FIG. 3. ROBERT DAWSON, *CRACKED MUD AND VINEYARD NEAR ARVIN, CALIFORNIA* (FROM THE GREAT CENTRAL VALLEY PROJECT), 1985.

*Introduction: An Outline for Nature and Culture*
We all experience the phenomenon in our personal growth. Something that seemed incredibly large, impossibly far away, or impressively fearful, becomes quite ordinary as we grow bigger, more mobile, and more confident. Uncle Joe's big dog, who once exuded fierce power at immense size, turns out to be just a middling, smelly old cur. The old mine pit contains neither gold nuggets nor secrets of the universe, but only dust, rats, and flies. But with an undeniable gain in comfort and comprehension, we also lose a sense of awe and mystery. The "radiance which was once so bright" must indeed be "taken from my sight."

I am much less likely than most people to endorse any comparison between the growth of individual people and the history of human evolution or culture—for I once wrote a long and turgid book (*Ontogeny and Phylogeny*, Harvard University Press, 1977) to expose the deep fallacy in the most common version of this myth: the idea that we "recapitulate," or pass through the adult stages of our evolutionary history during embryonic development. (The gill slits of an early human embryo do not represent our previous evolutionary existence as a fish.)

Still, knowledge and power do increase in both individual and cultural history, and some metaphorical comparison may be meaningful. Certain features in the history of changing attitudes toward nature in Western culture do seem to fit the childhood sequence of increasing familiarity and encompassment, combined with decreasing respect and mystery.

I see fear of nature in many medieval paintings. Walled cities are rich, familiar, and full of detail. The spaces between are bleak, empty, foreboding, full of danger. Even the rocks look hostile; vegetation is rendered without any loving detail, and includes, here and there, only a blob for a tree. Nature, evidently, was a

realm to be traversed as quickly as possible in order to reach the safety of the next town—as if everyone was the Sheriff of Nottingham trying to stay out of Sherwood Forest.

I see nature as a challenging domain for exploitation in many representations of the industrial era. She is vast and forbidding, but the trains get through and the mines get dug. As a counter to this attitude, in a version that most of us would favor today, the romantic preservationists battled exploitation with a plea for salvation, and depicted nature as majestically different from human scales and concerns.

All these attitudes record a time when human culture was small and weak compared with nature. We took up very little space on the earth, and the tendrils of our culture did not even pervade the woods and streams, much less the forbidding deserts and ice fields. These older visions of nature as something to be feared, conquered, or left alone in its majesty can only apply to a force that is both big and fundamentally outside of us.

But now, the scales have been recalibrated, and none of these attitudes can appeal to a contemporary seeker of meaning in landscape. The weight of *Homo sapiens*, both actual and metaphorical, has increased immensely. Oh, I don't want to lapse into paeans of hubris. You can still fly at thirty thousand feet above the ice fields of Greenland, or even above the Great Salt Desert in Utah (just west of the pitifully restricted modern lake), and see not a single sign of human culture below—not a town, not a road, not even a cut-line for telephone poles. But, for the most part, our tendrils now extend everywhere, and our weightier cities are rarely absent from an aerial view over any continent but Antarctica.

In this current context of balanced weighing pans between the spread of human culture (not to mention the sheer number of human beings) and the persistence of nature before and without us, aestheticians and philosophers of landscape simply must factor us in. It can no longer be us *and* her (I accept the ancient tradition of personifying nature as female)—either us against her or her without us. All we can now have is a more encompassing us—for *Homo sapiens* is everywhere, and therefore part of a system that may be composed of oddly mixed parts, but can no longer be separated into formative units with any meaningful status as separate entities.

If I see any common theme in the enormously varied work of the wonderful photographers in *Between Home and Heaven*, I can only point to their recognition that a modern theory and aesthetic of landscape must be rooted in an integrated and mutually reinforcing interaction of nature and human culture. Interaction, of course, is an old theme, but its simplistic and stereotypical version—our ugliness contrasted with her beauty—must be rejected. (I don't, of course, deny the occasional accuracy of the stereotype—for what else is a cliché but a truth too often repeated? I merely say that we must move beyond the theme of squalid waste dumps versus beautiful countryside, for it is profoundly unhelpful in casting the two realms of nature and culture as intrinsically apart. We must seek a unity in mutual respect; not in fusion, but in the interesting interaction of similarities and differences.)

As with any diverse exhibition, a sympathetic observer may choose a number of themes for sensible coordination. I do not advance my own way as better, but merely as a personal reaction from a scientist who has spent his professional life studying the meaning of organic form and the time scales of evolution. As an essayist, the concept of an "organizing theme" has a central, professional meaning for me. I never begin a piece until I find some mental framework to coordinate the research and observation that fueled my intent. These outlines seem so powerfully "right" to me that, in my arrogance, I actually view them as residing in a Platonic realm of ideas—one absolutely proper way to organize each possible topic. One only has to cast a celestial fishhook toward the empyrean and reel the outline down. This notion, of course, is total nonsense, though eminently useful. I therefore present my theme as a personal device that permitted me to make sense of a magnificently diverse presentation: modern portrayals of landscape are largely a quest to grasp interaction; the differing *forms* and *scales* of nature and culture can serve as a framework for understanding these attempts.

*Nature's Forms and Ours*
We often make the mistake of considering nature as built of simple and abstract geometries. We make this error for two reasons. First, many of these schemes are only our mental models of nature's processes, and their simplicity reflects our limitations, not the palpable forms actually encountered. Consider, for example, the standard model of an atom or a solar

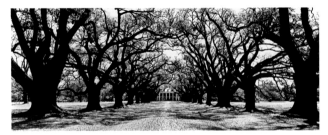

FIG. 4. ALLEN HESS, *OAK ALLEY PLANTATION, RIVER ROAD, LOUISIANA*, 1983 (SEE PL. 39).

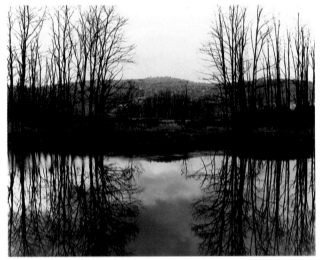

FIG. 5. JOE MALONEY, *EAST BRANCH, DELAWARE RIVER, NEW YORK*, 1979 (SEE PL. 52).

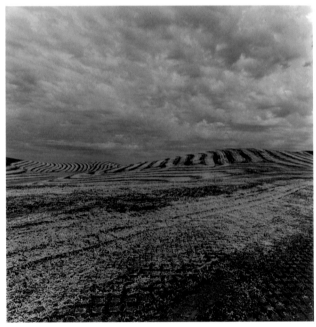

FIG. 6. LARRY SCHWARM, *SOUTHEASTERN WASHINGTON STATE*, 1989 (ORIGINAL IN COLOR).

system (to show our common strategy across all scales)—a central spherical object surrounded by well-ordered subsidiary bodies revolving in regular orbits. Then consider the reality of gorgeous complexity. The orbits are not Copernicus's ideal circles; they are not even the immutable ellipses shown in high-school textbooks as Kepler's solution. The earth's orbit changes constantly, with differing cycles for alteration in degree of ellipticity and for amount and direction of axial tilting. All three cycles interact to produce complex changes in climate, including the ice ages of the past few million years. Neptune revolves at an angle to the other planets and is now actually outside the orbit of Pluto—and temporarily the farthest planet from the sun. The Earth has a moon as big as a planet; Mars has two moons so tiny that a Russian astronomer thought they might be the space stations of an alien culture! The asteroid belt breaks the regularity of planetary distances. Comets move in and out of planetary space, sometimes colliding and perhaps triggering mass extinctions on earth. Unpredictable, historically contingent complexity rules much of "celestial mechanics."

Second, I will admit that nature shows some geometric regularity at scales very distant from our immediate view—either very small or very large. The earth, of course, is not a perfect sphere, but if we built an accurate scale model the size of a tennis ball, the planet's complex surface would disappear into smoothness. Our eyes and fingers could not even detect a bump so small as Mount Everest on a body with eight thousand miles diameter scaled down to a few inches. At broadest scale, planets are tolerably regular bodies.

But landscape photography works at the different scale of our immediate perceptions—processes and objects palpable by the limits of human body size and restricted life span. At this immediate scale, nature's formal signal is complexity. We rarely see simple symmetries and straight lines. The exceptions form an interesting class that only accentuates the basic rule of nature's signal as visual complexity. Radial and bilateral symmetry may underlie the form of most animals—but only, and quite literally, as a foundation or framework for hanging the changing complexity of a sea anemone's tentacle, or a human finger. Geology is a domain of visual complexity, and the few exceptions powerfully strike our imagination for their sheer oddity in the face of dominant irregularity: a symmetrical volcano, a spherical water-worn pebble (I have a collection of "perfect stones," but have

searched for hours to find a few that approach the ideal), horizontal lines of bedding planes in strata. Even these break down in detail. Get close to Mount Rainier and you find its distinctive "personality" of uniquely irregular erosion eaten out of the symmetry. To get unerring symmetry from nature, one must rely on such illusions (much exploited by photographers, including many in this exhibition) as the reflection of a landscape in a pond.

We used to regard the complex, irregular, meandering, unrepeated forms of overt nature as a sign of her intractability (a source of loathing for the exploiters and awe for the romantics), in contrast to the scientific formulations of human analysis. We could describe the motion of a frictionless ball rolling down an inclined plane, but not the form of a branch or a coastline. This difference—the unpredictable versus the analytical—seemed to mark the biggest, perhaps even the most unbridgeable, gulf between science and nature. But a series of exciting developments in science and mathematics, much reported in the press under such names as chaos theory and fractal geometry, have begun a reconciliation. The problem lay in the limitation of our mathematics, not the intractability of nature. Our geometries tend to operate at the integral values of 1, 2, and 3 (lines, planes, and simple solids). Nature builds in the fractional domain between 2 and 3—and we couldn't imitate her properly until we learned to construct fractal curves. Then we could draw coastlines that looked real and mountains that might stand on an actual landscape. Only then could we have a computer animation of tolerable reality; only then could the overt forms of things and the geometry of human construction coincide.

By contrast, the actual constructions of our culture are simple (we can animate with fractals, but we would not want to build our skyscrapers in these shapes). Our world of artifacts abounds with regularities and right angles. I don't know—perhaps "the meanest flower that blows can give /Thoughts that do often lie too deep for tears." But I do understand that the meanest flower presents a uniqueness and irregularity of form far too complex to reconstruct in anything of much use as a human artifact. We cut, pound, melt, mold, and shape in order to force natural materials into simple forms with right angles, so that we can build in our modular styles. Nature's meandering irregularity versus our lines and right angles forms the most striking, first-order difference between the two great realms, which can no longer avoid an intricate and

pervasive interpenetration. Use the best test of all—the visceral "how do you know?" criterion. When we look without any conscious concentration, analysis, or expectation, and see a straight line or a right angle amid the fractals, we smell the work of our species. (I use the "misplaced" sense because odor is the most telling of perceptions, and the strength and immediacy of my visceral reaction reminds me more of smell than of the actual visual modality). We look out an airplane window: the perfect circle of a centrally irrigated field, the quiltwork of agricultural plots on the Great Plains, the right-of-way of an old railroad line, the glitz of Las Vegas as a few straight scratches on the desert. Their discordant geometry stands out amid nature's curves. I stand in Central Park and play a game (it only works in summer, when the trees are clothed): Can I look in any direction and not see the surrounding city? (How do I know when I have lost?— rectangles and right angles on the horizon.)

As I look at these photographs, the play of difference between nature's complex geometry and our simple forms strikes me as the most pervasive common theme. I am, above all, delighted to note that none of these photographers falls into the cliché of trying to separate the modes, identifying ours as bad and intrusive, and trying to protect nature from the incursion. All seem to accept the necessity of interaction and our resulting need to find an acceptable aesthetic in the rich concatenation of differences. The strategies are several and fascinating. Consider just five, arranged in a continuum of sorts:

1. Nature alone, but in cameo. The great images in the romantic age of "big" nature (dwarfing tiny culture) showed vast landscapes either entirely untainted by human presence or, as in the case of Frederic Church's paintings, with the subtlest, smallest, almost invisible signs of human activity to show the scale of contrast (like Church's own signature, carved on a single tree in Heart of the Andes). Such vistas can hardly be found today, or simply seem anachronistic (as a symbol of landscape's current meaning) when they do remain. I was fascinated to note that of all photographs devoted to "pure nature" in this show, not a single one attempts to show vistas of large scale. Every single example is a cameo of something small—a little oasis in a world of intricate interaction. And every example focuses in upon the distinctive fractal geometry of nature—as if to tell us that the difference lies in geometry and can only find pure representation in the small. Consider, for

example, Mary Peck's Everglades series—particularly the richness of varying geometries (but all nature's fractals) in the 1988 *Everglades 88-2 #4* forming a mass so dense that we are almost in a rich abstract painting (fig. 1)—or Robert Ketchum's complex botanical geometries. Just consider Ketchum's titles: *Things Have a Life of Their Own, Trying to Stop the World*—both in his Order from Chaos series (fig. 2). *"The Voyage of Life"* bears as its subtitle *Homage to Thomas Cole* (pl. 11). Finally, look at the oddly meandering tree branches in Lois Conner's *Central Park, New York City* (pl. 45). (This photo passes the test of my game, but cheats a bit for its small scale.) My statistics professor taught me that a polynomial function can be fit to any curve, provided you are willing to use enough terms—but when you use too many, the mathematics has no general meaning, for you have merely copied a complex particular. I hate to think how many terms I would need to fit the main branch in the right half of this picture!

*2. Culture alone, but photographed in the ample scale of traditional landscape.* I almost feel a kind of sublime joke in these photographs that use a grand sweep of space but include only the verticals and horizontals of human construction. This mixed medium of one genre's scale with another's objects is trying to tell us something important. In Roy Mortenson's *Amtrak, Hudson Generating Station, Jersey City and Manhattan from Laurel Hill*, we note horizontals of road and railway line in the foreground, receding across a great vista to verticals of smokestacks at middle distance and finally (no taller than the smokestacks) the twin verticals of the Word Trade Center Towers in the far background (pl. 83). In Madoka Takagi's *Long Island City, Queens* (close to my childhood dwelling place, by the way), we look through the right angle framing of a pier, across the East River to a forest of Manhattan verticals (pl. 85). But a very irregular rock (or maybe only a broken hunk of concrete) sits in the foreground, equalling the distant Chrysler Building in size and reminding us of other geometries. Four of culture's major horizontals—a train on a railroad, a truck on a path, a barge in a river, and a bridge—dominate Lois Conner's *Baton Rouge, Louisiana*, while the dust kicked up by so much human activity fronts for the mist of a classical landscape (pl. 1). In Conner's *St. George's Hotel, Brooklyn, New York* (I used to swim in the pool there as a kid) we see two scales of verticals—the hotel's exhausts and chimneys, and the distant Manhattan skyline (pl. 37). The issue here, by the way, is culture's limited geometry (at the traditional scale of nature's fractals), not city versus country.

The same limitation, in all its expansive glory, makes the powerful point and vision in Gus Foster's panoramic *Cut Wheat* (pl. 58).

*3. Nature and culture in contrast.* This is the category that could fall into the worst, vulgar, disabling clichés of human limits versus natural beauty—but not a single photograph does; all seem to be struggling with integration. Starkly different geometries may form a pleasing, or at least challenging, tableau. Two orders of complex natural geometry—trees in the foreground and mountains in the background—frame the gridwork town of Robert Dawson's *Silverton, Colorado* (pl. 72). On a smaller scale, nature's mudcracks (probably on land desiccated by human action) yield to rigid rows of parched grape vines (with their individually complex geometry) in Dawson's *Cracked Mud and Vineyard Near Arvin, California* (fig. 3). Or consider a true contrast that yields a most pleasing harmony—an antebellum mansion with an elegant formal grand entranceway planted in rigid bilateral symmetry, but whose trees almost flaunt the chaotic complexity of their branches (Allen Hess's *Oak Alley Plantation*; fig. 4). (Incidentally, I was struck by the virtual isomorph of this photo, but all natural this time, in Joe Maloney's *East Branch, Delaware River, New York* [fig. 5]. The "house" is a distant clump of trees, and the bilaterally symmetrical grand approach is formed by two nearer clumps of trees that just happen to look like mirror images across a gap, with reflections in the foreground river enhancing both the scale and symmetry.) Sometimes, finally, the discordant geometries seem to blend into a fully coherent composition. In Larry Schwarm's *Southeastern Washington State* (fig. 6), the crisscross of tractor tracks (foreground) yields to the rows of crops (bigger scale in middle ground) and finally to the chaotic clouds (both up and distant). I wouldn't have thought that the towers of John Pfahl's *Three Mile Island Nuclear Plant, Susquehanna River, PA*, those symbols of our harmful intrusion, could ever blend into a natural landscape (pl. 91). Yet, by using the natural phenomenon of reflection in water, which gives a bilateral axis to all geometries, the towers behave like the fractal branches. (And when I turn this photo upside down, thus losing the horizon and the sense of scale correlated to distance, the whole composition devolves into an abstract exercise in bilateral symmetry of different forms.)

*4. Coopting nature's rarer lines and right angles to achieve integration with cultural artifacts.* I was struck by the number of

photographs that set the horizontals and verticals of culture against rare natural vistas that emphasize the same geometries. John Pfahl's *Niagara Power Project, Niagara Falls, New York* amazed me with its brilliant two-fold contrast of almost identical scenes: the horizontals and verticals of human construction above, and the almost rigidly horizontal bedding planes of the limestone below, with matching but "unnatural" verticals (in the rock) formed by drill holes made to set dynamite charges for blasting (fig. 7). In Skeet McAuley's *Alaska Pipeline*, you almost don't see the upper horizontal pipeline at first, but your eyes are finally drawn to it by the similarly colored, though vertical trees—making the right angles that spell culture (pl. 36). Stuart Klipper's *Snake River Gorge Bridge, Twin Falls, Idaho 1990* (pl. 70) seems an exercise in harmony, for the horizontality of the span matches the bedding planes of the strata and seems to extend the flat surface of the land (also concordant with the bedding planes).

In an interesting contrast, two of Barbara Bosworth's photographs show nature with rare, simple geometries and only a wisp of invading culture, but this time to supply some counterpoint. In *Niagara Falls*, nature makes the right angle with water falling in vertical ribbons off the horizontal crest, while culture—a light, house, buoy—provides a richer variety (pl. 73). *Windmills, Mt. Wachusett* features an unusually symmetrical hill, with three-armed windmills scarcely visible in the distance, breaking the larger bilateral symmetry both by their own form and by trailing off to emphasize only one flank of the hill (fig. 8).

*5. Culture can become fractal too; another style of integration.* Here is a precious irony, not at all lost on several artists in this exhibition. Our useful artifacts are geometrically simple, but when we break them, use them up, melt them down—when we say that they have "gone entropic" and passed beyond any recoverable function—then they often assume the complex geometries of nature. Destruction is geometrically complex and includes many random elements also common to natural building. We need bullets and trituration to turn the order of glass bottles into the complexity of Anthony Louis Hernandez's *"Shooting Sites" Las Vegas* (fig. 9). The foam on the water in Robert Dawson's *Polluted New River, Culexico, California* resembles the clouds above both in long trails and complex shapes (pl. 33). The dilapidated structure, located on a nuclear blast site, shown in *Collapsed Hangar Yucca Flat* by Peter Goin,

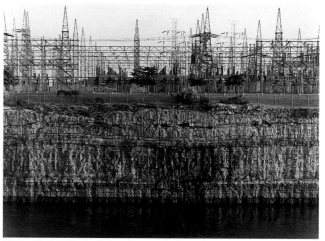

FIG. 7. JOHN PFAHL, *NIAGARA POWER PROJECT, NIAGARA FALLS, NEW YORK*, 1981 (SEE PL. 31).

FIG. 8. BARBARA BOSWORTH, *WINDMILLS, MT. WACHUSETT*, 1986.

FIG. 9. ANTHONY LOUIS HERNANDEZ, *"SHOOTING SITES" LAS VEGAS*, 1987 (ORIGINAL IN COLOR).

has lost its right angles and taken on an uncanny resemblance in basic shape to the hills in the background (pl. 59).

*Nature's Scales and Ours*
If our geometries are pitifully limited compared with nature's complex fractals, we fare even more poorly on the issue of time scales. Life on earth is three-and-a-half billion years old (at least); our species, *Homo sapiens*, may be 250,000 years old, and our entire distinct lineage (since the branching point with chimps and gorillas) does not extend back more than six to eight million years. Our personal lifetime, the psychological measure actually used as our basic temporal ruler for things considered long-lasting (for what do most of us know about the duration of our species?), is but a joke of a moment compared to anything earthly.

Our misunderstanding of this temporal limit underscores most common errors about our role on earth. Our vicious errors (of assuming dominion over creatures and ownership over land) are well enough recorded. Our well-meaning errors, based on the same misunderstanding, are not so well appreciated. For example, on the theme of our current environmental crisis (the impetus for many thoughts embodied in the photographs of this exhibition), we often make the mistake of assuming that we are stewards for the entire planet's future geological history. But we can hardly scratch the earth at its own scale measured in millions of years. The worst predictions of a global greenhouse (including the melting of ice caps on Greenland and Antarctica) still yield an earth far cooler than many prosperous times of our geological past. All the bombs in our nuclear arsenal, if exploded at once, don't come close in megatonnage to the asteroid or comet that probably triggered the great Cretaceous mass extinction.

Our threat is not to the earth at its ample scale. Our danger is to ourselves in our tiny little segment of time (all we can or will know, so we rightly cherish it, despite cosmic limitations). Greenhouse is no threat to the planet, but would be a disaster for us, as most of our great cities (built at sea level as ports and harbors) would founder and our agricultural belts would shift. Mass extinction doesn't end the history of life (and actually leads to interesting evolutionary experiments among few survivors in a relatively empty space), but nothing could possibly be more unpleasant for creatures caught in the midst of such an episode.

We have enormous power to destroy our own little world. The majesty of geological time, however, is abstract and untouchable.

Nature is bigger than us; nature is longer than us. The statements are clichés, but the themes are a foundation for any understanding of scale. I argued in the last section that we now pervade nature with our different geometry—this is true enough, but only in the immediacy of now and the specificity of any particular place. Our struggle to develop a modern concept of landscape must titrate this interpenetration with the larger geological theme that nature, for all our intrusion, is both bigger and longer than us. We mesh in the geometry of form; we are overwhelmed by the spaciousness of earthly time. Again, as with form, I take pleasure in recording the subtle and non-hackneyed representation of these vital themes in the photographs of this exhibition.

*1. Nature is bigger.* The clichéd version shows our ugliness in nature's vastness. The subtle and proper account merely displays our littleness. I love Jim Stone's representations of this theme—beautiful pictures to be sure but, for me, more conceptual than visual. In *Fisher's Landing: Martinez Lake, Arizona*, three molded plastic chairs sit, unobtrusively and to the side, amid a classical vista of all standard elements: vegetation, water, hills, and clouds (pl. 99). The chairs are not "spoiling" the natural scene, but paying proper respect on the periphery. In *Desert Home: Ferguson Lake, AZ*, a dwelling makes the most minimal intrusion upon the greatest of open spaces (pl. 77). Only a cleared circle—a mere superficial scraping of the flat landscape—and the bare minimum of habitation: a car and trailer are seen. In a whimsical note, indicating the interplay in our sense of "roots" versus nature's knowledge of our fleeting presence, the foreground delivery box for the "Yuma Daily Sun" is even larger than the mobile home in the background.

I was also powerfully moved by the richness and striking similarity of themes in Karen Halverson's *Death Valley, California* and Len Jenshel's *Monument Valley, Navajo Tribal Park, Arizona* (figs. 10, 11). Both show a car at the right edge of a lovely landscape of great extent. Again, the cliché would proclaim: how ugly amid the form, peace, and vastness of nature. To me, both pictures convey an opposite message. All entrances of both cars are open, acknowledging nature's heat and mastery. Most important (and I had to stare at the photos for quite a while

before this telling point dawned upon me), both cars are not present as intrusions, but as integral parts of the total scene—for both are fractally scaled-down versions of the larger natural vista. The raised rear flap in the Death Valley car matches the slope of the background hill, while the raised hood mimics the leftmost hill. The car therefore becomes a miniature of the scene it contemplates. *Monument Valley* is a more complex rendition of the same idea. The brickwork of the roadside pullout, and even the white concrete blocks serving as bumpers and markers for parking places, match the horizontal bedding and vertical jointing of the strata that build the natural monuments. (The monuments themselves are among the most beautiful and eerie works of nature. Their trapezoidal shapes mounted on rectangular pedestals, and their positioning as vertical blocks on a flat and starkly empty desert landscape, suggest the explicit work of a purposeful giant sculptor, rather than natural erosion. I once saw the monuments from thirty thousand feet, where the illusion is even more powerful, for their scale then resembles something that an ordinary-sized person might carve.) The car is not intruding, but reproducing the geometry of the monuments at a tiny and immediate scale. The open door is a dead ringer for the most distinctive shape of the monuments—a trapezoid mounted on a rectangle—while the upward sloping antenna and windshield frame mimic the triangular base of the monuments. The fractal downstepping cranks even another notch, as the mirror within the window (within the door) forms yet another trapezoid to reflect the monumental tops.

Big and little exist in both nature and culture, but nature's difference overwhelms ours. We saw the full range of our efforts, with right angles for both large and small, in the chimneys versus skyscrapers of Lois Conner's *St. George's Hotel* (pl. 37). Consider the immensely vaster disparity between aerial big (*Konza Prairie*) and on-your-knees little (*Sage and Scribner's Panic Grass, Fent's Prairie*) in Terry Evans's photographs, both boasting nature's complex geometries at their maximal difference (pls. 53, 55).

*2. Nature is longer.* Vanity of vanities, saith the Preacher— whether it be the starkness of dust unto dust in Richard Misrach's *Dead Animals, #327* (pl. 14) or the sweetness of a champion growing tree, raising the carved letters of past children far above the reach of their present counterparts (Barbara Bosworth's *National Champion American Beech, Ashtabula County, Ohio*;

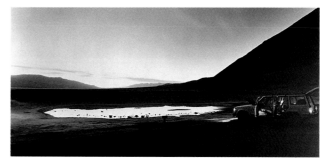

FIG. 10. KAREN HALVERSON, *DEATH VALLEY, CALIFORNIA*, 1987 (SEE PL. 75).

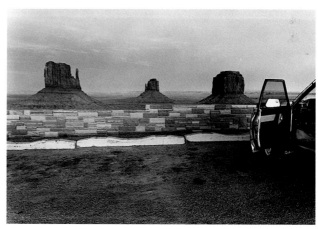

FIG. 11. LEN JENSHEL, *MONUMENT VALLEY, NAVAJO TRIBAL PARK, ARIZONA*, 1985 (ORIGINAL IN COLOR).

FIG. 12. ALLEN HESS, *RAILROAD FERRY INCLINE, MISSISSIPPI RIVER, LOW WATER JULY 1988, STE. GENEVIEVE, MISSOURI*, 1988.

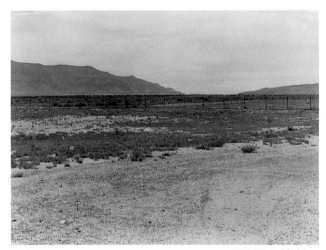

FIG. 13. PETER GOIN, *TRINITY SITE* (LEFT PANEL, TRIPTYCH; ORIGINAL IN COLOR; FROM THE NUCLEAR LANDSCAPE SERIES), 1985–87.

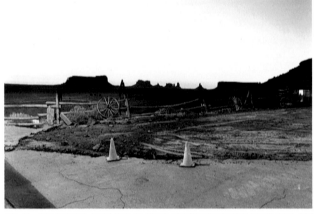

FIG. 14. LEN JENSHEL, *GOULDINGS LODGE, MONUMENT VALLEY, UTAH*, 1987 (SEE PL. 23).

FIG. 15. LEN JENSHEL, *GREAT BASIN NATIONAL PARK, NEVADA*, 1987 (SEE PL. 7).

pl. 47). We simply cannot compete with nature's longer time scales (though we can be devastatingly effective in the world of our own immediacy). If we are obligated, by treaty, to maintain a continuous flow of water along the entire length of the Rio Grande and its tributaries, we must snake two hoses pitifully across the broad arroyo—Peter Goin's *According to treaties negotiated...* (pl. 82). Our works crumble as our technologies change, but Old Man River just keeps rolling along (Allen Hess's *Railroad Ferry Incline Mississippi River, Low Water July 1988, Ste. Genevieve, Missouri*; fig. 12). (At least our tugs still push barges along the river.) In the most didactic photograph in the show, the surrounding high desert frames an antler tree in an inset (representing, I assume, cast antlers collected and heaped up for human pleasure, so we look upon the quick cycling of natural generations, not human cruelty or murder). Meridel Rubenstein's *Penitente* (pl. 25) reminds me of Psalm 39, our canonical statement of this vital theme: "Lord, make me to know mine end, and the measure of my days ...that I may know how frail I am. Behold! thou hast made my days as an handbreadth; and mine age is as nothing before thee: Every man walketh in a vain show...he heapeth up riches, and knoweth not who shall gather them." (If you know the magnificent setting of these words in Brahms's *German Requiem*, then consider the triple emotional impact of words, sounds, and these photographs—and maybe this most important of all lessons from nature will sink in.)

No site could be more symbolic of nature's healing powers in the large than Trinity, locus of our first atomic blast. Not even half a century has passed, yet nature has already reclaimed her stark land (Peter Goin's *Trinity Site*; fig. 13). In *Burial Ground*, another in Goin's Nuclear Landscape series, we see nothing of our incursion, but only a vast flood plain of that finest symbol of natural persistence in slow, effective change—smooth, water-worn pebbles (pl. 63). Triturate and polish, triturate and polish. Though the mills of God grind slowly, yet they grind exceedingly small. (And we therefore make a dangerous mistake in assuming that we can find any inert and permanent earthly dumpsite for toxic waste.)

*Closing Illustration and Conclusion*
Once we accept the necessity of integrating nature and culture as the foundation for a modern and conceptually meaningful notion of landscape, we may proceed in a number of modes—and I make no judgment among the many honorable versions.

We might search for a style quite foreign to Western culture, but so worthy of our attention, even if outside the bounds of conceivable emulation—the acknowledgment of our frailty and boundedness, and a consequent attempt to follow, even to obey, nature's forms. Linda Connor's photos of southwestern Indian petroglyphs remind us of this worthy, if inaccessible, mode. In *Dots and Hands, Fourteen Window Ruin Bluff, Utah*, the images follow the bedding planes of these ancient and petrified sand dunes (pl. 16). By contrast, the surrounding rocks in *Design Petroglyph, Wupatki, Arizona* are angular and jointed—and the human design follows the natural contours (pl. 18).

Another strategy keeps the realms spatially separate, but searches for isomorphism in abstract forms and processes common to any object with shape or duration. (This technique, so striking when good examples are found, has limits in the light of characteristically different geometries for nature and culture.) The oxbow lake (a natural, cutoff river meander) of Terry Evans's *Solomon River Oxbow* (pl. 9) takes the same circular form as a human construction for dubious purposes in *Smoky Hill Bombing Range Target, Tires*—and is isomorphic, at much smaller scale, with *Fairy Ring #2, Fent's Prairie* (pls. 76, 56). Place the three together and note that abstract geometry behind the particulars can bind the realms.

Larry Schwarm searches for rare situations of utmost simplicity in nature—where, for example, the horizon line separates land and sky, and few or no details can be discerned in either realm. (The entire composition then resembles a minimalist abstract painting—and art imitates an unusual picture of life.) A blaze on a flat prairie separates two realms of darkness in *Flint Hills Prairie Fire Near Cassoday, Kansas* (pl. 94). A single diamond of water breaks the contrast of dark land and light sky in *Near Cottonwood Falls, Kansas* (pl. 93). In *Snow, Near Greenburg, Kansas*, even the horizon is almost obliterated in pervasive whiteness, though we can barely make out an electric line on the horizon (pl. 96).

As a reveler in detail, I am struck by the conceptual richness of Len Jenshel's integrations, with their equality of balance and respect for difference. I view *Gouldings Lodge, Monument Valley, Utah* as a comment on bridging the realms by contrasting geometries and scales—the two major themes of this essay (fig. 14). We note three pairs of objects, getting larger and further

apart as they recede into the distance. Each pair represents a simple geometry: the cones (triangular cross sections) of the road markers, the circles of the wagon wheels, and the nearly perfect rectangular prisms of the two distant mesas. Usually, we make our taxonomic break between nature and culture—but not here, where we can only acknowledge a continuum of geometries and distances.

*Great Basin National Park, Nevada* is even richer in its symbols (fig. 15). A lowly cattle grate, made of culture's horizontal bars, dominates the foreground (though with a lovely surround of two flowering bushes, flaunting nature's complex geometry). The grate ends in an A-shaped frame at the edge of the path. But does it end? I think not, for the A-framework, as an illusion or metaphor, extends far into the sweeping vista behind the path. The frame is not really just a few feet long, terminating at a point. It is culture's device for teaching perspective. The sides of the *A* are really parallel lines extending indefinitely into nature to form a vanishing point at their apparent apex! Culture does flow into nature, and the most sublime of geometrical abstractions can lead us.

I speak as a city boy, who has (with some slight sense of guilt, given my profession) always preferred a walk amid the vibrancy of Manhattan to a peaceful stroll in the pristine woods. Nonetheless, I know both the simplicity and the ephemerality of our products versus nature's. We have managed to intrude upon nature to the point where an aesthetic of romantic wilderness simply will not do as a philosophy of landscape. But she can wait us out until we do ourselves in. I regard nature as most accommodating and gracious in tolerating our entry (though perhaps she is only wily, given her knowledge of relations of power at her own scale). Let us repay the favor both in our practical dealings and in our search for a new aesthetic. With special good fortune, a successful aesthetic may even inspire due respect in our practices.

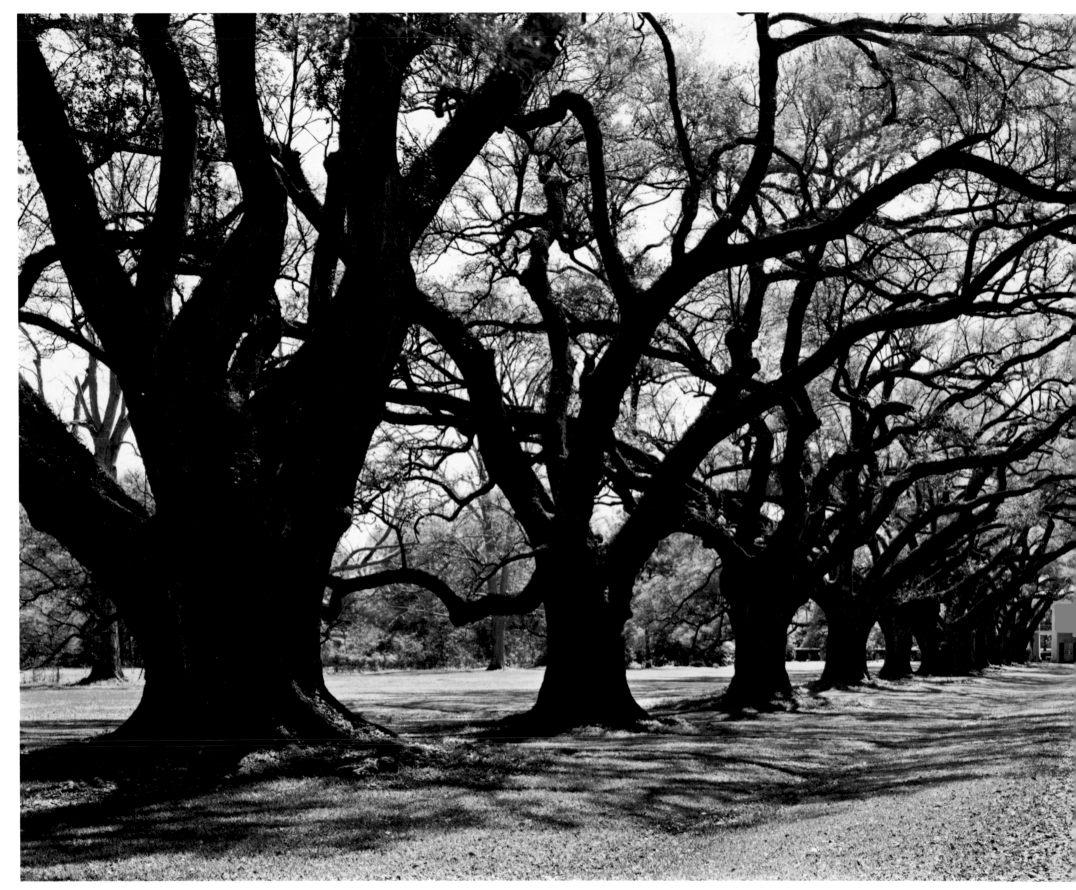

**39. ALLEN HESS,** OAK ALLEY PLANTATION, RIVER ROAD, LOUISIANA, **1983**

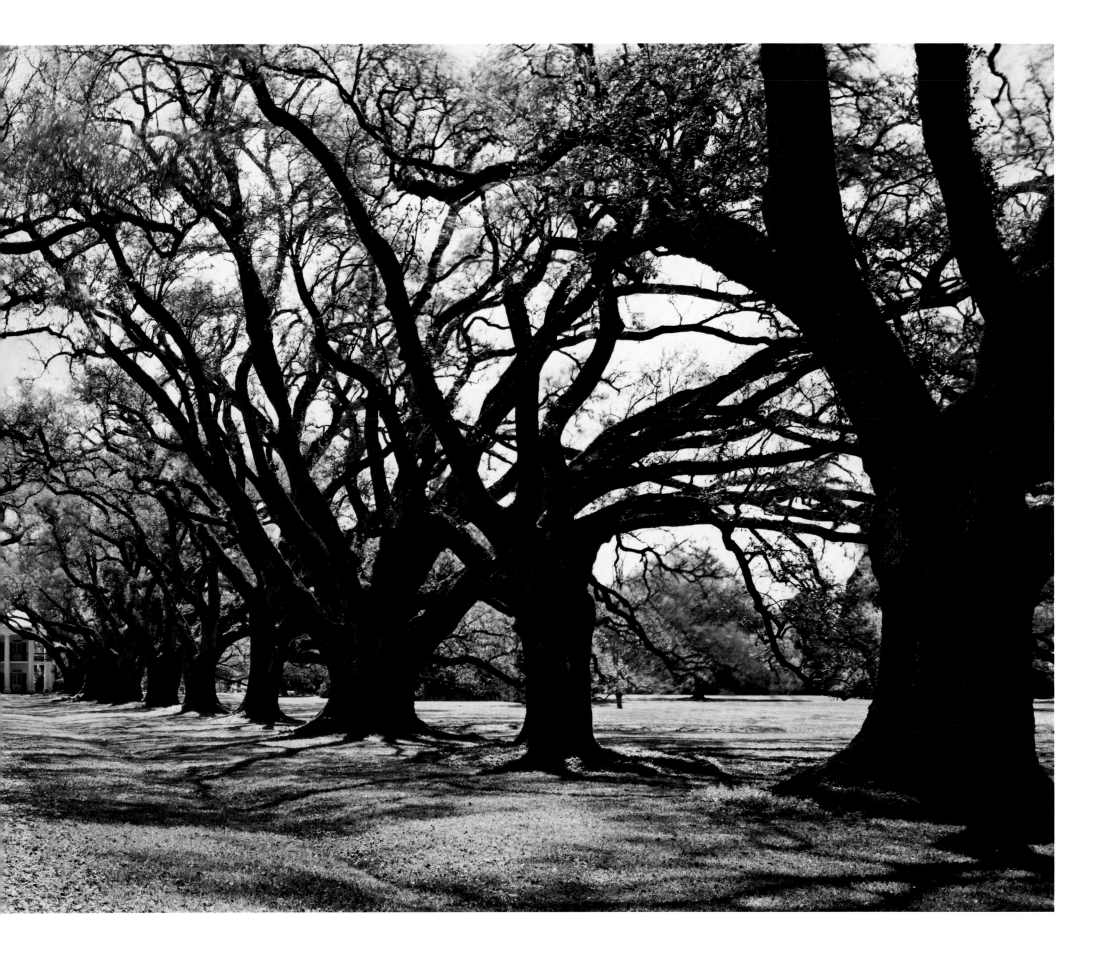

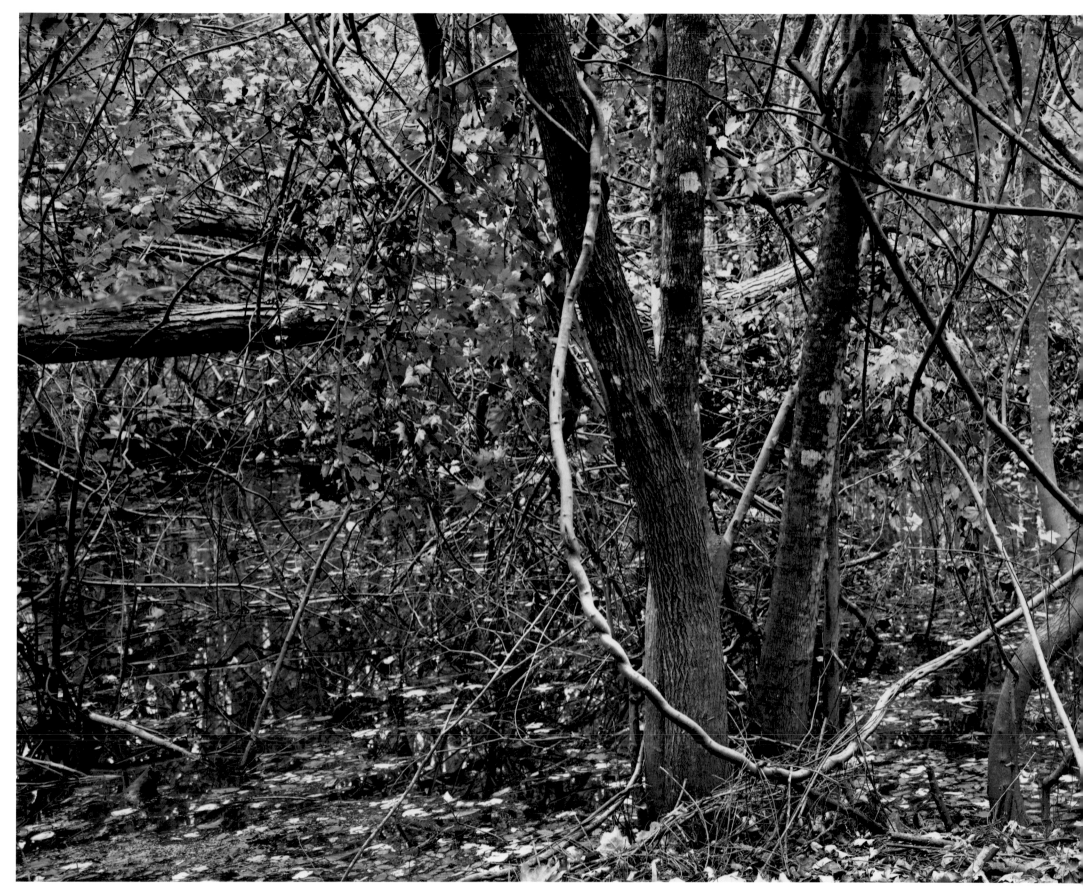

**40. ALLEN HESS,** CYPRESS LOGGING SLOUGH AND BOAT, LOUISIANA, **1985**

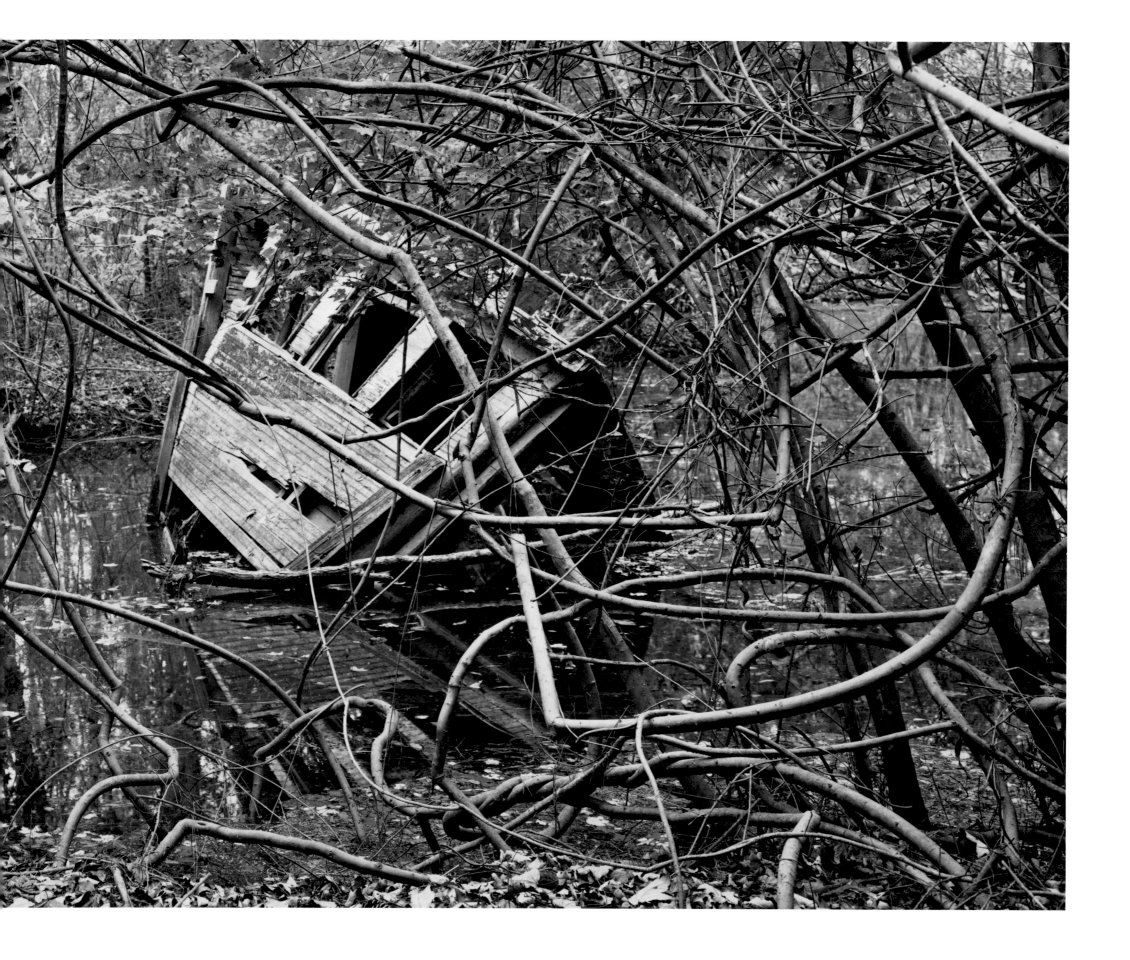

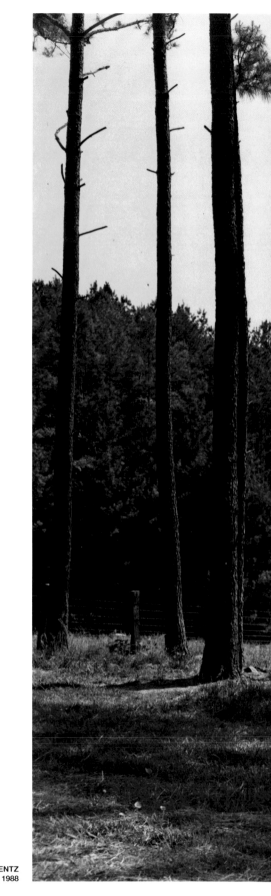

**41. RICHARD ARENTZ**
CUMBERLAND GAP, **1988**

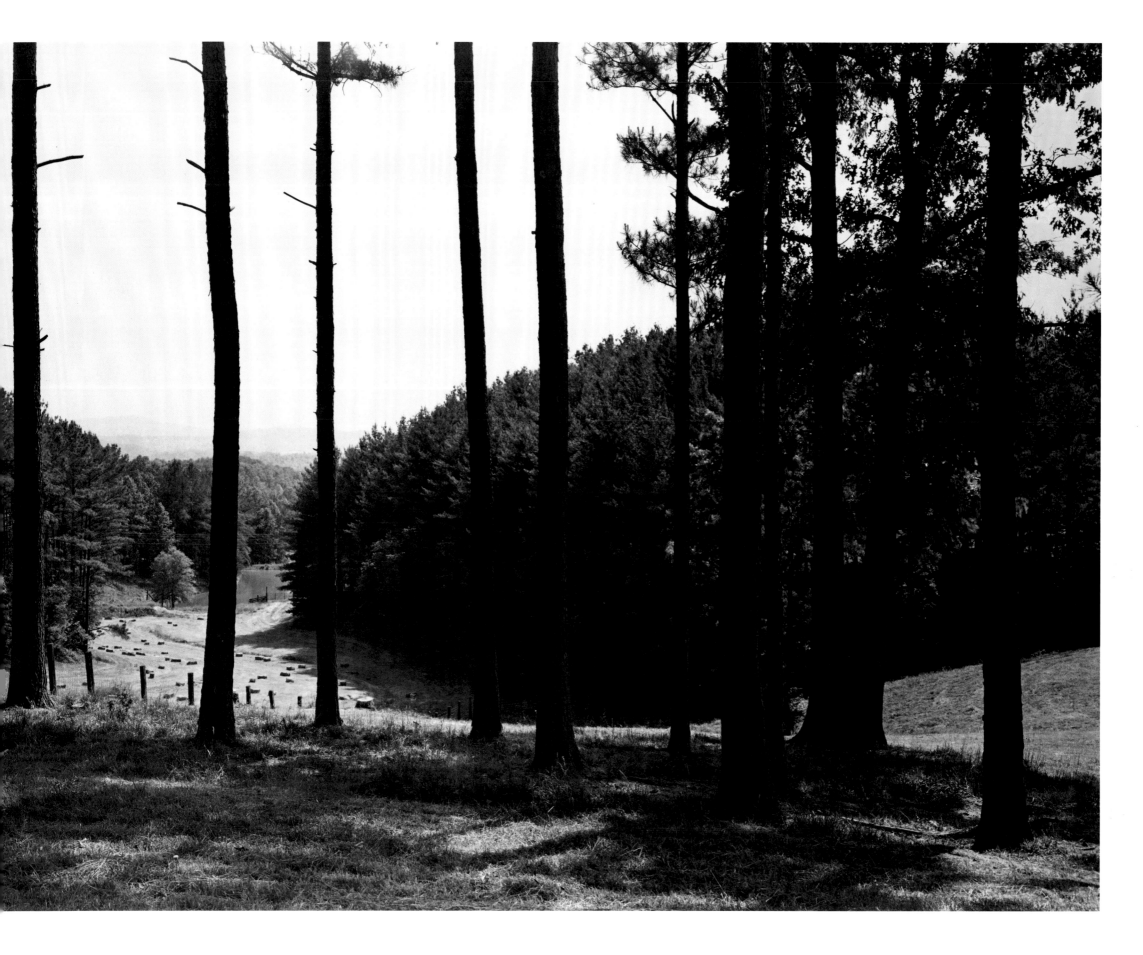

I wish all to know that I do not propose to sell any part of my country, nor will I have the whites cutting our timber along the rivers, more especially the oak. I am particularly fond of the little groves of oak trees. I love to look at them, because they endure the wintry storm and the summer's heat, and—not unlike ourselves—seem to flourish by them.

*Sitting Bull, Lakota*

**42. DREX BROOKS**
SWEET MEDICINE: COUNCIL
GROUNDS OF THE GREAT TREATY
AT HORSE CREEK,
NEBRASKA, **1987**

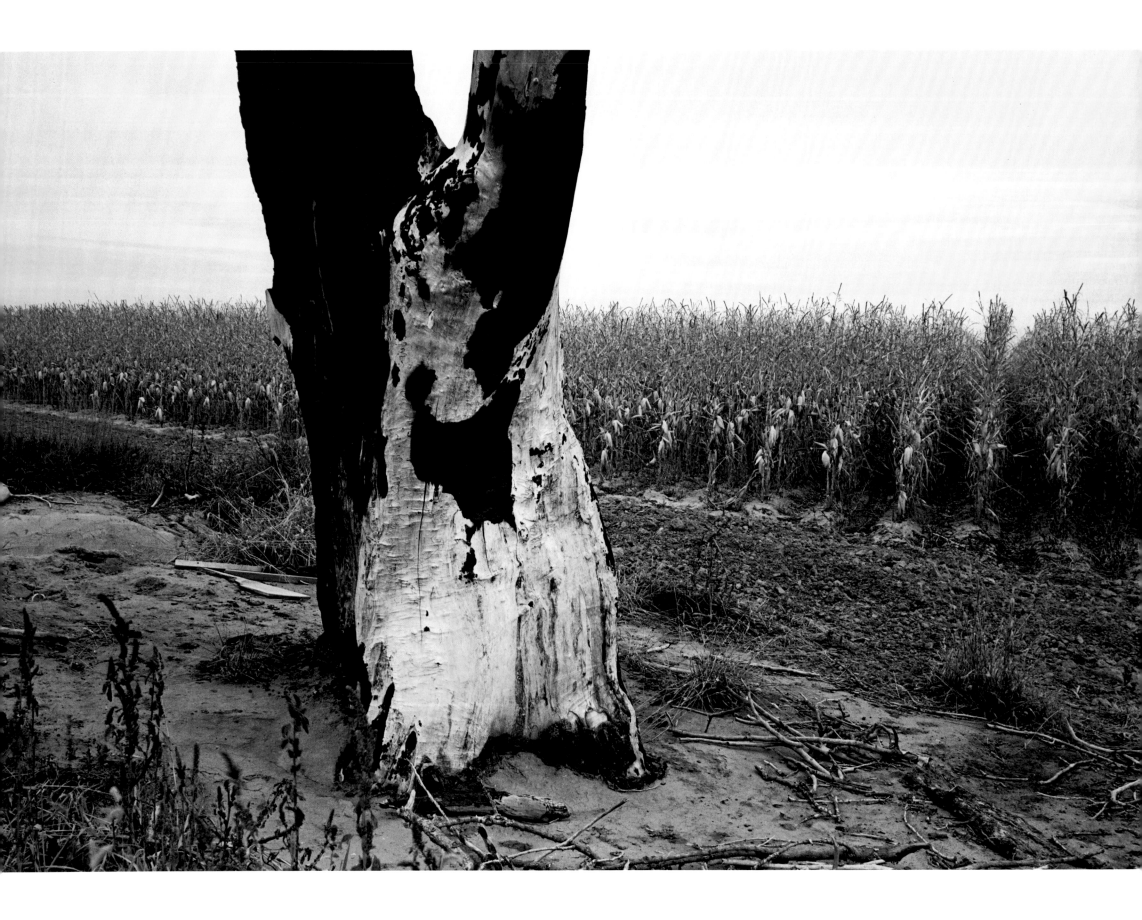

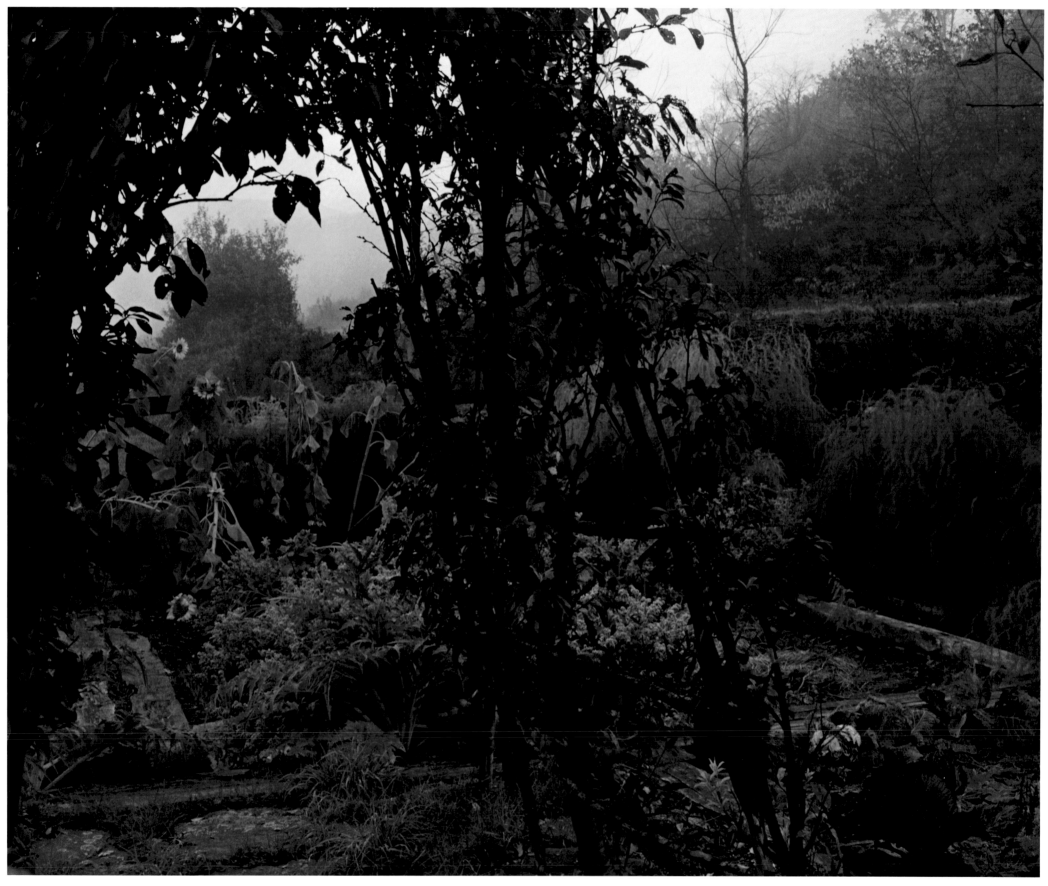

**43. GREGORY CONNIFF,** ONEONTA, NY; FRECKELTON/BEAL GARDEN, **1987**

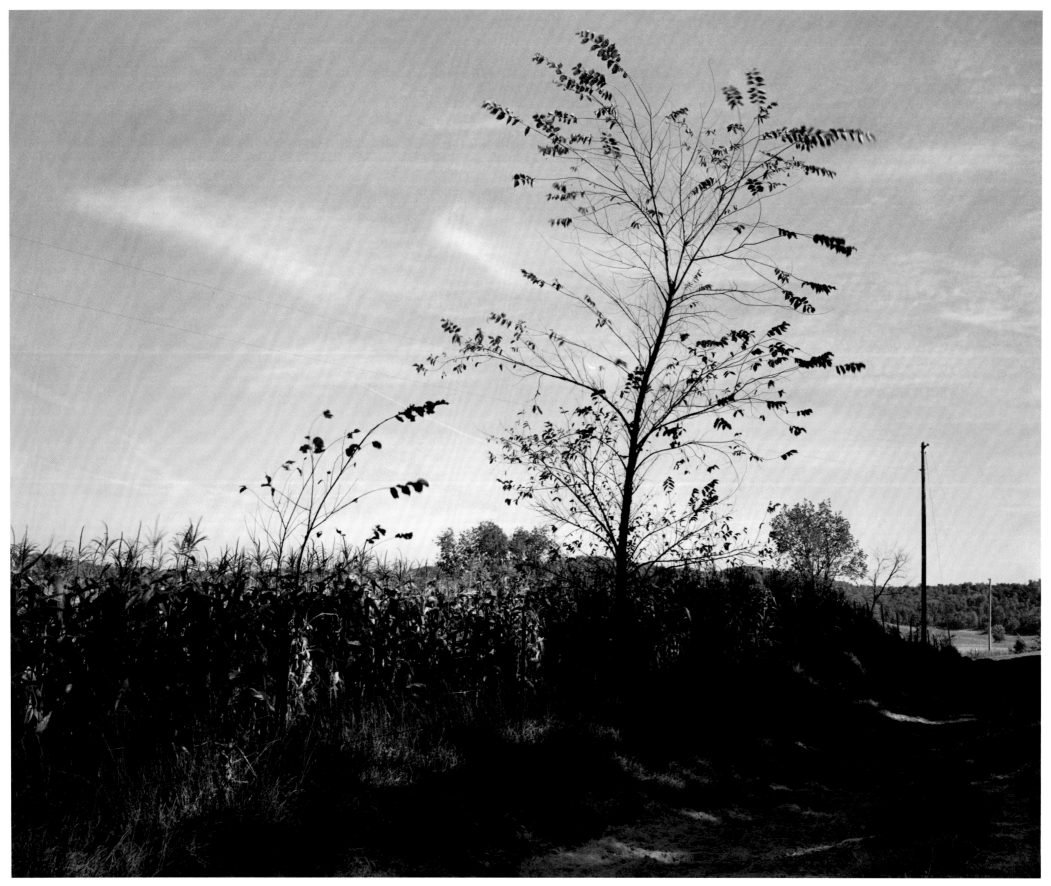

**44. GREGORY CONNIFF,** IOWA CO., WI, OCTOBER **1990**

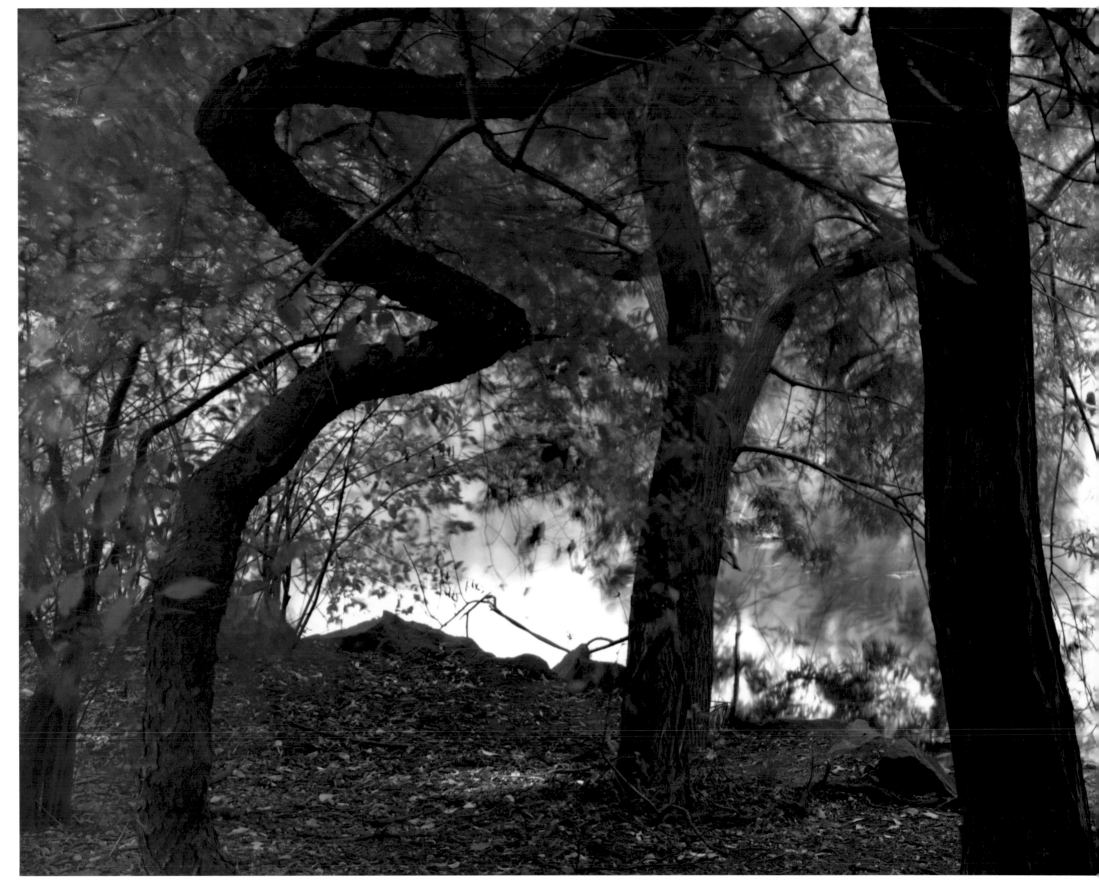

45. **LOIS CONNER**, CENTRAL PARK, NEW YORK CITY, **1986**

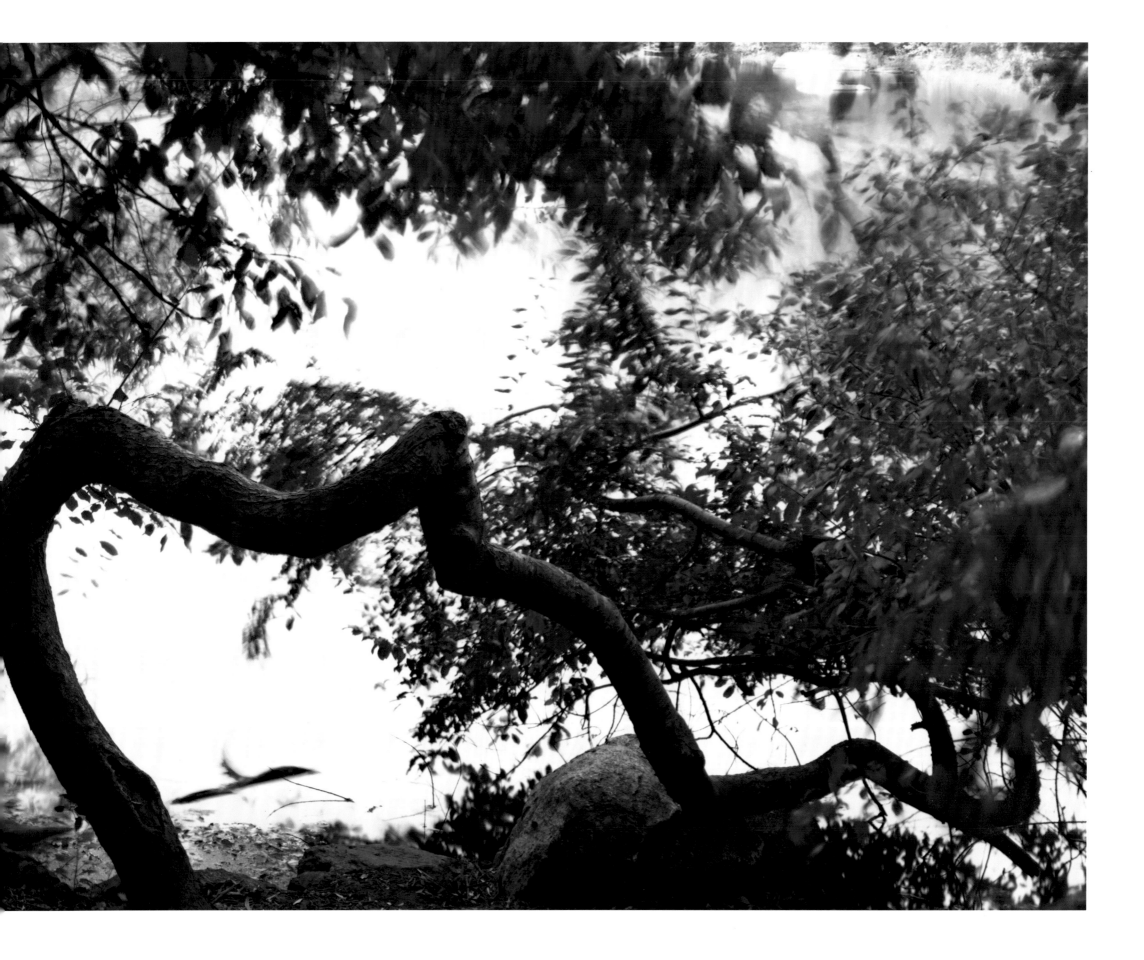

46. **BARBARA BOSWORTH,** NATIONAL CHAMPION SYCAMORE, CLARENCE BRIGGS FARM, OHIO, **1990**

**47. BARBARA BOSWORTH,** NATIONAL CHAMPION AMERICAN BEECH, ASHTABULA COUNTY, OHIO, **1990**

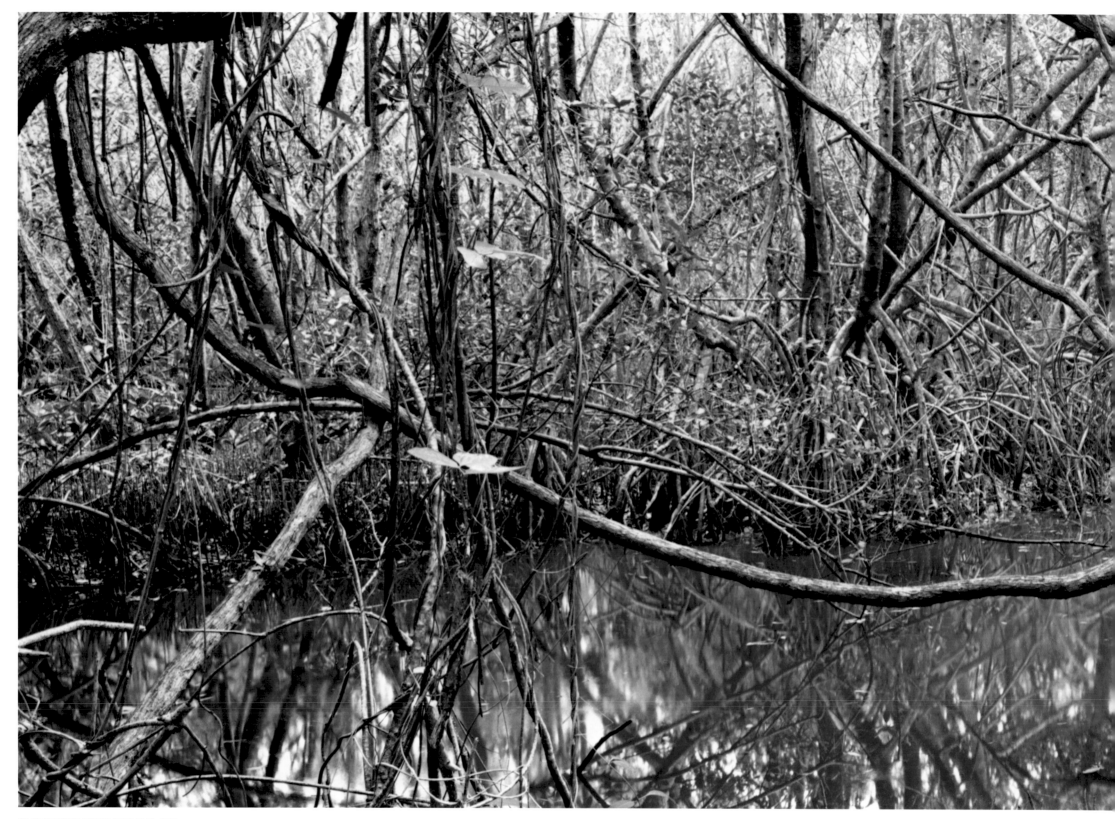

**48. MARY PECK,** EVERGLADES 40 #1, **1986**

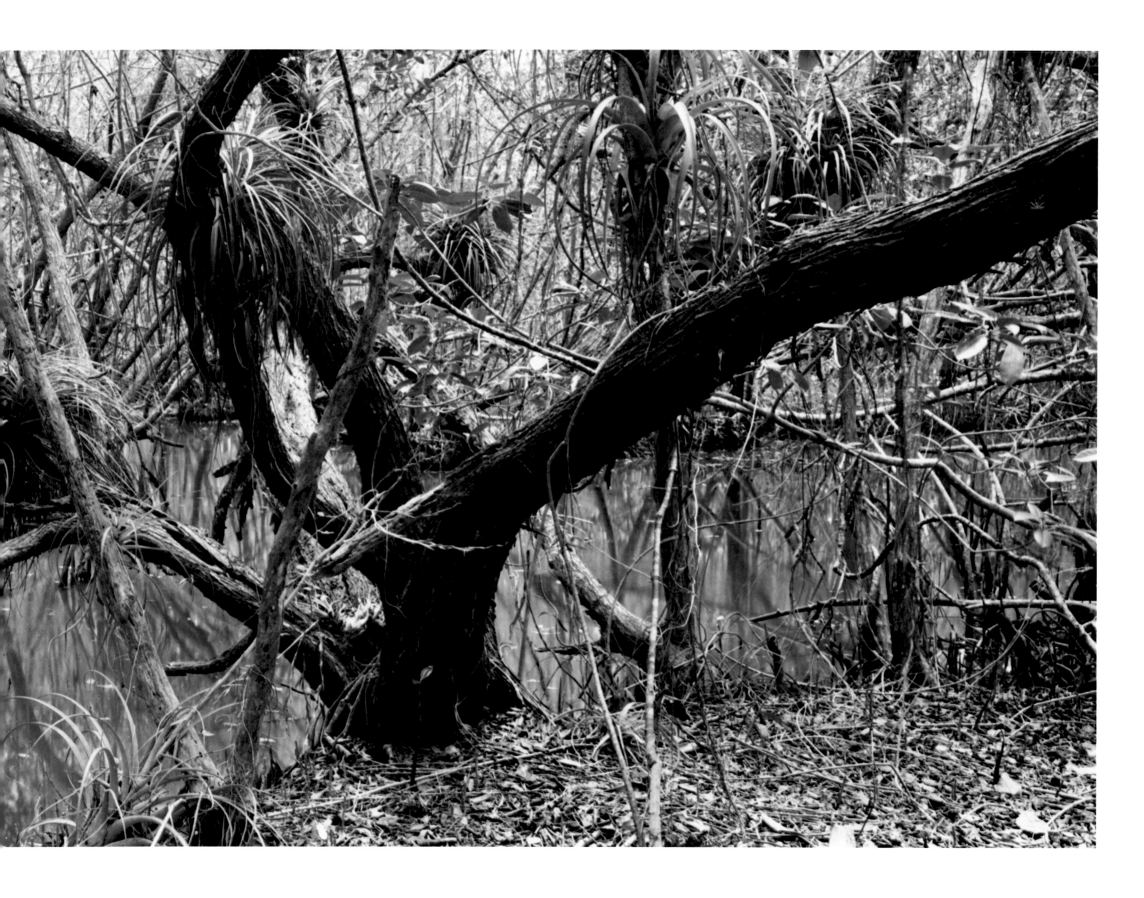

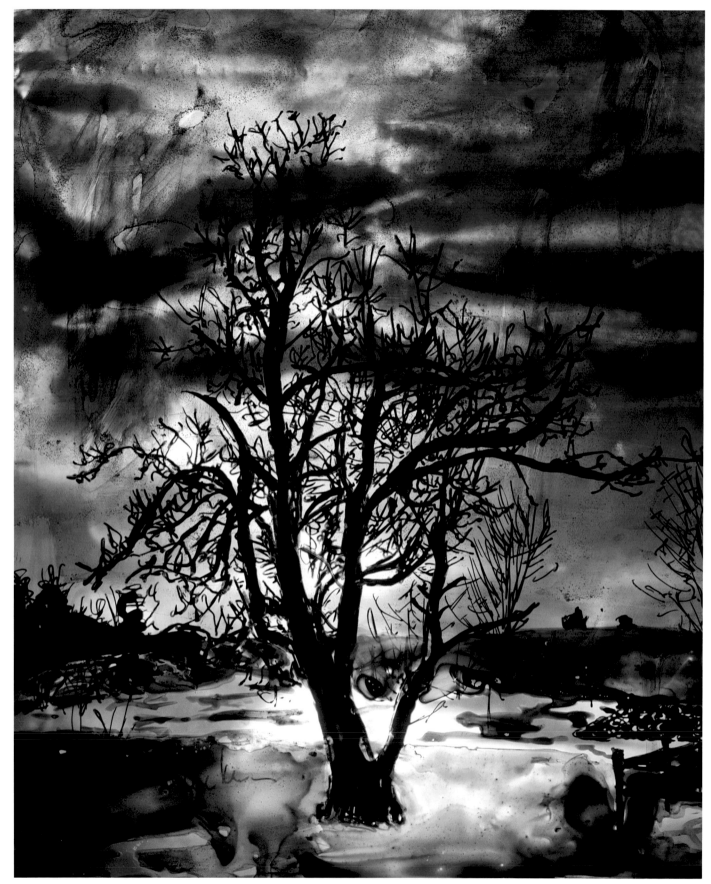

**50. STEEL STILLMAN**
PLANE TREE, 1990

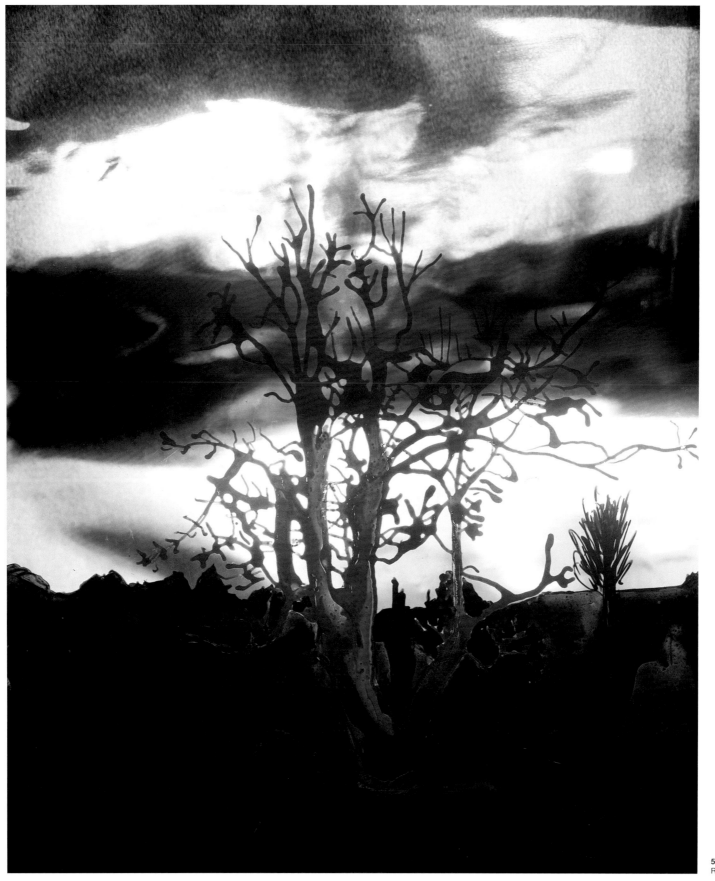

**51. STEEL STILLMAN**
RED PLANE TREE, **1990**

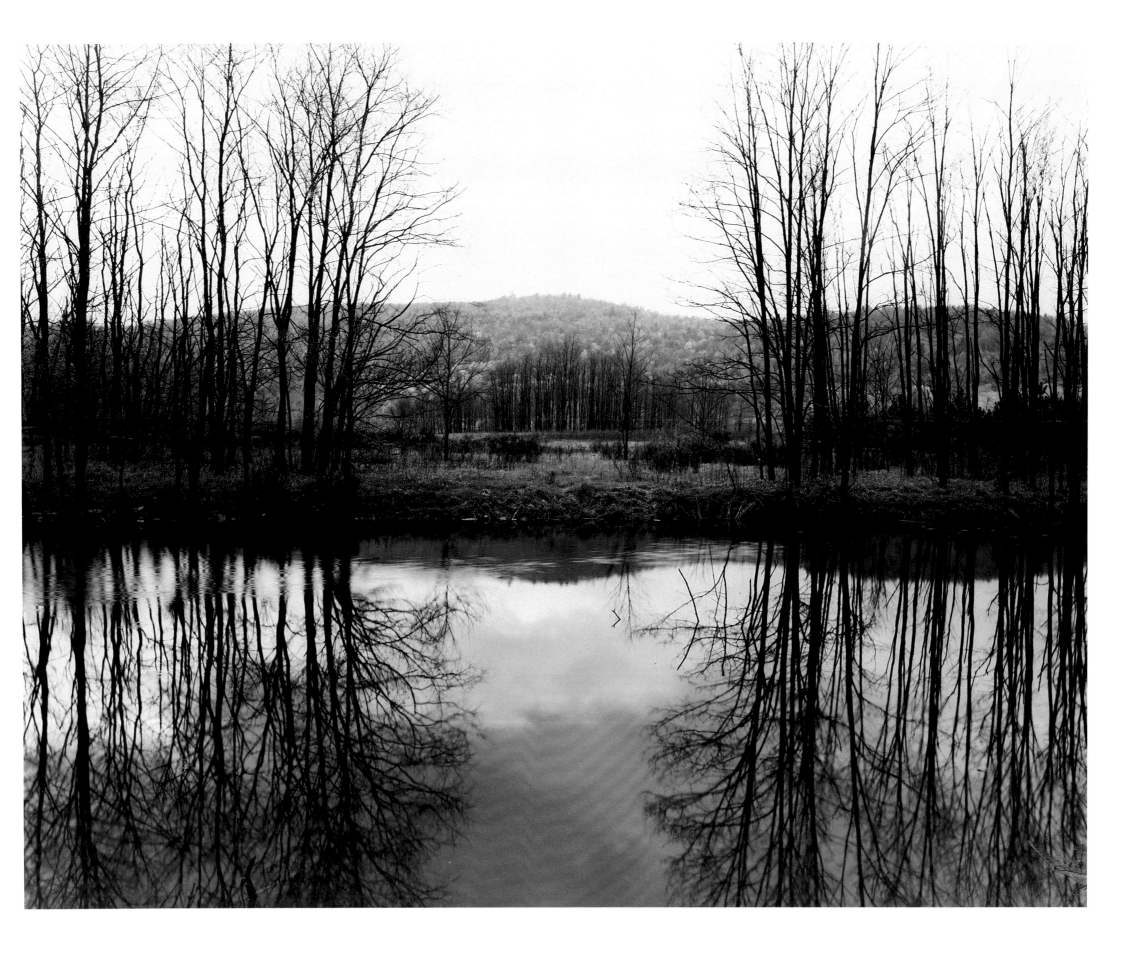

**53. TERRY EVANS,**
KONZA PRAIRIE, 1982

**54. TERRY EVANS**
MELVERN LAKE,
APRIL **1981**

**55. TERRY EVANS**
SAGE AND SCRIBNER'S
PANIC GRASS, FENT'S
PRAIRIE, 1979

**56. TERRY EVANS**
FAIRY RING #2,
FENT'S PRAIRIE
1979

**57. RICHARD MISRACH**
BOMB, DESTROYED VEHICLE
AND LONE ROCK, 1987

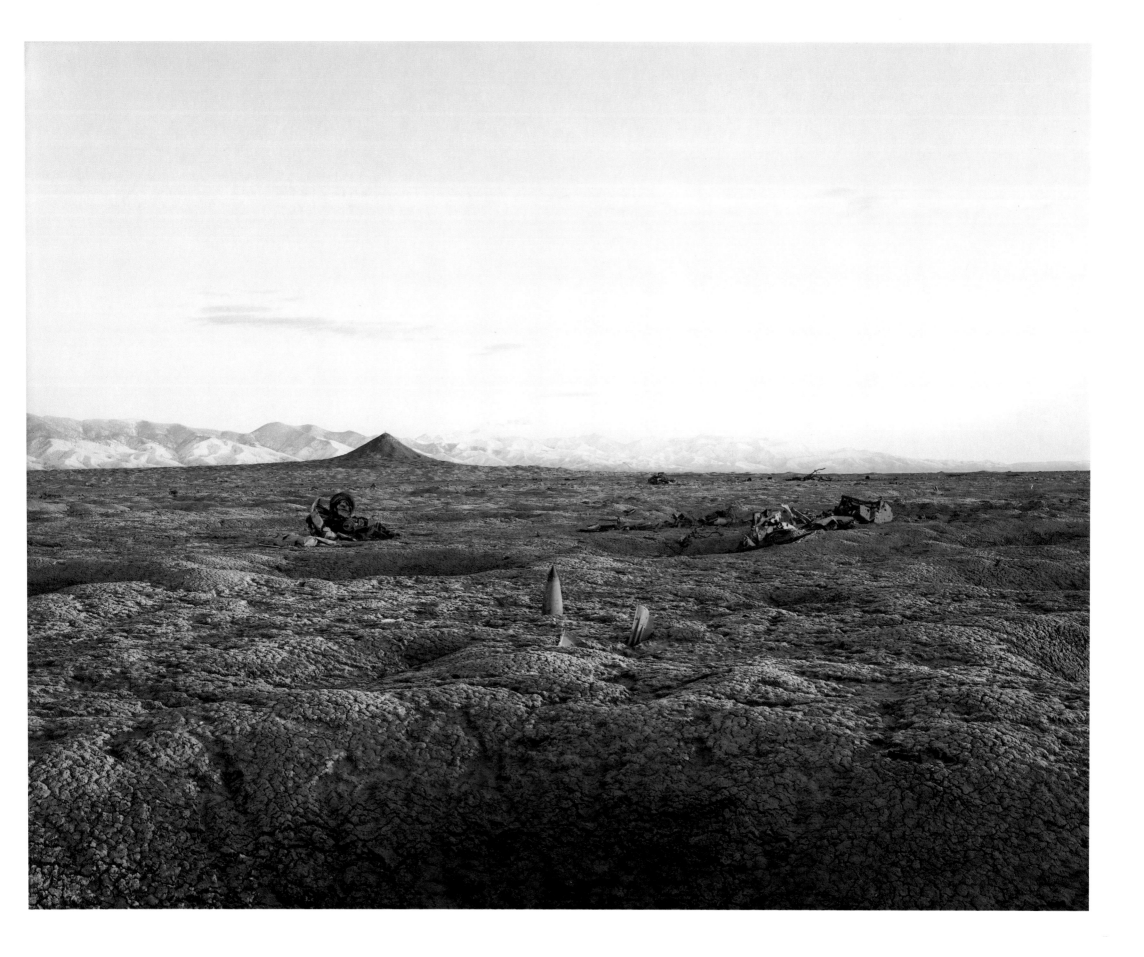

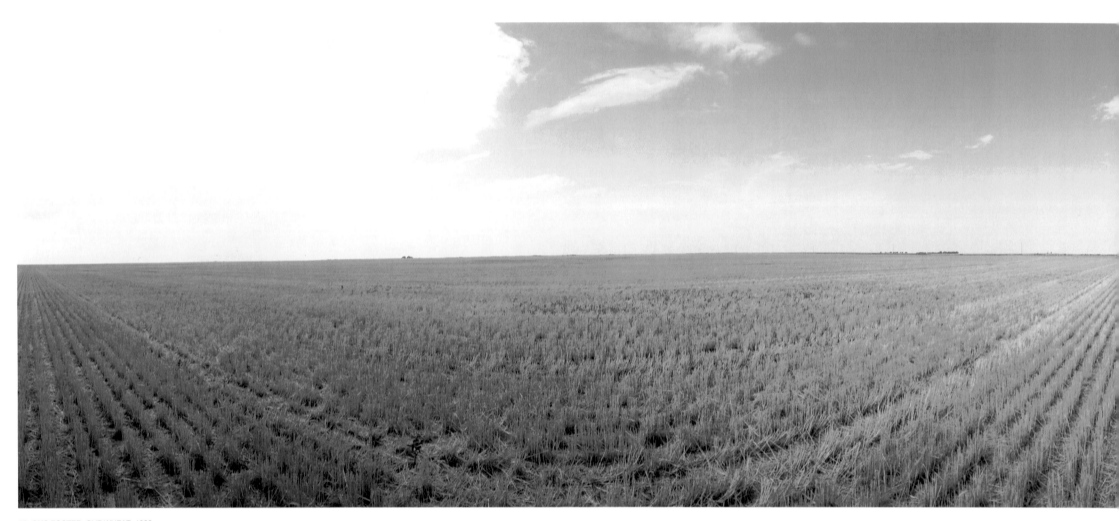

58. **GUS FOSTER,** CUT WHEAT, 1988

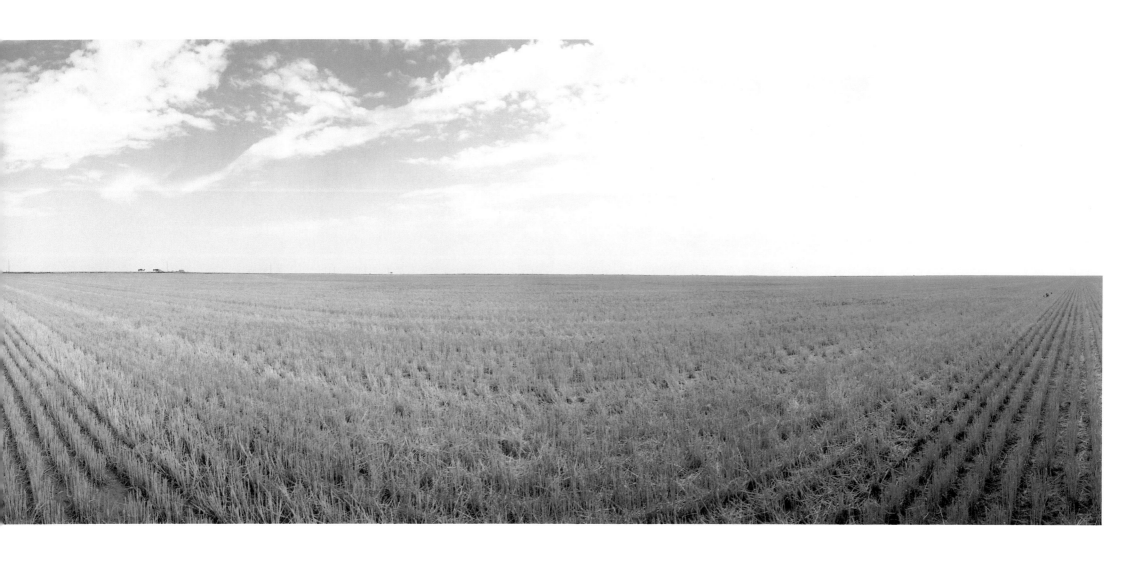

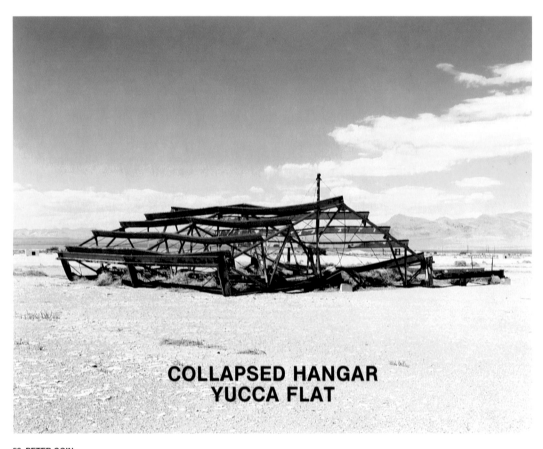

**COLLAPSED HANGAR
YUCCA FLAT**

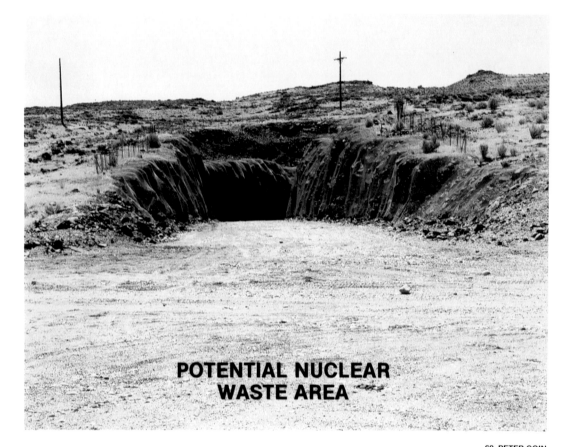

**POTENTIAL NUCLEAR
WASTE AREA**

59. PETER GOIN
COLLAPSED HANGAR YUCCA
FLAT (FROM THE NUCLEAR
LANDSCAPE SERIES)
1985–87

60. PETER GOIN
POTENTIAL NUCLEAR
WASTE AREA (FROM THE
NUCLEAR LANDSCAPE
SERIES), 1985–87

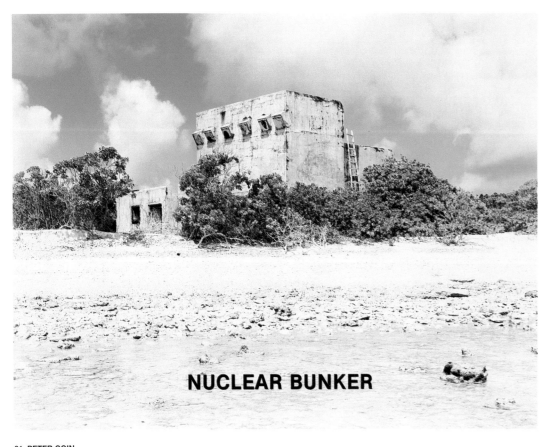

**NUCLEAR BUNKER**

61. PETER GOIN
NUCLEAR BUNKER
**(FROM THE NUCLEAR**
**LANDSCAPE SERIES)**
1985–87

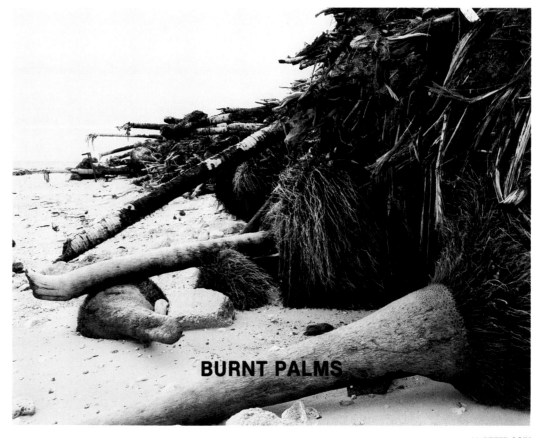

**BURNT PALMS**

62. PETER GOIN
BURNT PALMS **(FROM**
**THE NUCLEAR LANDSCAPE**
**SERIES), 1985–87**

63. PETER GOIN, BURIAL GROUND (FROM THE NUCLEAR LANDSCAPE SERIES), 1985–87

ORCHARD SITE

**64. PETER GOIN,** ORCHARD SITE **(FROM THE NUCLEAR LANDSCAPE SERIES), 1985–87**

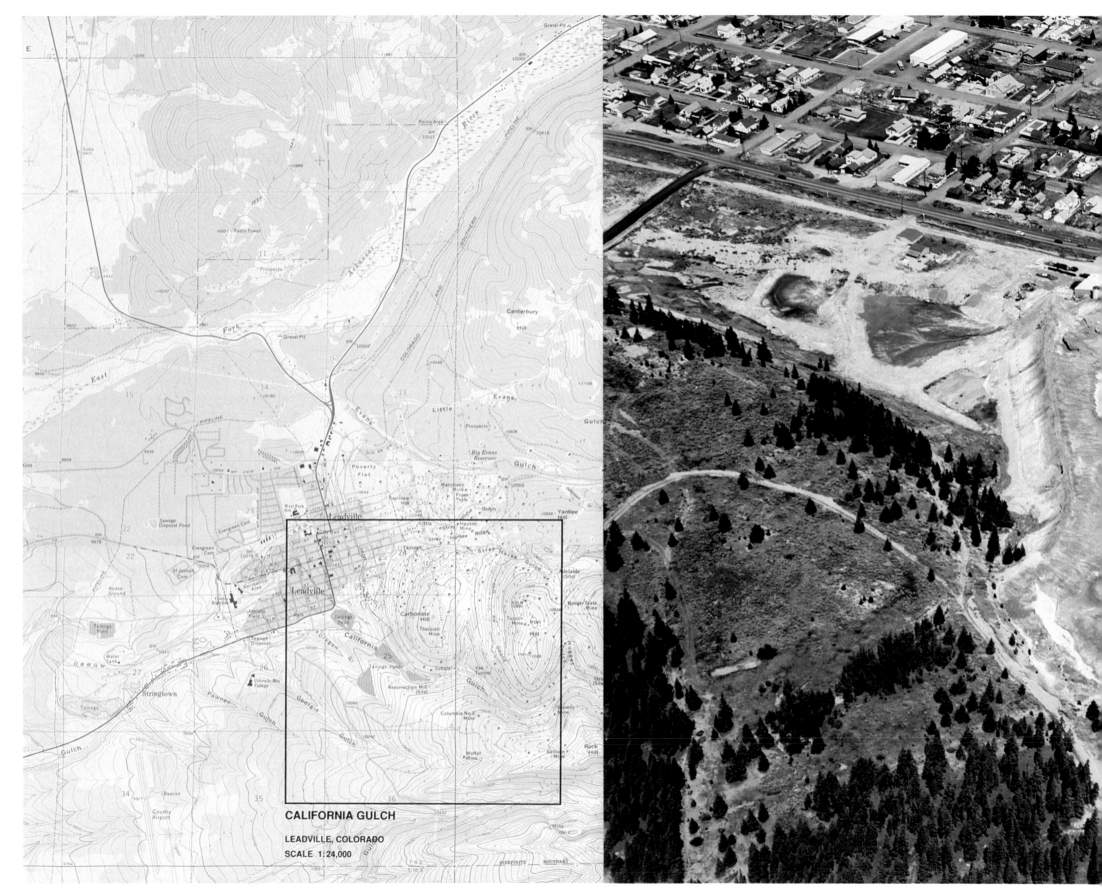

CALIFORNIA GULCH

LEADVILLE, COLORADO
SCALE 1:24,000

65. DAVID T. HANSON, CALIFORNIA GULCH, LEADVILLE, COLORADO: AUGUST 1986 (FROM THE SERIES WASTE LAND), 1986–88

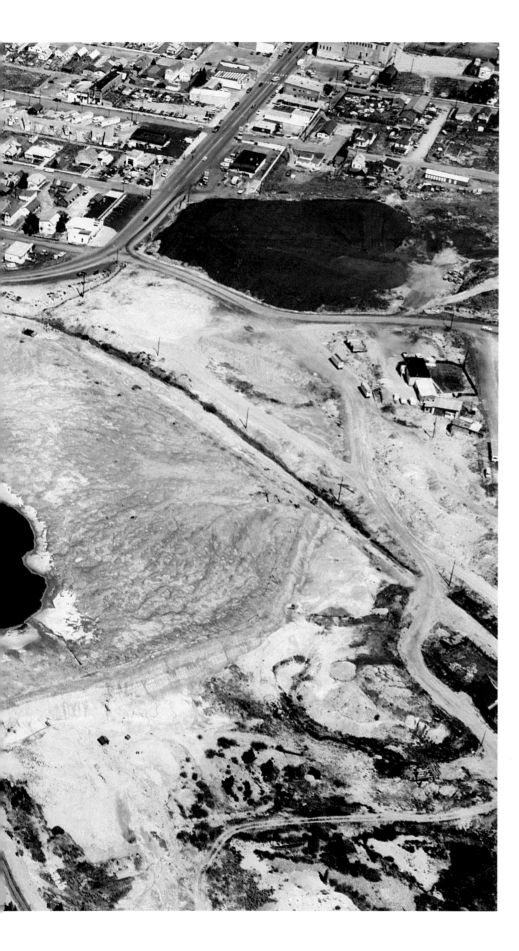

**National Priorities List Site**

Hazardous waste site listed under the
Comprehensive Environmental Response, Compensation and Liability Act of 1980 (CERCLA)("Superfund")

## CALIFORNIA GULCH
### Leadville, Colorado

California Gulch flows about 1.5 miles to its confluence with the Arkansas River in Colorado's Leadville Mining District. The gulch has been seriously impacted by lead, silver, zinc, copper, and gold mining activities. Numerous abandoned mines and tailing piles are located in the gulch. The most serious water quality problem is acid mine drainage from the Yak Tunnel, a 3.4-mile tunnel constructed from 1895 to 1909 for the purpose of exploration, transportation of ore, and mine drainage. The tunnel is connected to 17 mines. The flow from the tunnel contains high concentrations of dissolved metals, including iron, lead, zinc, manganese, and cadmium.

California Gulch drains to the Arkansas River. There is concern about the potential for (1) contamination of domestic ground water supplies in the California Gulch area, (2) adverse impacts on fish in the Arkansas River, and (3) adverse impacts on livestock and crops grown on agricultural land irrigated by the Arkansas River.

EPA is conducting a remedial investigation to define the contamination problem the Yak Tunnel and tailings piles pose to ground water and surface water and a feasibility study to evaluate and select a remedy to correct the problem.

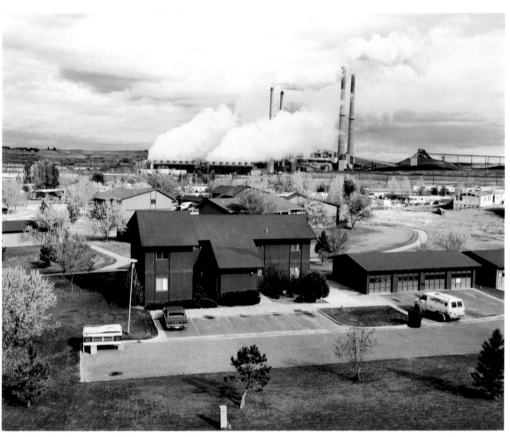

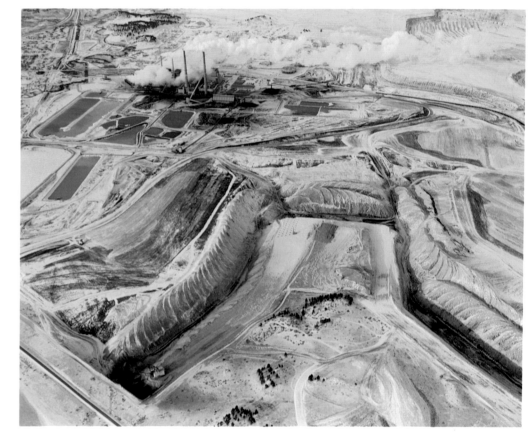

66. DAVID T. HANSON
VIEW FROM FIRST BAPTIST
CHURCH OF COLSTRIP:
COMPANY HOUSES AND
POWER PLANT. OCTOBER, 1984
(FROM THE SERIES
COLSTRIP, MONTANA)
1982–85

67. DAVID T. HANSON
COAL STRIP MINE, POWER
PLANT AND WASTE PONDS.
JANUARY, 1984 (FROM
THE SERIES COLSTRIP,
MONTANA), 1982–85

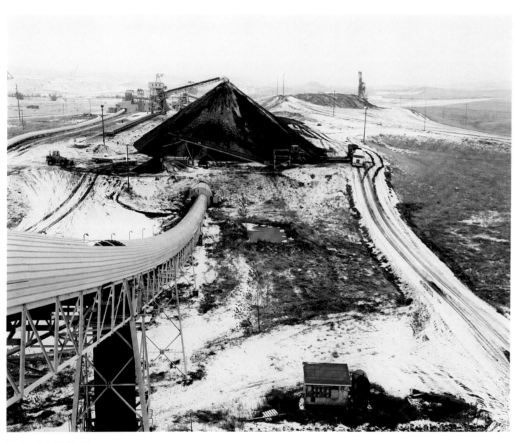

**68. DAVID T. HANSON**
COAL STORAGE
AREA AND RAILROAD
TIPPLE. OCTOBER, 1984
**(FROM THE SERIES
COLSTRIP, MONTANA)
1982–85**

**69. DAVID T. HANSON**
B & R VILLAGE MOBILE HOME
PARK AND BURLINGTON NORTHERN
COAL TRAIN. JUNE, 1984
**(FROM THE SERIES COLSTRIP,
MONTANA), 1982–85**

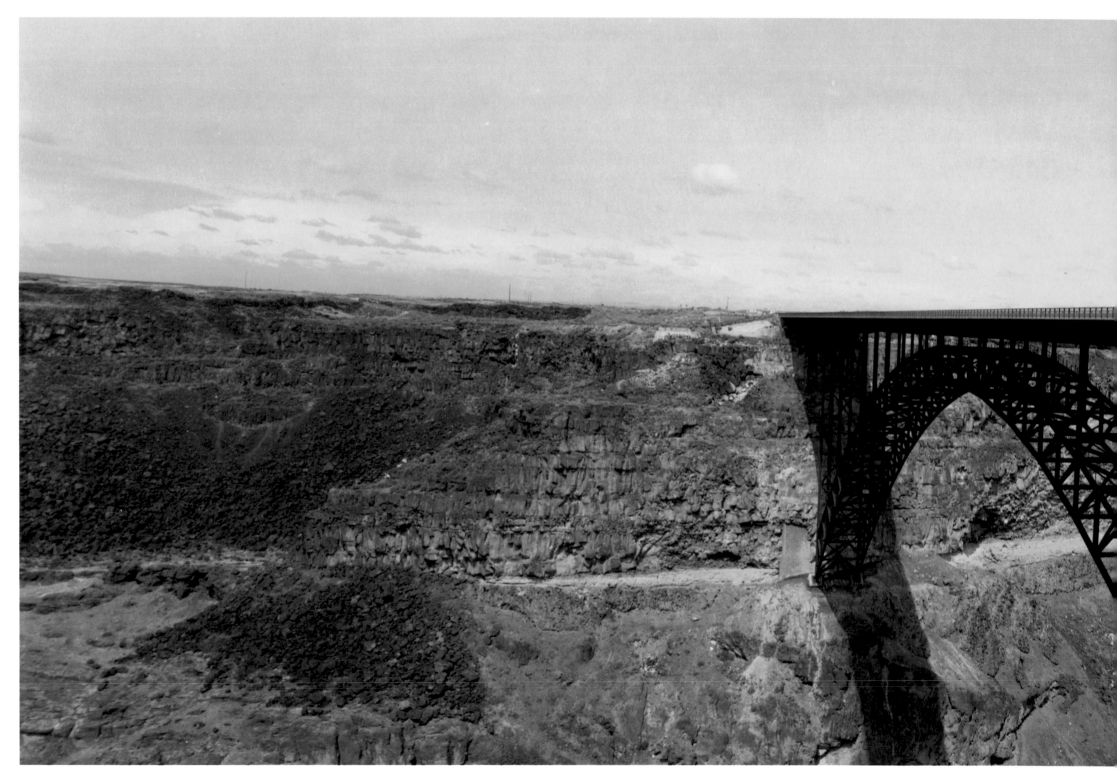

70. **STUART D. KLIPPER,** SNAKE RIVER GORGE BRIDGE, TWIN FALLS, IDAHO **(FROM THE SERIES THE WORLD IN A FEW STATES),** 1990

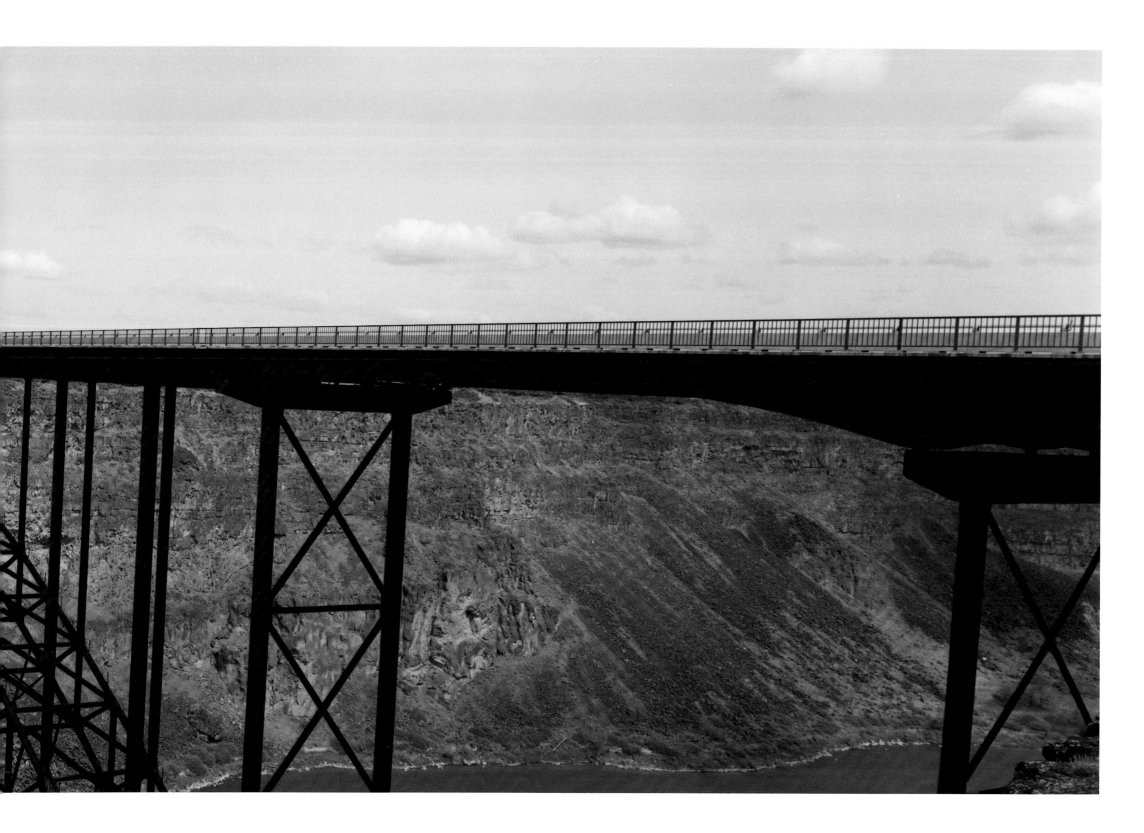

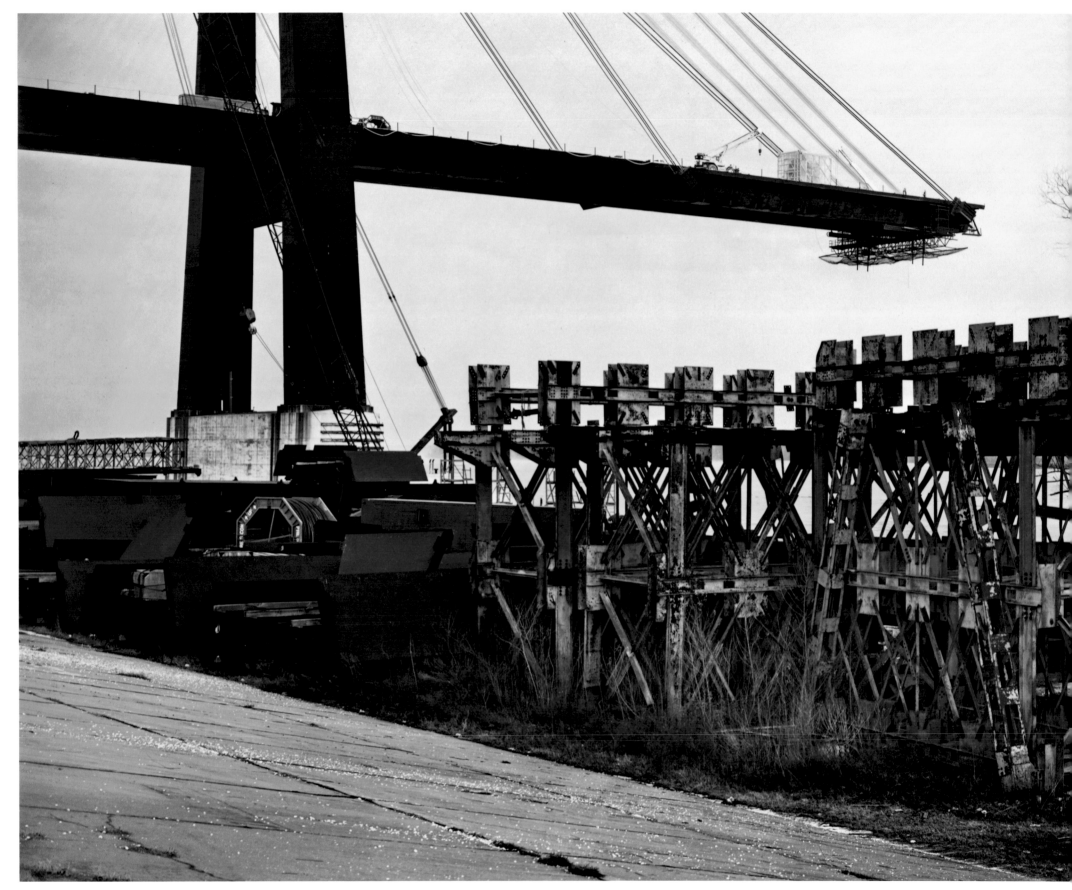

**71. ALLEN HESS,** THE NEW MISSISSIPPI RIVER BRIDGE, LULING, LOUISIANA, **1982**

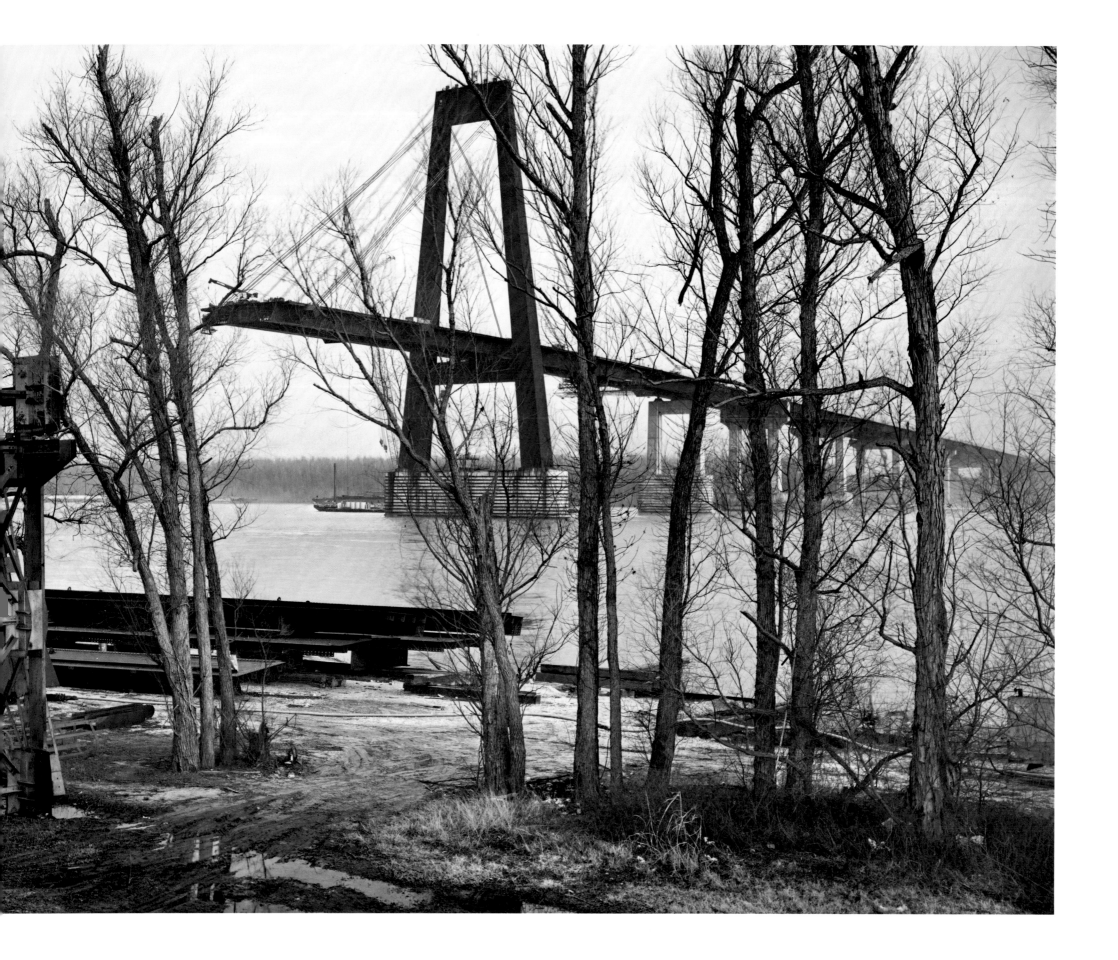

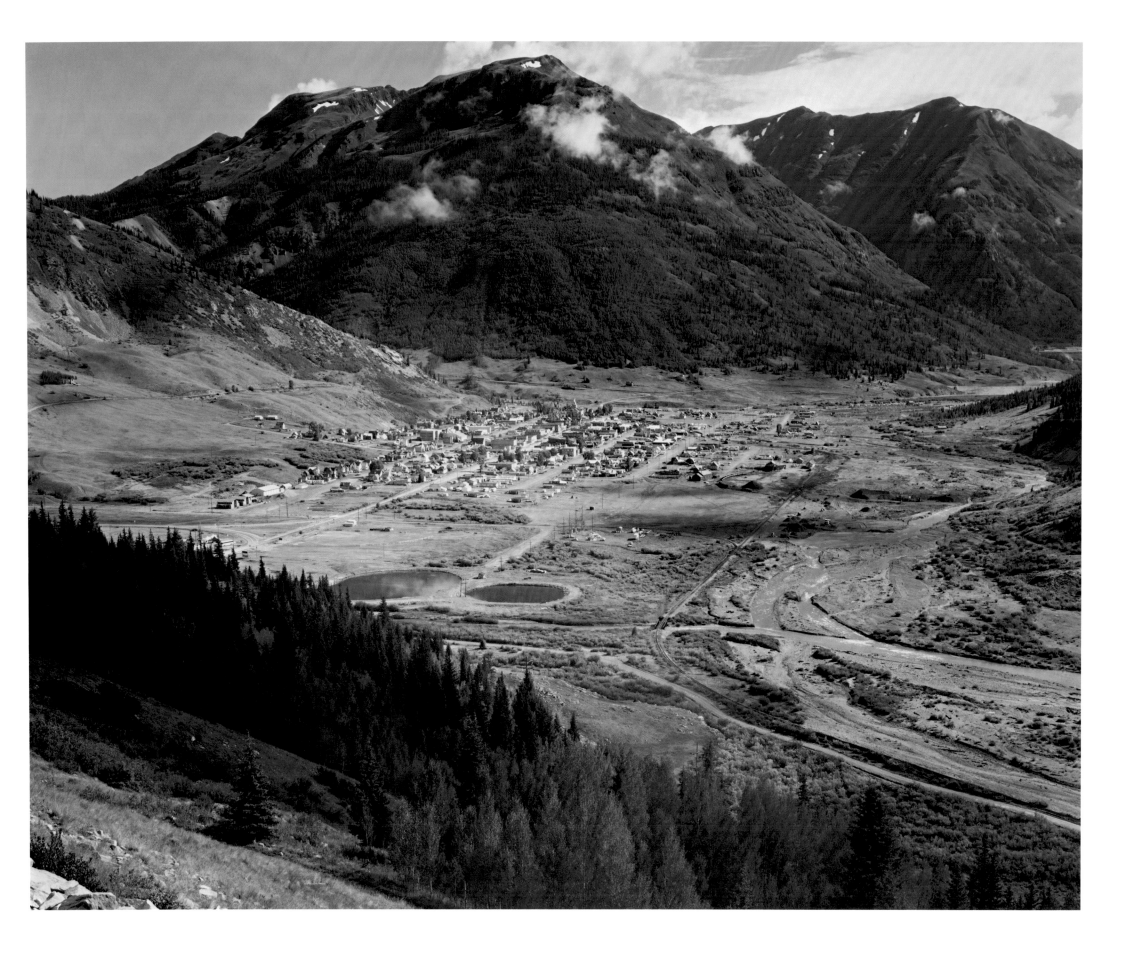

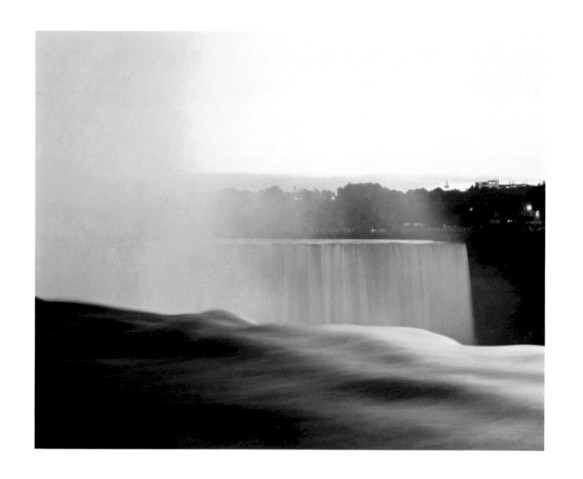

73. BARBARA BOSWORTH,
NIAGARA FALLS, 1986
(THIS PAGE)

74. ROBERT DAWSON
DELTA FARM, SACRAMENTO
RIVER, CALIFORNIA (FROM
THE GREAT CENTRAL
VALLEY PROJECT), 1984

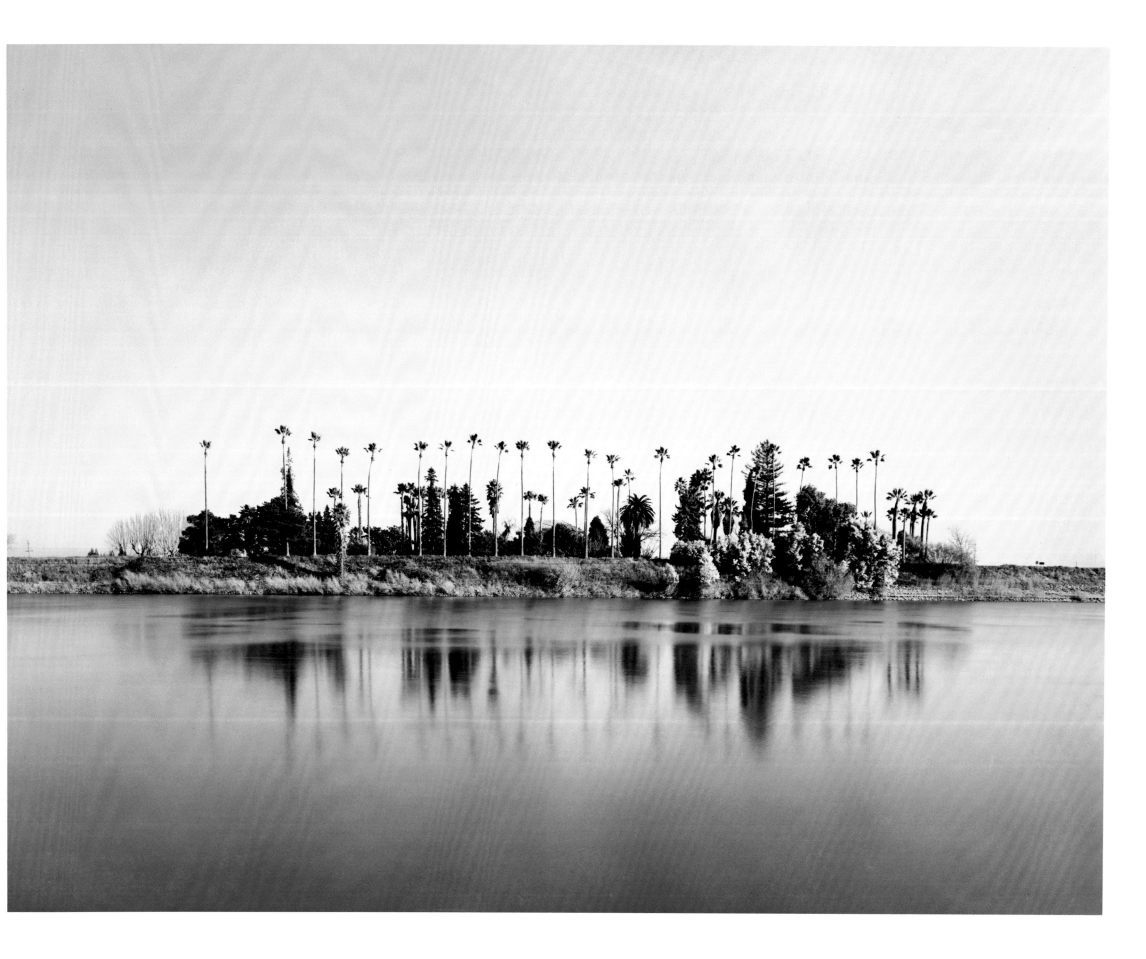

**75. KAREN HALVERSON**
DEATH VALLEY, CALIFORNIA, 1987

# not there but here

## karal ann marling

Landscapes are suburban affairs at heart. Whether painted in oils, in the manner of an Old Master, or framed and bathed in a golden patina by an eighteenth-century "Claude glass" (an optical viewing device), or photographed with glass plates laboriously hauled up the leeward flank of the Rockies in the nineteenth century, landscapes are always edited versions of scenery that define a mediating zone between the city and the wild green yonder. That middle distance, where civilization meets and mingles with the natural realm, is also the American frontier—the historical site where the ax-blade edge of progress once confronted the primal forest, the mythic place in which bad men in black Stetsons still square off against struggling communities of preachers, farmers, and busty schoolmarms in Hollywood classics on the VCR (fig. 1). It is, in modern-day reality, a place of manicured lawns and meandering culs-de-sac, power mowers and power lines, patio furniture, golf courses, mailboxes, and Aerostar vans.

It—landscape-frontier-suburb—is an aesthetic construct, balancing the verticals and horizontals of the city and its technology against the subtler symmetries of nature and the barely contained chaos of crab grass and tree limbs felled by thunderstorms. The landscape is inherently suburban, a Walden Pond, as much Concord and the railroad cut as trackless wilderness: faced with the sheer, alien inhumanity of Mount Katahdin, even Thoreau trembled and gibbered ("*Who* are we? *where* are we?") and went back to his bean-rows, laid out according to the linear logic of all such things—gardens, fences, telephone poles, superhighways that point at Mount Katahdin, Yellowstone, or Monument Valley.

The suburbs as we know them—the two-income, ranch-house and split-level suburbia of barbecues and PTAs, to which Lucy Ricardo loudly aspired—are components of a prosperous post-war sensibility that includes *I Love Lucy*, big family cars, and two-week family vacations (fig. 2). The picture windows of the 1950s framed the view of nature, translating mosquito attacks, sunburn, and scraggly rows of saplings into something

contemplative, indoorsy, and comfortable, like the "brush-stroke original" of a mountain lake hanging over the sectional sofa. And the TV screen framed views of distant places. No need for a long drive, a late-night scramble for a motel room. Monument Valley and Death Valley, Mount Katahdin, the Grand Canyon, and the Mississippi in full flood came indoors courtesy of the networks, tame and handsome as they glowed from the thirteen-inch RCA console in the corner of the family room. Nature was transformed into spectacle, entertainment, something beautiful and different, but not so alien as to be forbidding. Seen from the vantage point of one's favorite chair, the rocks and weeds and sunsets over waterfalls enclosed in the Formica wood grain cabinet of the television set were instantly domesticated: wilderness with commercials was really nothing more than a souped-up version of the asphalt, lawns, and backyard pools composed by the picture window.

Walt Disney replicated this arm's-length approach to nature, this middle-class landscape of the middle distance, at Disneyland, opened in suburban Orange County, California, in 1955. Divided into a series of Amazon jungles, Western deserts, and broad prairie rivers manufactured with bulldozers, plastics, and electronic gizmos (the artificial Alpine peak with the steel innards came later!), the theme park let the tourist move from one picturesque environment to another—from Adventureland to Frontierland to the Rivers of America—with the ease of flipping the channels on the TV set. Kodak even marked out the best spots for taking snapshots, places where the viewfinder was sure to miss the trash cans and pay phones that might give the game away. In family pictures taken at Disneyland, exotic nature was as neatly arranged, as orderly, as knowable and nice, as any machine-tamed garden in Levittown. Disneyland looked like a postcard or a TV travelogue, and it made its visitors feel as though they were back home in the middle distance, cozy and happy, between the picture window and the big, new black-and-white set.

The artificial landscapes of Anaheim were fabricated specifically for visual perusal: seen from little boats or trains, the scenic locale is background, other, out there, over there—something to be understood by being looked at, experienced primarily by sight, TV-wise. Adventureland is a landscape painting rendered in 3-D, an updated Cole or Bierstadt, redolent of built-in meaning. To the Transcendentalist and the westering romantic

of pre-Disney times, nature was sublime; places rendered sacred by their breathtaking size, their geological freakishness, by marks of vast power and endless time had lessons to teach humankind about humility, hope, and the shape of nature's plan. On the precipice of Niagara, in the remoteness of Yosemite, to see was to learn the features of the face of God. The presence of the deity, however, is harder to discern aboard the Jungle Cruise ride. At Disneyland, the foreground of the picture—landscape painters used to give us tiny figures to gauge the scale and show us how to act in outdoor shrines—is full of you and me, of switches and gadgets. The cleverness of the illusion fills the foreground up: what lies beyond, framed in the viewfinder, is the end result of gadgetry. The plastic jungle is a kind of technological sublime, a backyard mini-marvel on a par with Astroturf and baseball-size tomatoes raised on plant food— man-made, suburbanized.

The spectrum of landscape-as-view runs from Disneyland, at one extreme of artifice, to the national parks, at the other. Yellowstone and Yosemite, after all, are real. The sun *does* set in crimson glory over majestic peaks. The geysers belch and plop according to a timetable never encoded on a microchip. But scenic wonders are set off from mere scenery by designated overlooks encased in rusticated stone and by parking lots that open onto rustic fenceposts, parapets, and vistas. On the road, in the middle distance of the tourist, banality—the litter baskets and the traffic cones—comes face to face with sublimity. The near of smells, heat, and elbow-rubbing propinquity abuts the far of vision. And what does that farness, that formal place beyond the parapet, mean? What does the picture mean, so beautiful, so remote, so perfectly unlike the guardrail, the chewing gum, the steamy car? The leap of sympathy required to vault the gap between nature and the culture of the summer vacation makes a motorcycle jump across the Grand Canyon seem an easy matter. Culture frames the wild vista but keeps us out, out here, in the parking lot, with lines ruled on the blistering pavement and stone laid up just so to mark the overlook. Take a picture. Prove you've been here. Not there but here. *Here* is where the car is. *There* is really no place at all. It's just a picture hung upon the edge of space, a boundary marker between suburbia and chaos. It is nothingness.

Suburbs invented pretty pastel colors to sort the driveways out: the Joneses belonged in the pink house and the Smiths in

FIG. 1. MONUMENT VALLEY, FROM JOHN FORD'S *STAGECOACH*, 1939.

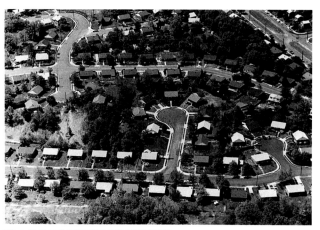

FIG. 2. SUBURBAN HOUSES AND DRIVEWAYS.

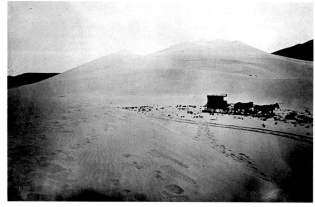

FIG. 3. TIMOTHY O'SULLIVAN, *SAND DUNES, CARSON DESERT, NEVADA*, 1868.

the asteroid blue one, and their vacation pictures were in color, too. Disneyland exists in Kodachrome. But landscape as an art form sometimes comes in black and white, like old TV sets used to do, back when suburbia was new. The pictures taken by the survey photographers of the 1860s and 1870s seem exceptional, rational, and worthy of special notice in an age of color because they are so matter-of-factly devoid of crimson sunsets. They carry an unpolemical conviction missing from the glossy color calendars, whereby defenders of the wilderness attempt to seduce us into a love of trees with sentiment and tonal charm. But there is something seductive, all the same, in Timothy O'Sullivan's footprints and his wagon, in William Henry Jackson's habitable foregrounds, strewn with hand-size stones: despite the absence of blues, reds, and pinks, theirs is a natural environment that tolerates the human presence (fig. 3). It welcomes those who would measure and blast, those who would photograph the scene in black and white. A true frontier, part here, part there, it gives them room to stand atop a lump of scenery (So-and-so's Knob? Skull Rock?) and admire a railroad cut.

In Ansel Adams's corpus of western views, his 1958 study of Monument Valley is an anomaly because the photographer is visible in the image in the form of a shadow, looming godlike over the desert floor, as mysterious and inscrutable as the mesas and buttes of that totemic landscape (fig. 4). But the classic Adams shot of the 1940s and 1950s virtually excises the foreground and, with it, any sense of connection between viewer and what is being scrutinized, between American and scenic America. The metaphoric hiker has no starting point toward the distant crag, no place to stand and marvel and plot a course. With planar barriers of shadow and foliage, Adams makes it clear that crag and waterfall are sublime by virtue of their remoteness from humankind. By carrying the concept of the framed view to an extreme of formal beauty, he also pushes the question of meaning to its limits. What is there to be gained from an encounter with a mountain so oblivious of me? And if nature is black and white, perfect, indifferent to my puny scrutiny, unwilling to make its peace with me, then—damn it—the mountain can deal with my railroads, my blasting and clear-cutting, the wrapper from my candy bar.

In megagorgeous nature shots, the scorn for those excluded from the frame—the unheroic tourist in a station wagon—is almost palpable, a prelude to the eco-snobbery that would keep us out of the national parks and forests with our polluting RVs, the non-biodegradable, plasticized detritus of a culture of malls and 7-11s. Even if we come just to look across the designated parapets, to stay between the painted lines and do no harm, even if we police our Styrofoam, there are too many of us: the raucous democracy of cars and vacations means an end to the solitude of the wilderness. The middle distance is a crowded place, full of the racket of settlers' axes, power mowers, and mufflers gone bad. But the landscape is supposed to be as still as a cathedral, profoundly empty, made for meditation. Everything that errant tourism is not. Everything that we are not. "Eastward I go only by force," wrote Henry David Thoreau as the railroad whistle echoed across his Massachusetts pond, "but westward I go free.... Wildness is the preservation of the world."

Civilization and nature are incompatible. Although the machine belongs in the garden nowadays—chuffing and whining, making furrows set at calibrated angles to the fence line—clamorous apparatus ought not invade the wilderness. Back from war-torn Europe, Hemingway's Nick Adams has to jump down from the train and put the burned-out town along the tracks behind him to find the healing quiet of the Big Two-Hearted River. Sinclair Lewis sends his babbling, gadget-loving hero to the woods, where silence "freed him from the pomposities of being Mr. George F. Babbitt of Zenith." In the epic cowboy movie Shane, Alan Ladd gets his fill of guns and rawboned towns, of farms and shy flirtation with the farmer's wife, and as the credits roll, rides back into the fastness of the Grand Tetons above Jackson Hole, into the eerie quiet of an Ansel Adams view. The mythic hero, larger than ordinary life and purer, calmer, is at one with the noiseless, solitary hills of the West.

To Frederick Jackson Turner, the West—the historical frontier of the nineteenth century—had shaped the fundamental institutions of American democracy with the promise of fresh starts and the imperatives of innovation and independence. But even as Turner described the process in 1893, census figures suggested that the age of westering was over, that the frontier no longer existed except, perhaps, in the memories of the cowboys who ranched the Dakota Territory with Teddy Roosevelt in the 1880s or in the imaginations of cowboy writers, like Owen Wister, who made memory into legend at the turning of the century. When Shane heads for the sunset hills in 1953, he rides off into a powerful legend of the West embodied in the look of the landscape, its

changeless nullity and emptiness. Out there, in John Ford's Monument Valley, the cowboy hero of the silver screen takes his definition from the scenery—taciturn, obdurate, alone.

When Norman Mailer first sees the sprawling vacuity of the Space Center at Cape Canaveral, he conjures up the broad vistas of the old cowboy movies and wonders "if the Twentieth Century had become the domain of all the great and empty territories," if bombs and rockets by their awful power demand a setting calibrated to the scale of lonely spaces in the West. Watching the tourists in their vans and minibuses come to see a moonshot, Mailer remembers Wild West movies and the meaning of the landscape. "[A]fter a hundred years and more of a tradition that the frontier was open and would never close," he writes, with the polyvinyl stench of the campers' blow-up air mattresses still in his nostrils, "and after twenty more perplexing technological years when prosperity came to nearly every White pocket, and technology put out its plastic, its superhighways, its supermarkets, its appliances, its suburbs, its smog, and its intimation that the frontier was damn shut ... America had erupted from this pressure between its love of adventure and its fear that adventure was not completely shut down; America had spewed out on the road."

A paradox, then: the meaning of America, the crimson sunset that beckoned the pioneer on, over the next hill west—that loneliness, that resonant silence of the wild—was to be sought n noisy parking lots and crowded parapets that framed a far-off place as alien as the pockmarked surface of the moon in NASA telecasts from space (where a pre-stiffened flag laid claim to the last, windless frontier). A hundred years ago, the meaning of it all was plain enough. God. America. Manifest Destiny. The transcontinental railroad. The gold of California. The landscape had moral lessons to teach about self-reliance and perseverance, scientific lessons about time, process, and precision. The language of a John Wesley Powell counted by accumulation every rock and canyon on the Colorado River. The language of a Clarence King mimicked the risings and fallings, the fracturing, the fire that shaped the Sierra Nevada over eons of history. America had no history, no ruins, no antiquity. But there was a West of canyons, glaciers, ancient ice. The landscape became history, the spawning ground of myth. Heaven, perhaps. The paradise where all true cowboys went when they rode off into the sunset. A shining El Dorado at the end of the open road. A

glint of adventure on the horizon, framed by the windshield, out there in the distance where the edges of the highway finally met. F. Scott Fitzgerald's magic, mythic spot of green, aglimmer "in that vast obscurity beyond the city, where the dark fields of the republic rolled on under the night."

Seen from a distance, in the manner of a painted landscape, the city's manmade buttes and canyons are as enigmatic as natural forms: the metropolis is Monument Valley in concrete. And the "monuments" of Monument Valley are monoliths rising straight and true from the desert floor like buildings reared by spacemen besotted with the principles of earthly architecture. They hint, these places, at some elusive bond between forms carved out by wind and water and those fashioned by human artifice and sweat, between the logic that builds urban monuments too large and cold for the good of the spirit and the alogical workings of a universe that duplicates them in the still emptiness to warm the soul.

The park abuts these inimical, these oddly kindred landscapes—the city and the wilderness—but never reconciles them, never finds the middle distance. In the confines of urban parks, rocks and trees come much too close to city life for comfort. Urban predators hide in the concealing immediacy of leaf and branch that obscures the distant view prized in landscapes of a mythic cast. Without the vanishing point, there is no focus for the imagination, no spot of green where liberating romance takes its rise. Without the distant view, adventure turns to claustrophobic terror. In the national parks, one's fellow tourists press in on every side, concealing the genuine perils of rock and gorge. Paths, steps, and overlooks create a theme park out of real-life nature; sheer conviviality—follow-the-leader fun—drags the eye away from the lonesome, beckoning sunset. Without the distant view, adventure dies. What remains is everyday, business as usual. In both instances, nature is denatured, diminished as much by "wilding" rapists in Central Park as by kindly retirees in shiny Airstreams camped on the rim of the Grand Canyon. Nature is extravagantly admired but at the same time rendered lethal, too, by all the parapeting and planting, as if the naked sight of it alone could kill. The nuclear test sites of the West, with their chain-link fences and their warning signs, look just like parks and that, somehow, is no surprise at all.

In the great suburban short story "The Swimmer," John Cheever's protagonist decides to splash his way home from a

Sunday afternoon cocktail party, via a chain of backyard pools scattered across eight miles of Connecticut's Bullet Park. On his mental map of the county, Neddy Merrill sees a "Lucinda River" (named for his wife—the wife of that stream's first explorer) meandering from headwaters at the pools of the Westerhazys, the Grahams, and the Lears toward the Merrills' house between banks of concrete and tile, past landmarks comprised of lawn furniture and gazebos. He sees himself as a legendary figure, a trailblazer, a bold adventurer. But the Lucinda River's discontinuities—reflected in Neddy's long portages over highways and through assorted cocktail hours—hint at the shattering of his consciousness: all unwitting, he arrives at an empty house that has been sold to pay his debts. The tragedy of the exhausted Neddy Merrill is the tragedy of parks, where water flows as it is told and nature never measures up to mental maps. If American heroes take on their luster from the grandeur of the natural setting they inhabit, Neddy is subtly diminished by his concrete river of chlorine blue. Thoreau, Ishmael, Huck Finn: the hero leaves civilization behind and withdraws to nature in search of salvation. Neddy Merrill cannot escape the world of concrete; his make-believe river flows straight into madness. Bullet Park has swallowed nature whole and spit it out as swimming pools rimmed with barbered hedges.

Like life itself, American literature used to offer a choice between conquering the West and finding solace there, between Zane Grey's high-minded engineers, testing themselves and their technology in the wilderness, and a John Muir, discovering the "Majesty of the Inanimate" in the high mountains of California, where "nature's poems [are] carved on tablets of stone." Neddy Merrill fails the crucial test of character: he has done so before the story even begins and all his aquatic flailings cannot change the outcome. And in the end, he discovers nothing. The reader learns that he has lost his house but nature has left no fulsome notes of explanation for Neddy, no map, no fixed star to guide his way back home. In the park, nature has already been conquered, its texts reworded, paraphrased. In Bullet Park, it lingers on as memory or myth, a swimming pool afloat in a green suburban lawn. Or the dead Jay Gatsby floating face-up in his Long Island pool, looking sightlessly "at an unfamiliar sky through frightening leaves."

In the picture of Gatsby staring up through a canopy of "frightening leaves," Fitzgerald taps a strain of ecophobia deeply embedded in the national memory. To Puritan America, nature was fearsome, a howling wilderness full of savages, a hateful thing. O. E. Rolvaag's pioneers, making the long wagon trek into the "Sunset Land" of the Dakotas, are driven to the brink of panic by the sudden storms, the utter silence of the prairie, the old Indian burial ground on the edge of their homestead plot. The arrowheads point up the contradiction between the lore of the virgin land—empty, ownerless, devoid of any past and ripe for exploitation—and the undeniable presence of the Native American. Haunted by petroglyphs and arrowheads, every homestead west of Gatsby's pool has been carved out of equal parts of prairie, fear, and guilt. This sense of guilty trespass lends an eerie resonance to the filmic suburbs of the 1970s and 1980s. Steven Spielberg's placid subdivisions yawn peevishly over an abyss of pain. In Tobe Hooper's *Poltergeist* (1982), the source of the unease is specified at last: America's air-conditioned, wall-to-wall, split-level Nirvana has been built upon the weary bones of those who farmed and hunted there. And swimming pools crack open like the jaws of Hell when history rises from the grave to exact its just revenge.

Suburbia means a fixed abode, a home, concern for mortgages, gutters, the proper pruning of ornamental shrubs, and measuring out the chemicals for the pool. Suburbia hates and fears wild nature: storms and snowdrifts, ice that knocks down power lines, moles beneath the lawn. But more than that, suburban houseproud tidiness wars against the wild disorder of nature in the raw and the wandering, erratic lives of those who roam its secret trails. Dan'l Boone never made a mortgage payment and Davy Crockett didn't have a balky septic tank. The pastoral mode of Bullet Park nonetheless demands some little knowledge of such primitives and of the opposite extreme, the slick sophistication of the city.

The winding cul-de-sac stands midway between a busy shopping street ruled on a grid and a twisted path faintly worn in the grass by scampering fawns. The split-level colonial mediates between the skyscraper and the tepee (or the trailer). The lawn with pool has just enough concrete and subterranean plumbing to gesture toward some vacant urban plaza-with-fountain in downtown L.A., and just enough mosquitoes and unruly dandelions to conjure up the mountain meadow and the spring-fed lake that decorate the pages of the L.L. Bean catalogue. Suburbia is

precisely halfway by car between the office, a suit, a filofax and some semi-scary, green and leafy place where phones have never rung. But the driveway always points west and any lawn in America is only a tank of gas away from freedom. As Cheever and Fitzgerald understood, the modern quest begins and ends at poolside, by the shining waters of forgetfulness, yearning, and myth.

Standing on the cement levee of the Mississippi at St. Louis in the early 1950s, Jack Kerouac "watched the logs that came floating down from Montana in the north—grand Odyssean logs of our continental dream." Kerouac was out on the road, questing by Cadillac, by bus and truck, looking for himself and what the dream might mean. "So in America when the sun goes down and I sit ... watching the long, long skies over New Jersey and sense all that raw land that rolls in one huge bulge over to the West Coast, and all that road going, all the people dreaming in the immensity of it," he writes, the dreaming and the land amount to pretty much the same thing. Roseate vision and stubborn fact. The Mississippi and the swimming pool. The place that glows in the imagination—and mile after dusty motel-littered mile along the shoulder of the interstate. The dream and the land. Clouds of glory over pools of acid rain. Landscape and dirt. Monument Valley, Disneyland, Yosemite: our own backyards.

Contemporary filmmakers lean toward the mythic side of the equation. In *Paris, Texas* (1984), Harry Dean Stanton plays a post-modern Shane who materializes on screen, striding out of Monument Valley as the credits end, like some down-at-the-heels *deus ex natura* destined to transform the world of lesser mortals. But to do so—and to find his wife and son—the hero must sink down into the Hades of denatured America, where freeways flow instead of rivers. Here, John Ford's Wild West survives as a neon sign for the Rancho Motel, the cowboys all drive pickups with fancy boots-and-saddles names, and land is a parched square of backyard patio in a smoggy suburb of L.A. In *Thelma and Louise* (1991), the movement is reversed. The title characters begin in the suburbs, the truckstops, and the honky-tonks and, casting off the rule of law and custom along the way, end up in the wasteland, purified and free, as they drive their green convertible off the rim of the Grand Canyon, into legend-land. The wide screen was made for Westerns with a mystic, mythic twist: mirroring the line of

the horizon, it makes the far edge of reality into a protagonist, a character to which some vast and cosmic peace clings like a shroud, a set that fixes the attention on tomorrow, up ahead. By contrast, the spindly verticals of manmade things insist, intrude. They violate the calm, flat spread of space. Civilization indicts itself by looking bad. Culture clanks and chatters, too, while nature lies there quietly, in luscious Technicolor, speaking esoteric volumes by saying not a word.

Yet, despite the hocus-pocus, the quests and the redemptions, Monument Valley and the Grand Canyon, civilization has won out in our America. The movie myths are just that—stories to explain how we came to be the way we are (or how we wish it had all turned out). Not sober accounts of how things are in the natural world. The moviemakers may be the last, legitimate heirs of Albert Bierstadt, pumping nineteenth-century sublimity into locations chosen for their second-hand grandeur. Painter Edward Hopper used the detritus of suburbia to puncture the inflated claims of landscape art in 1957, with his *Western Motel* (fig. 5). A woman sits on an as-advertised-on-TV double bed in an anonymous room: at her right, two suitcases; at her left, outside the picture window, the car, the road, a swatch of western scenery. She is posing stiffly there, in the one spot from which woman and car, buttes and motel room come together for a tourist snapshot. The viewer is forced into the role of the missing husband (note that second suitcase!) with his camera, composing the ideal landscape of a vacation way out west, a picture proving she and he and you and I were there. Hopper's landscape is as generic as the room, a challenge to the false nobility of his predecessors' work. The room dominates and frames a sad, domesticated West, devoid of higher meaning but full of profit when the tourists stop to spend the night. A place that looks for all the world like the house with the picture window at the end of the driveway back home where the journey started.

In Hopper's painting, the car, the woman's dress, the picture window all help to fix the time: it is the 1950s of Roy and Dale and *Gunsmoke*. That niggling specificity undercuts the eternal grandeur of the standard landscape, in which a season or a time of day serves to highlight the timeless endurance of purple mountain majesties and show how meager are the works and pomps of those who come to gasp in wonderment. Conversely, the precise o'clocks of nature may also carry associations that

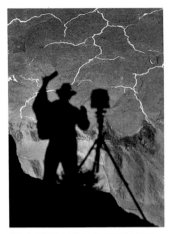

FIG. 4. ANSEL ADAMS, *SELF PORTRAIT, MONUMENT VALLEY, UTAH*, 1958.

FIG. 5. EDWARD HOPPER, *WESTERN MOTEL*, 1957. OIL ON CANVAS. 30 1/3 X 50 1/8 IN.

FIG. 6. DEVIL'S TOWER, FROM STEVEN SPIELBERG'S *CLOSE ENCOUNTERS OF THE THIRD KIND*, 1977.

blur the distinction between subjective emotion and observable fact. When a homocentric sunset stands for the pull of human dreams and the promise of tomorrow, the red-white-and-blue sky over Frederic Church's *Twilight in the Wilderness* (1860) becomes a divine warrant for Manifest Destiny and the national push toward the end of the continent.

Thomas Cole's *Voyage of Life* series (1839–40) equates the stages of human life with the transformation of the landscape over the cycle of seasons and the hours of the day, from a smiling spring morning—babyhood—to the gray winter twilight of old age. In Cole's pictorial sequence, entropy rules. People age and die, but so does nature: both must answer to a higher law of time and change. The snapshot taken in Hopper's motel room staves off age and change by stopping the bedside clock one late afternoon in the summer of 1957. Stalled by the power of art, the West outside the window will remain just as it is in *Gunsmoke* or the old John Ford picture playing on the Late Show—at least until the woman and her camera-toting husband get back in the car and set off once again on their vacation, their voyage of American life, and the landscape unravels mile by mile and hour by hour behind them, in the rear-view mirror.

Travel—movement through the landscape—is a kind of death; the thread of life plays itself out along the center line. When the railroad first blazed the route to the Pacific after the Civil War, sportsmen killed buffalo by the thousands from the open windows of their Pullman cars. But moving across plains and mountains, by whatever means, affirms life, too. It measures progress as the miles slip away behind the wagon, one by one: this much has been accomplished. We've come this far. The past is back there, with the dawn, and the future lies up ahead: movement locates pioneer and tourist on a fever-chart of optimism, headed toward infinity. The railroad tracks and superhighways straighten and smooth a path already rutted deep in the imagination, a vision of progress that would obliterate whatever stands between the traveler and the horizon. Mountains purple in the twilight gloom. Flowers. Mighty rivers. The nemesis of natural beauty, eternal and true, the highway reeks of dynamism, change, and progress. Gas stations. Fast food. Speed. The rush to get there, to be one's self transformed.

William Least Heat Moon advocates a slower form of tourism, on the back roads, the two-lane routes printed in a romantic shade

of blue on the maps. There it is still possible, he insists, to see the real tint of the twilight, unadulterated by the afterglow of neon branding irons and spurs. "[J]ust before dawn and a little after dusk," Moon promises, "the old roads return to the sky some of its color. Then, in truth, they carry a mysterious cast of blue, and it's that time when the pull of the blue highway is strongest, when the open road is a beckoning, a strangeness, a place where a man can lose himself." Lost in America, in the cool shadows of the twilight, the pilgrim is at one with nature. Things change more slowly in places the chain motels have not yet paved for parking; things just seem to crumble away, like old asphalt. No progress here. The slower we go down the blue highways, the faster does the burden of selfhood—the planning, the striving, the believing—fall away, until we are lost, lost to ourselves, to time and to our times, to places named on maps so we can find them, up ahead.

On road maps, the world is a conceptual place: red lines, blue lines, eighteen miles to the inch deployed across a pleated expanse of paper that molds itself to the lap in the heat, a vaguely bowl-shaped America, rising from horizon to horizon, with a center that hardly moves as the car creeps along, from dot to dot, over the creases. A dot is a town, a momentary blip in a flow of perception that occurs in two separate dimensions of near and far. Up close, gravel, route signs, and dead raccoons speed by so fast they are registered, not seen. But out beyond the windshield, at the distant rim of vision, nothing moves at all. There it lies, stunned by gravitation—prairie, butte, or farmer's field: the still, quiet end of the world. Beyond is nothing. Off the map. A place that always stays just out of reach, no matter the m.p.h.'s or the assurances of maps, like the heat mirage that shimmers on the center line up ahead, wherever the blue line wanders making patterns on the page. Plotted on a map, space is linear and rational, but the same quarter-section of geography framed by the windshield of a Cadillac is sculptural, mysterious, and inescapable. The distant edges curl up, catching car, tourist, map, and all in the palm of some ancient, cosmic hand. Going fast makes time stop along the road that always leads to the same place, the one just up ahead, that can't be seen over the curve of the horizon. The place you know must be there.

After days on the maps and off, looking at the edges, barely moving, we came, this summer, to such a place, to Devil's Tower, in eastern Wyoming, on the morning of the Fourth of July. On this same morning back in 1893, amid great patriotic fanfare, two local ranchers had rigged a ladder and made the first recorded ascent of the tall, straight, singular thrust of rock, to plant Old Glory up on top. It seemed right to have landed here on a blistering Fourth almost a century later. It might have seemed spooky, too—we didn't know the story of the climb—except that Devil's Tower is supposed to be the locus of peculiarities: its own striated shape, its proximity to the geographic center of the United States, and its symbolic role as the site of the harmonic convergence of the spheres in *Close Encounters of the Third Kind* (1977) make it hard to be surprised by anything that happens in the neighborhood (fig. 6). The Park Service calls the butte a "national monument" (the first of eighteen named by Theodore Roosevelt in 1906) as though alien beings actually had fashioned it like a giant statue and left admonitory inscriptions for Americans up on top, alongside the flag. In the movie, Richard Dreyfuss saw it in his dreams and then sculpted the formation in his suburban kitchen with dirt dug out of the front lawn, as the neighbors watched and wondered.

Devil's Tower insists on meaning something, on being a landscape, poised between Route 24 and eternity. So we took a Fourth of July picture, a picture that may or may not come out, what with all the dazzling light and inky shadows—a tall, looming something fringed with pines, a tourist family from Connecticut huffing up the trail and one from North Dakota sprinting down, happy in the sunshine. It's no great loss either way—the photograph, that is. For like all pictures, this one stopped short of the edges, where the laughter and the tower slipped over into memory, into anticipation, as we drove off into the summertime shimmer of the American Dream—toward home.

LIST OF WORKS CITED

Cheever, John. "The Swimmer." In *The Stories of John Cheever*. New York: Alfred A. Knopf, 1978.
Fitzgerald, F. Scott. *The Great Gatsby*. New York: Macmillan Co.,1981.
Hemingway, Ernest. "Big Two-Hearted River." In *The American Landscape: A Critical Anthology of Prose and Poetry*, edited by John Conron. New York: Oxford University Press, 1973.
Kerouac, Jack. *On the Road*. New York: New American Library, 1957.
Lewis, Sinclair. *Babbitt*. 1922. Reprint. New York: New American Library, 1961.
Mailer, Norman. *Of a Fire on the Moon*. New York: New American Library, 1971.
Moon, William Least Heat [William Trogdon]. *Blue Highways: A Journey into America*. Boston: Little, Brown & Co., 1982.
Muir, John. "The Mountains of California." 1894. Reprint, in *The Wilderness Reader*, edited by Frank Bergon. New York: New American Library, 1980.
Rolvaag, O. E. *Giants in the Earth*. 1927. Reprint. New York: Harper and Row, 1965.
Thoreau, Henry David. "Ktaadn." 1846. Reprint, in *The Wilderness Reader*.
———. "Walking." In *Looking Far West: The Search for the American West in History, Myth, and Literature*, edited by Frank Bergon and Zeese Papnikolas. New York: New American Library, 1978.

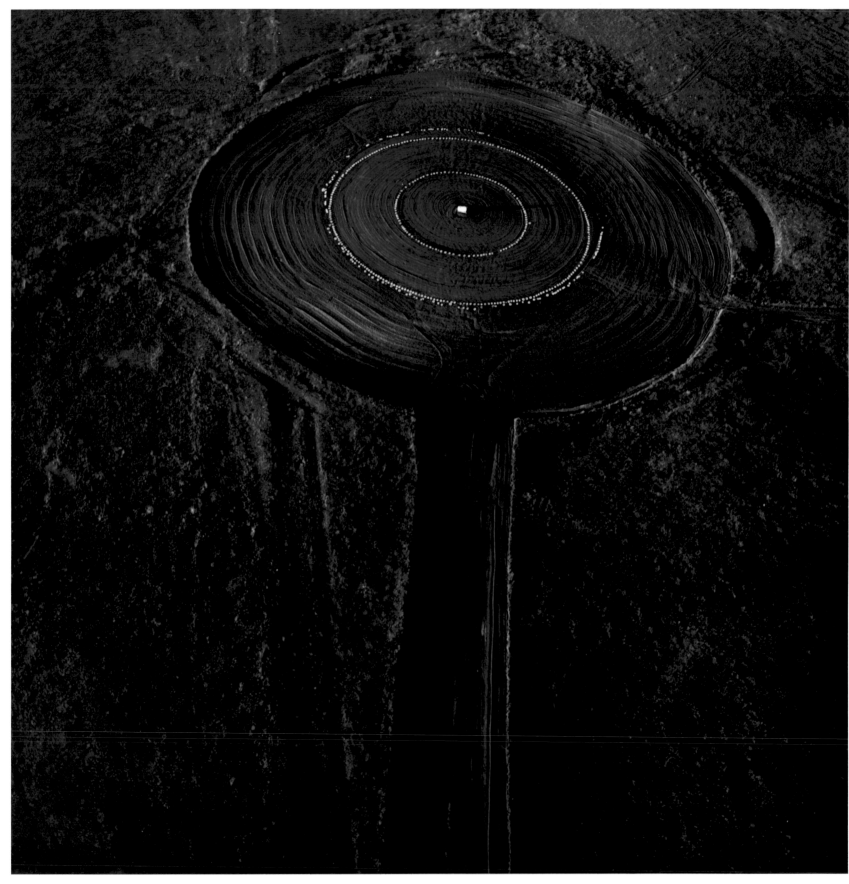

**76. TERRY EVANS**
SMOKY HILL BOMBING
RANGE TARGET,
TIRES, **1990**

**77. JIM STONE**
DESERT HOME:
FERGUSON LAKE,
AZ, **1988**
**(RIGHT)**

DESERT HOME: FERGUSON LAKE, ARIZONA

**78. PETER GOIN** DURING PRESIDENT CARTER'S
ADMINISTRATION, THE IMMIGRATION AND NATURALIZATION
SERVICE CONSTRUCTED AN "IMPENETRABLE" FENCE AT
SELECTED AREAS NEAR EL PASO, CALEXICO, AND SAN YSIDRO,
AMONG OTHERS. IT IS TWELVE FEET HIGH AND CONSTRUCTED
OF METAL WEBBING (MUCH LIKE CHAIN LINK) TOPPED WITH BARBED
CONCERTINA WIRE. IT IS CALLED THE TORTILLA CURTAIN AND
DOES LITTLE TO STEM THE FLOW OF ILLEGAL CROSSINGS
INTO THE UNITED STATES. THE METAL SECTIONS ALONG
THE FENCE WERE INSTALLED TO REPAIR HOLES.
MEXICO IS ON THE LEFT. **1985–87**

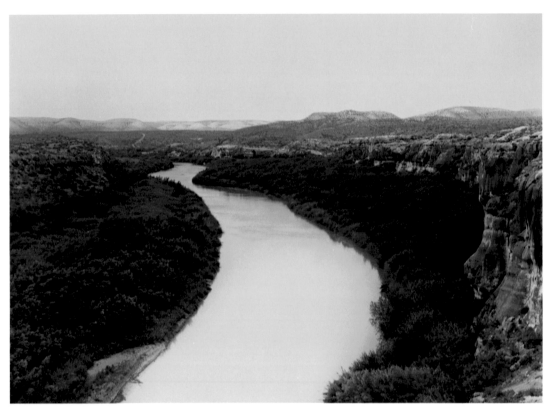

79. **PETER GOIN**
"BEST GENERAL VIEW"
OF RIO GRANDE RIVER
LOOKING WEST AT PUMP
CANYON. **1985–87**

80. **PETER GOIN** IN 1907, BY PROCLAMATION OF
PRESIDENT ROOSEVELT, ALL FEDERAL LANDS IN
CALIFORNIA, ARIZONA, AND NEW MEXICO WITHIN
60 FEET OF THE BORDER LINE WERE SET APART AS A
PUBLIC RESERVATION. ALTHOUGH THIS FRONTIER
IS OCCASIONALLY USURPED BY RANCHERS AND FARMERS
OR FOR URBAN DEVELOPMENT, IT REPRESENTS THE
FORMAL ESTABLISHMENT OF A "NO-MAN'S LAND" ALONG
THE ENTIRE LENGTH OF THE MEXICAN-AMERICAN BORDER.
IN PRINCIPLE, THIS ZONE PROVIDES EASY ACCESS FOR
MONUMENT MAINTENANCE; IN AREAS LIKE THIS NEAR
TECATE, IT ALSO PROVIDES A CONVENIENT AND
EXPANDED FIRE BREAK. THE VIEW IS LOOKING
EAST TOWARD MONUMENT NO. 244. **1985–87**

81. **PETER GOIN** THE AMISTAD RESERVOIR WAS CREATED BY MUTUAL INTERNATIONAL AGREEMENT, FLOODING A LARGE LAND AREA. THE ORIGINAL RIO GRANDE CHANNEL WAS PRESERVED AS THE PERMANENT BORDER LINE THROUGH THE RESERVOIR. BELOW THE AMISTAD DAM, THE WATER IS FREE OF SILT AND MUD AND IS EXCEPTIONALLY CLEAR. MOST OF THE PROPERTY IN THIS AREA IS USED FOR RECREATION, INCLUDING THIS SCREENED, RIVER-FRONT PICNIC AREA NEAR DEL RIO. **1985–87**

82. **PETER GOIN** ACCORDING TO TREATIES NEGOTIATED BETWEEN MEXICO AND THE UNITED STATES, SHARED WATERWAYS MUST MAINTAIN SPECIFIC WATER FLOW. INSTEAD OF LOSING WATER TO EVAPORATION AND SEEPAGE, HOSES MAY BE USED TO CARRY THE REQUIRED WATER ACROSS THE BORDER. THESE HOSES RUN THROUGH THE ALAMO ARROYO TOWARD THE RIO GRANDE NEAR FT. HANCOCK, EAST OF EL PASO AND CIUDAD JUAREZ. **1985–87**

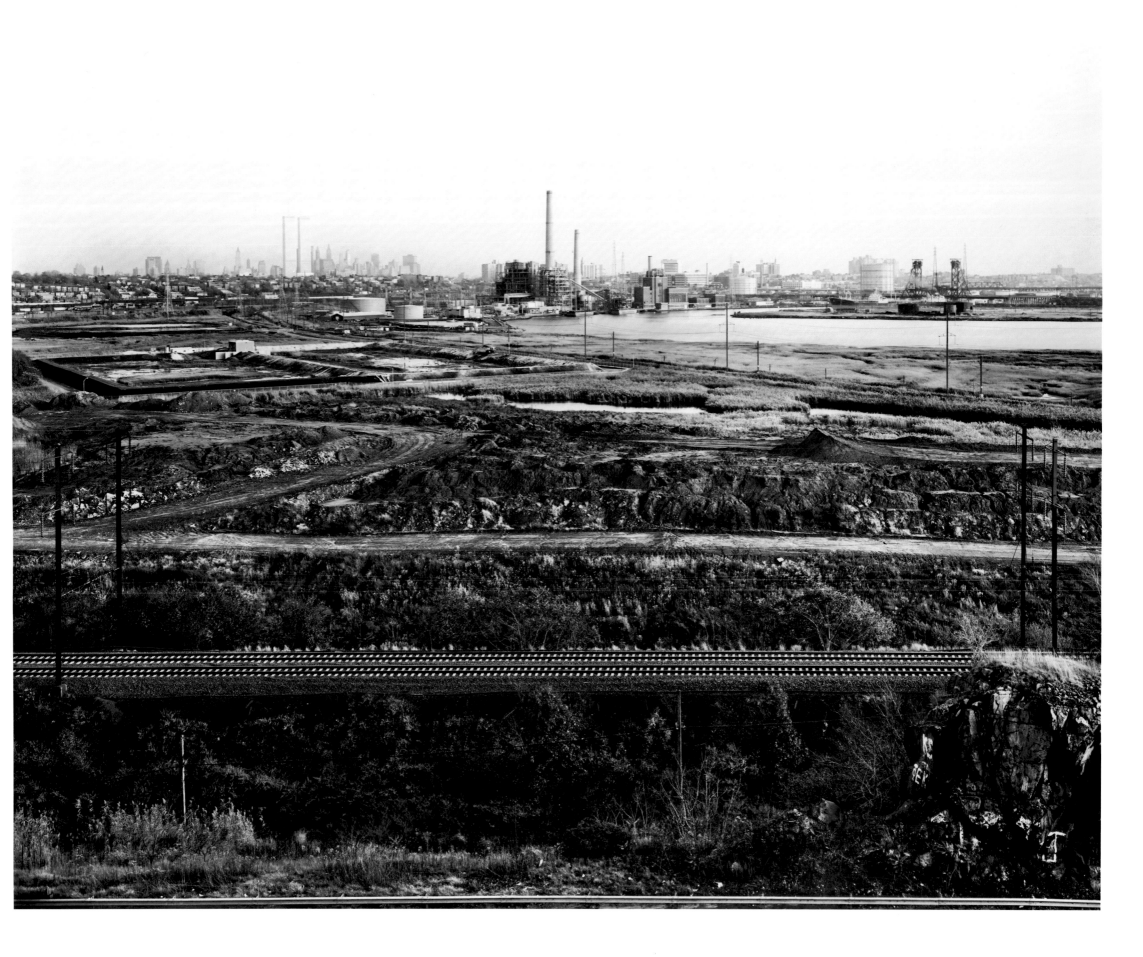

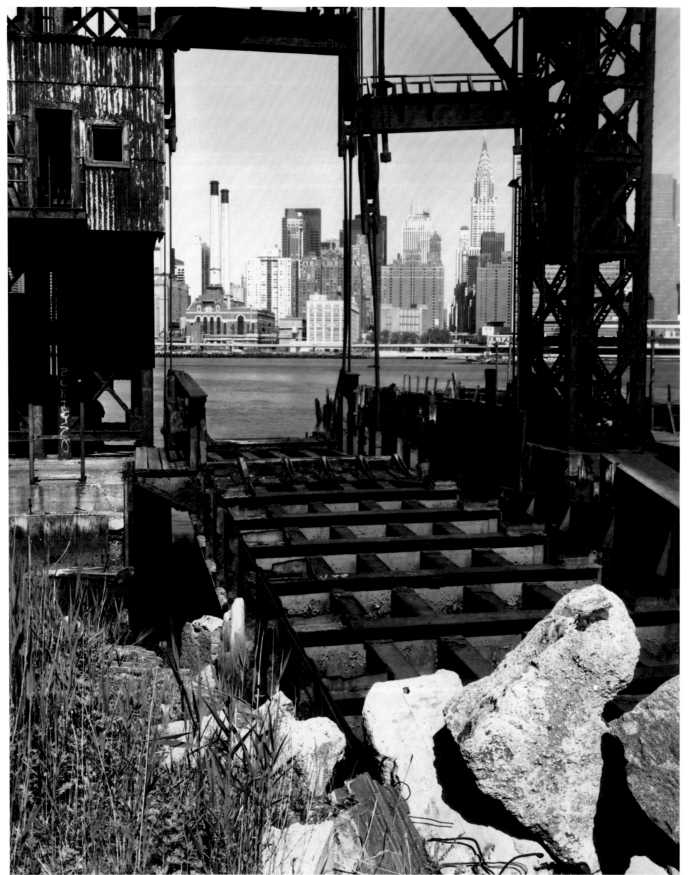

**84. MADOKA TAKAGI**
NORTH VIEW FROM MUNICIPAL
BUILDING, MANHATTAN
**(NEW YORK SERIES #145), 1990**

**85. MADOKA TAKAGI**
LONG ISLAND CITY, QUEENS
**(NEW YORK SERIES #90), 1990**

**86. ROGER MERTIN**
LIBERTY ISLAND; CENTENNIAL
OBSERVATION, OCTOBER 28, **1986**

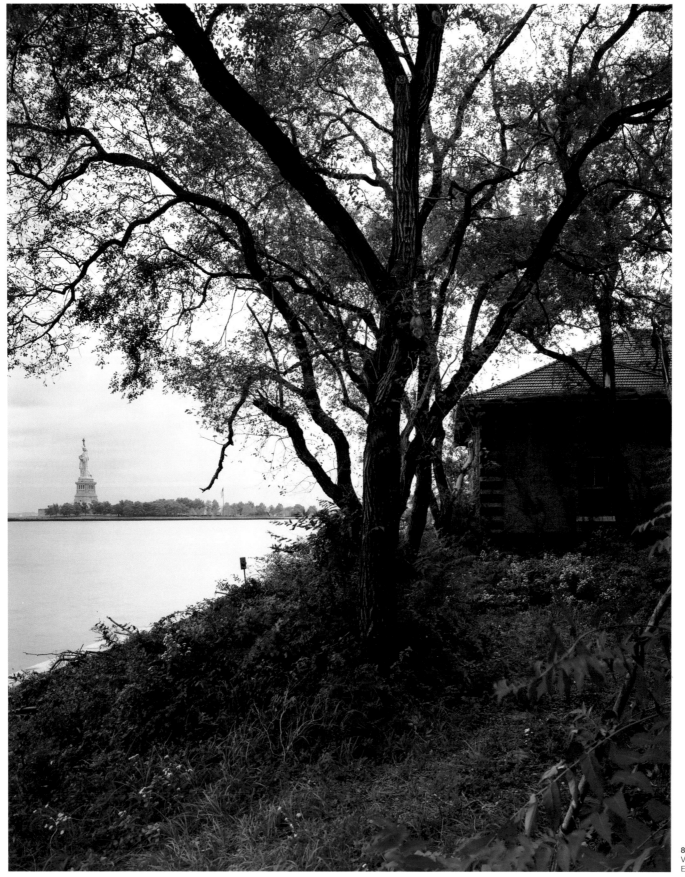

**87. ROGER MERTIN**
VIEW; LOOKING SOUTHWEST,
ELLIS ISLAND, #3, **1988**

**88. DEBORAH BRIGHT**
BLOODY LANE: BATTLE OF ANTIETAM
1983 **(FROM THE SERIES BATTLEFIELD**
**PANORAMAS), 1981–84**

**BLOODY LANE: Battle of Antietam (Maryland).
September 17, 1862. Duration: one day.**
View of the length of sunken farm road called Bloody Lane,
looking down the private drive to the Roulette Farm.
Confederate troops entrenched along Bloody Lane held off
repeated suicidal charges by Union forces from the hill
opposite where the lone monument was erected (left
background.) Later outflanked at the point where the
observation tower now stands (extreme right), the Southern
ranks were caught in a lethal enfilade. At day's end, so many
corpses clogged Bloody Lane that observers recalled
unanimously that a person could walk its entire length without
stepping on the ground. Still the United States' "bloodiest
day," the total casualties at Antietam numbered 41,000.
Photographed June, 1983.

**89. JOHN YANG**
SOMERSET HILLS
COUNTRY CLUB
GOLF COURSE, **1987**

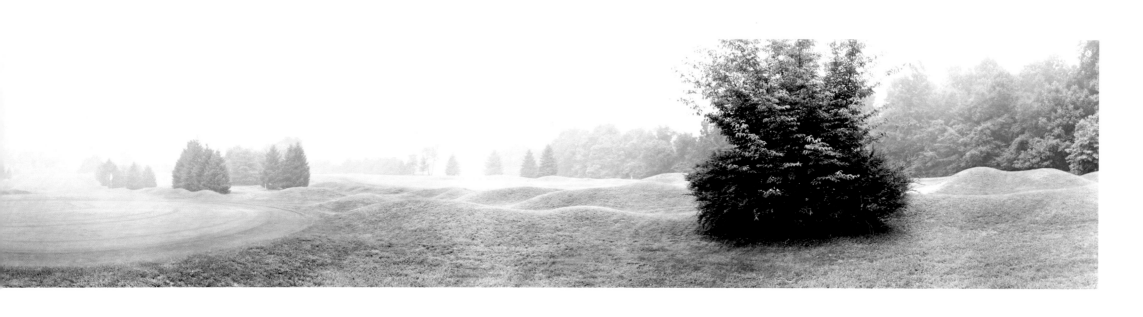

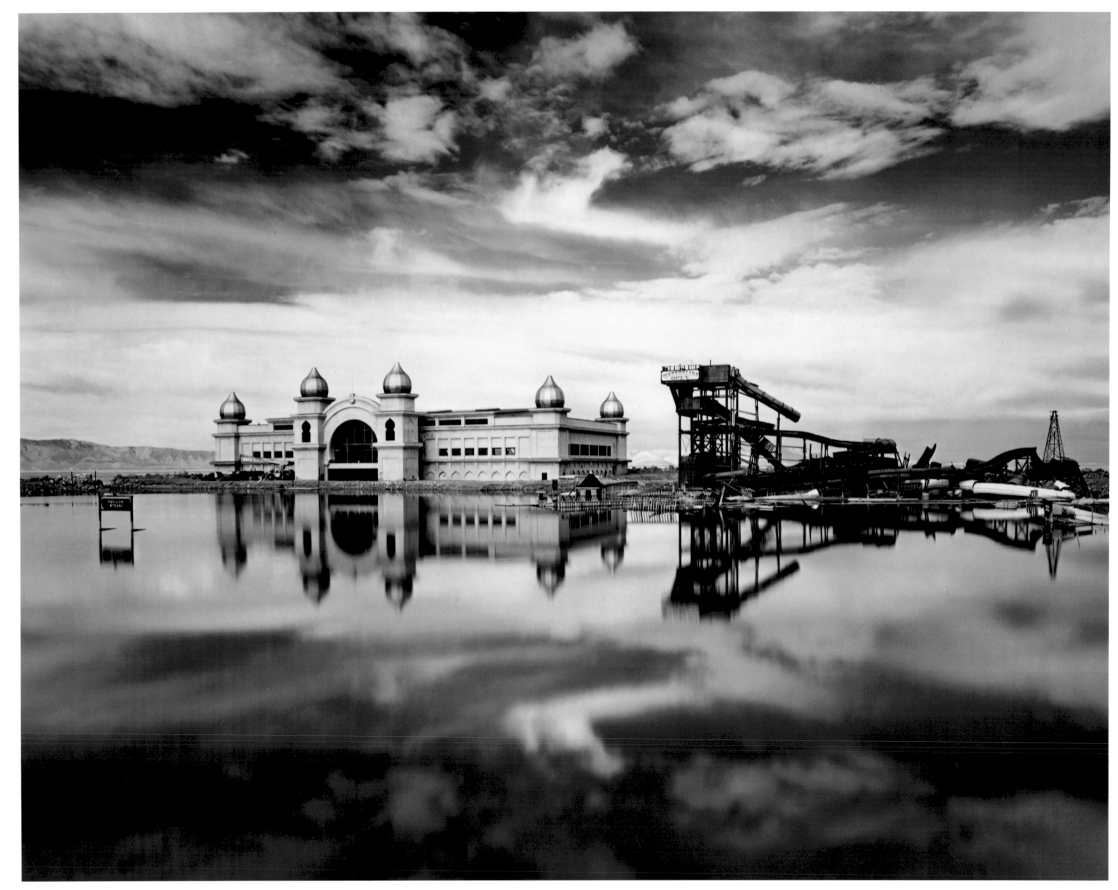

90. **ROBERT DAWSON**, FLOODED SALT AIR PAVILION, GREAT SALT LAKE, UTAH **(FROM THE WATER IN THE WEST PROJECT)**, 1985

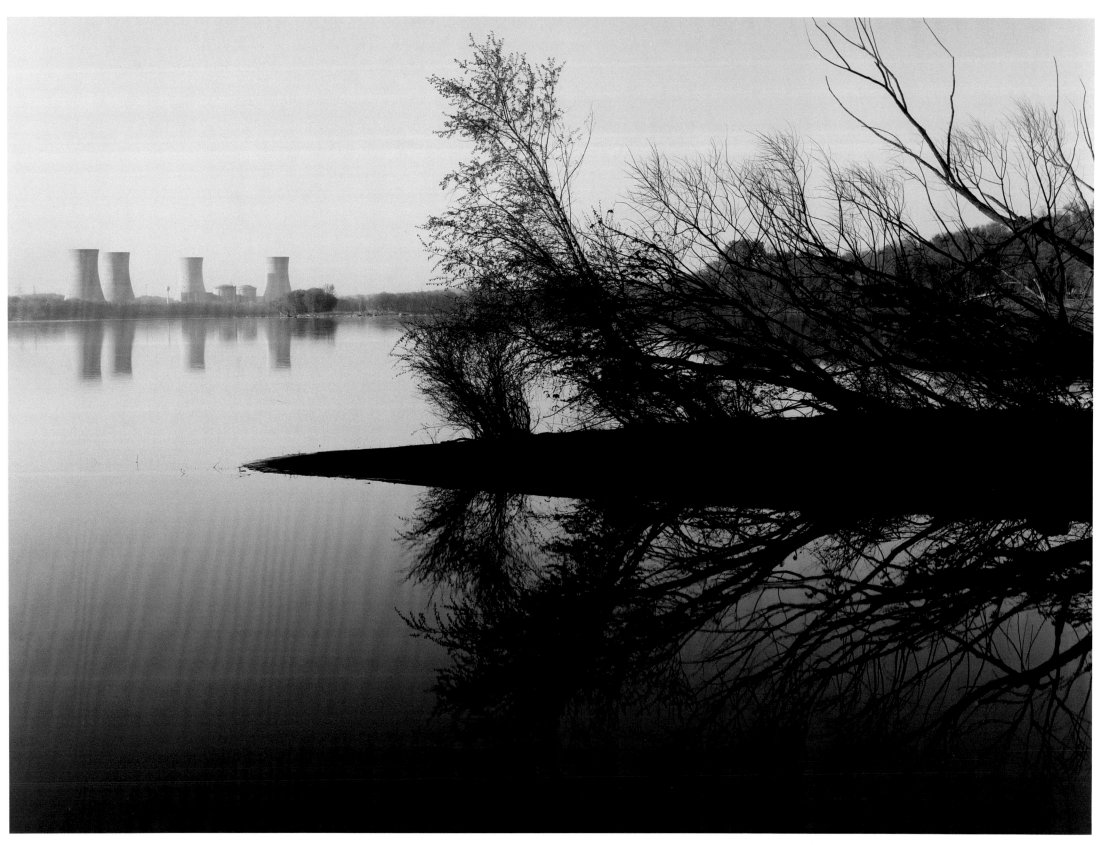

**91. JOHN PFAHL,** THREE MILE ISLAND NUCLEAR PLANT, SUSQUEHANNA RIVER, PA, **1982**

**92. KAREN HALVERSON**
HITE CROSSING,
LAKE POWELL,
UTAH, 1988

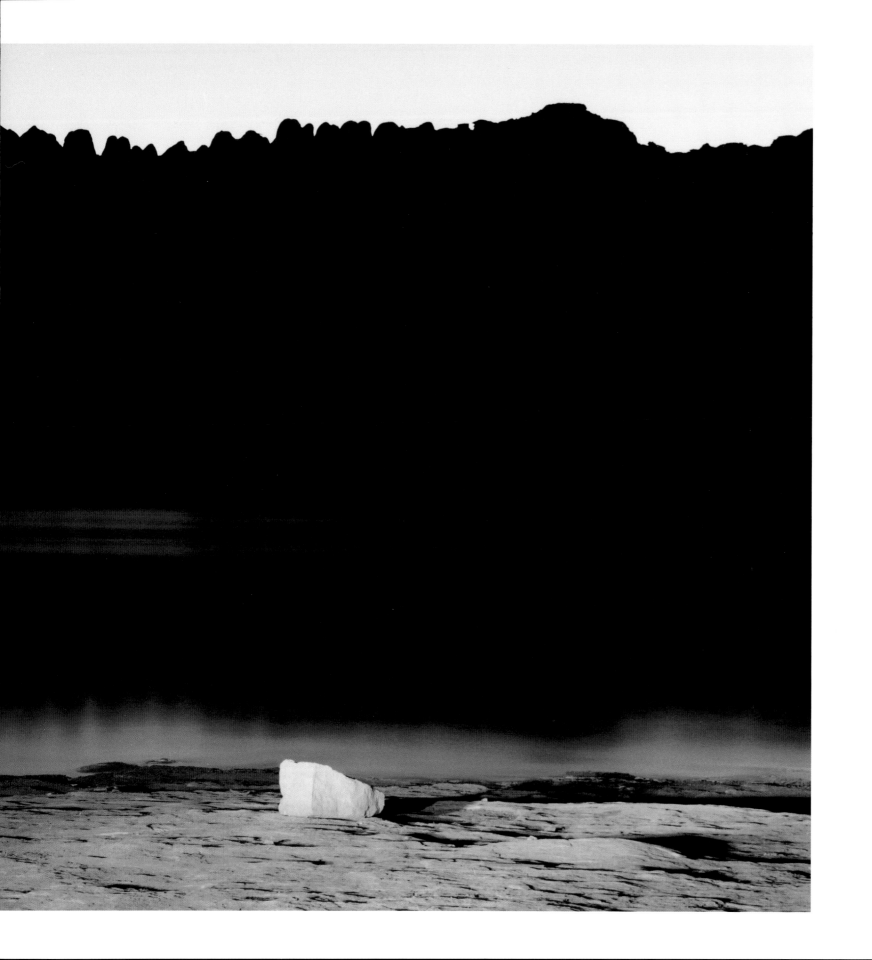

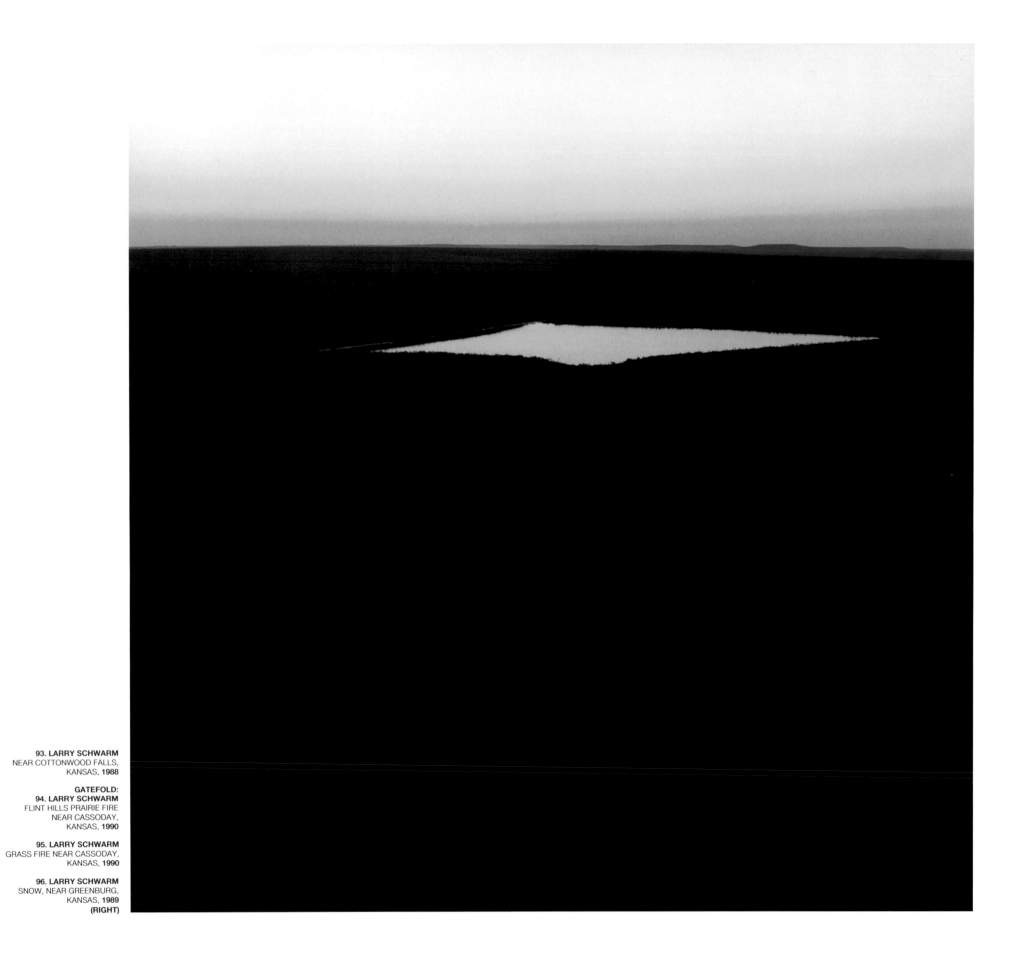

**93. LARRY SCHWARM**
NEAR COTTONWOOD FALLS,
KANSAS, **1988**

**GATEFOLD:**
**94. LARRY SCHWARM**
FLINT HILLS PRAIRIE FIRE
NEAR CASSODAY,
KANSAS, **1990**

**95. LARRY SCHWARM**
GRASS FIRE NEAR CASSODAY,
KANSAS, **1990**

**96. LARRY SCHWARM**
SNOW, NEAR GREENBURG,
KANSAS, **1989**
**(RIGHT)**

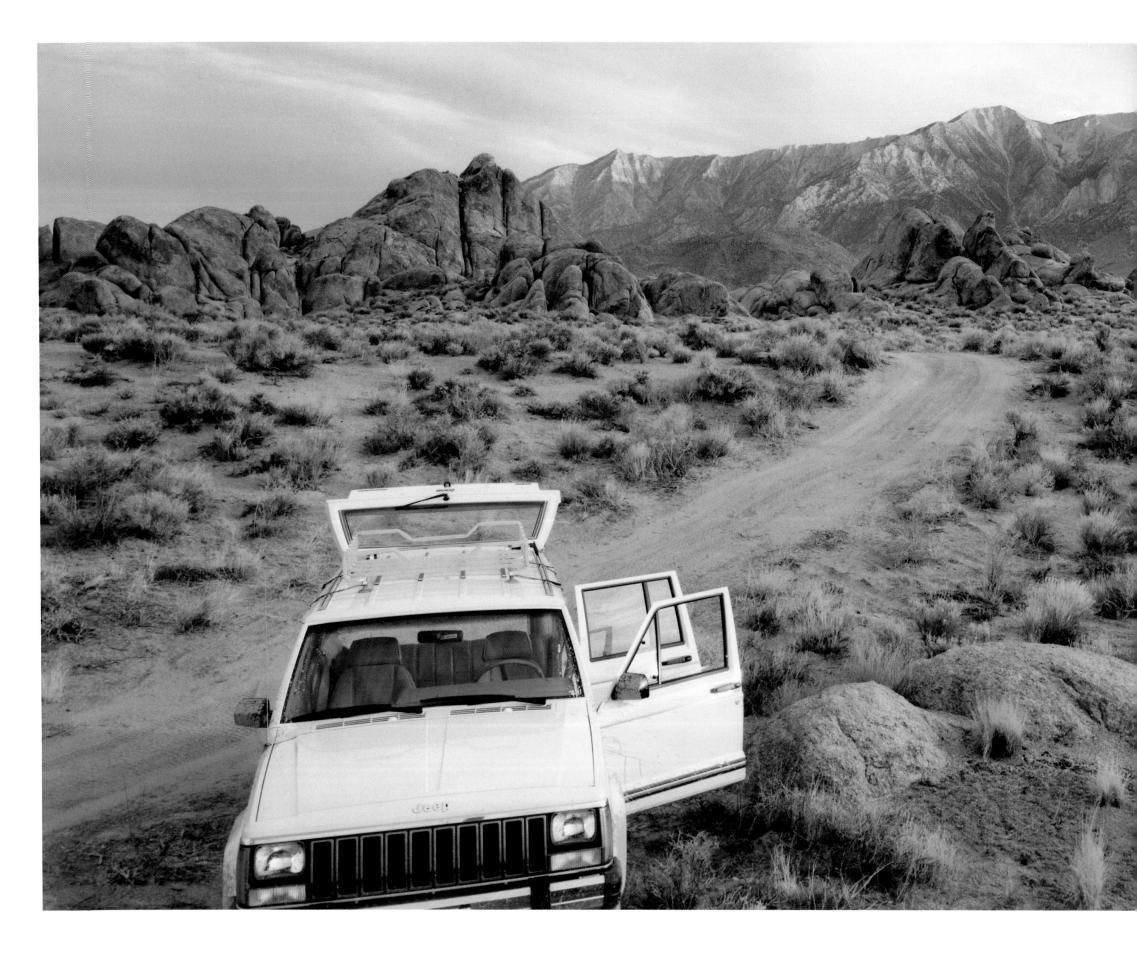

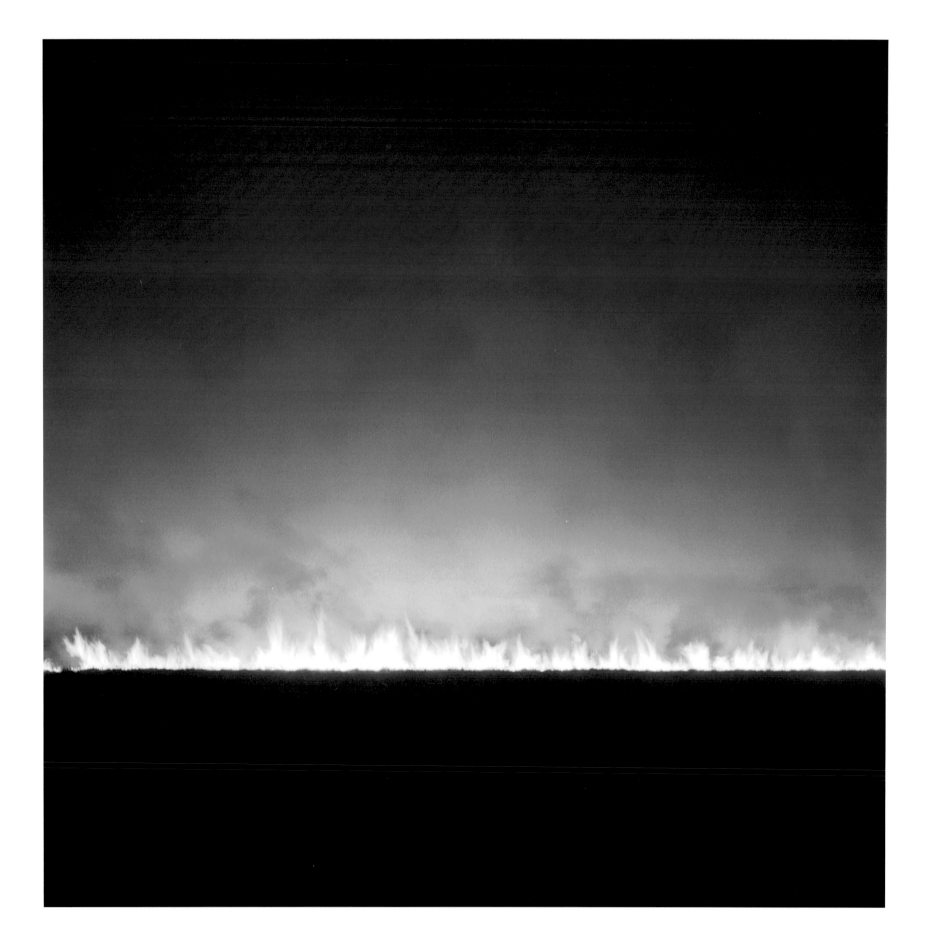

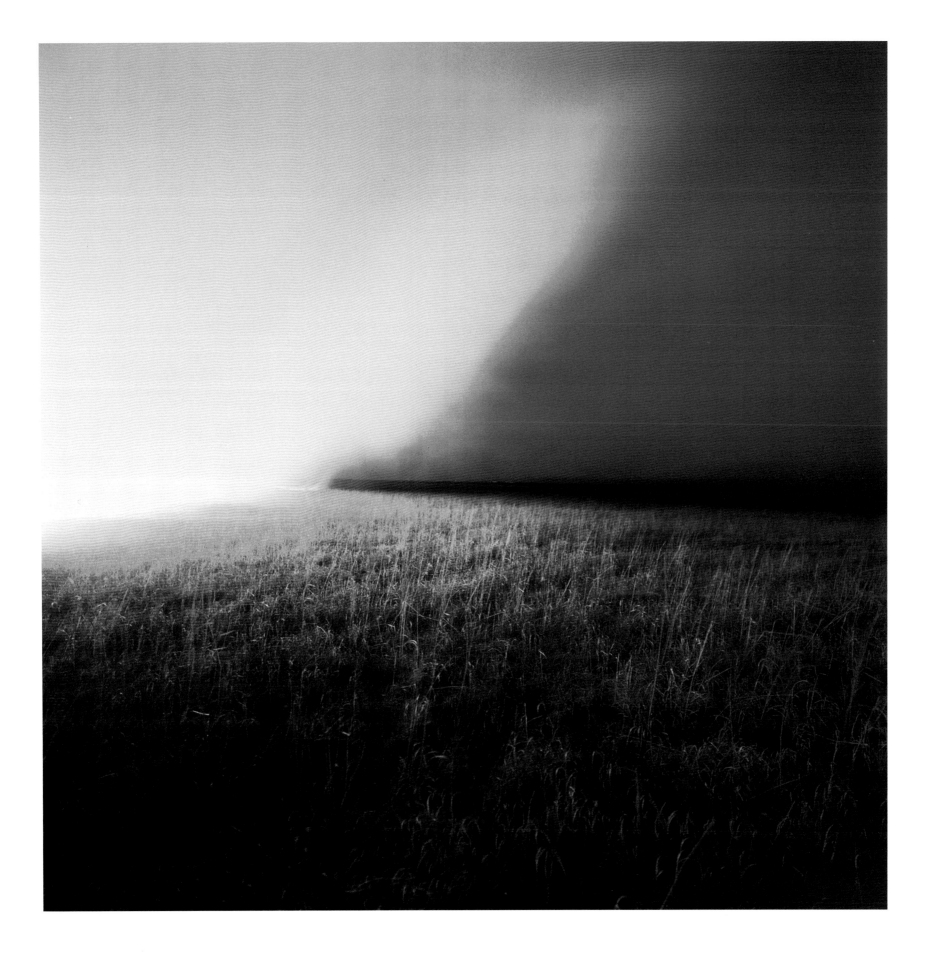

**97. KAREN HALVERSON**
OWENS VALLEY, NEAR LONE
PINE, CALIFORNIA, **1987**

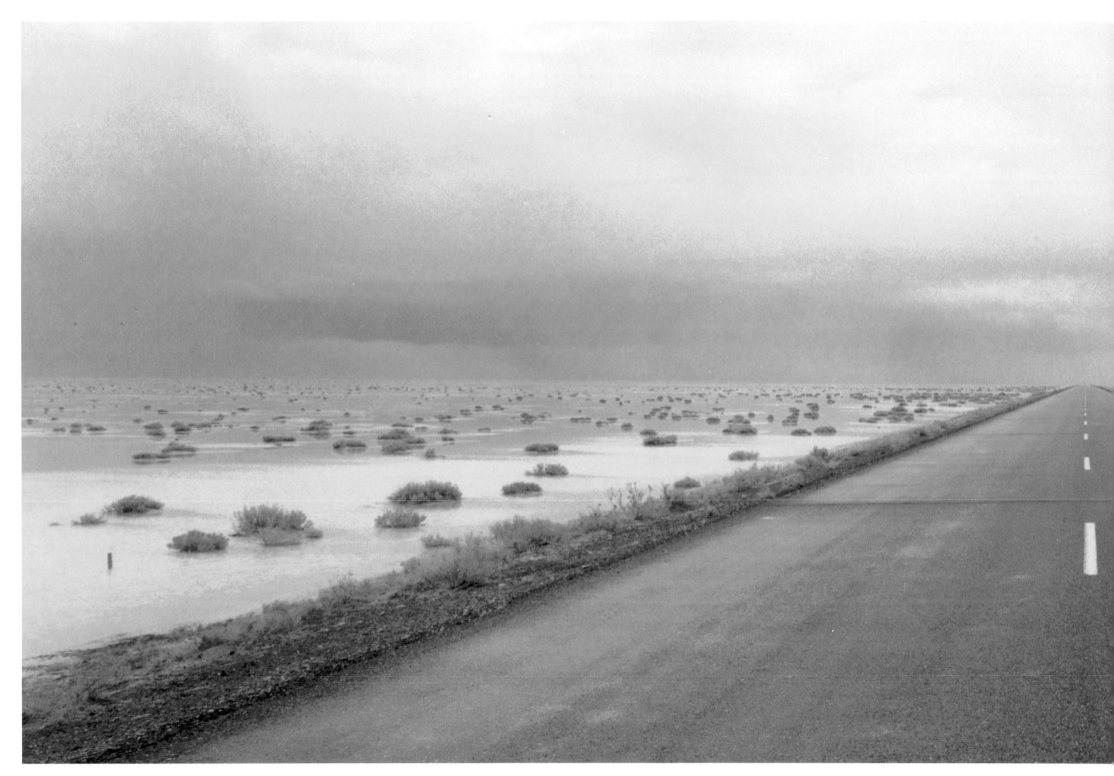

98. **STUART D. KLIPPER,** ROAD TO BONNEVILLE RACEWAY, UTAH **(FROM THE SERIES THE WORLD IN A FEW STATES),** 1990

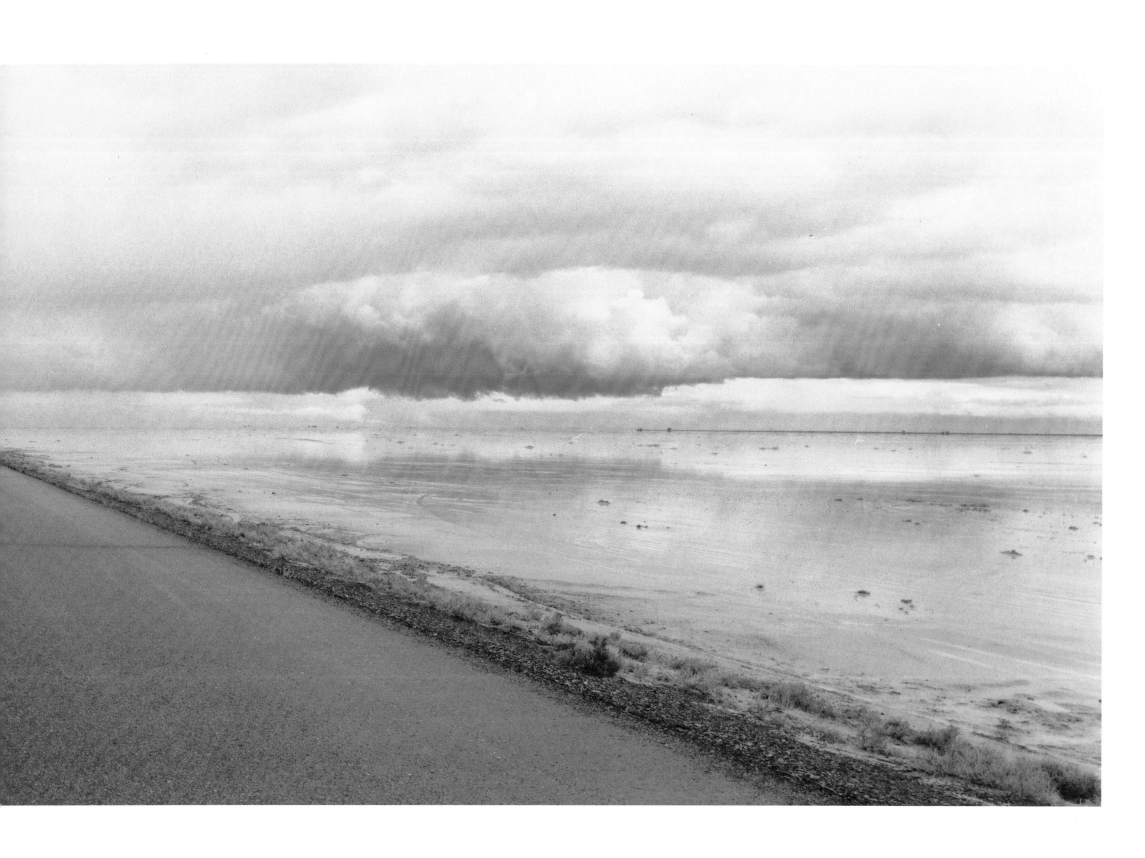

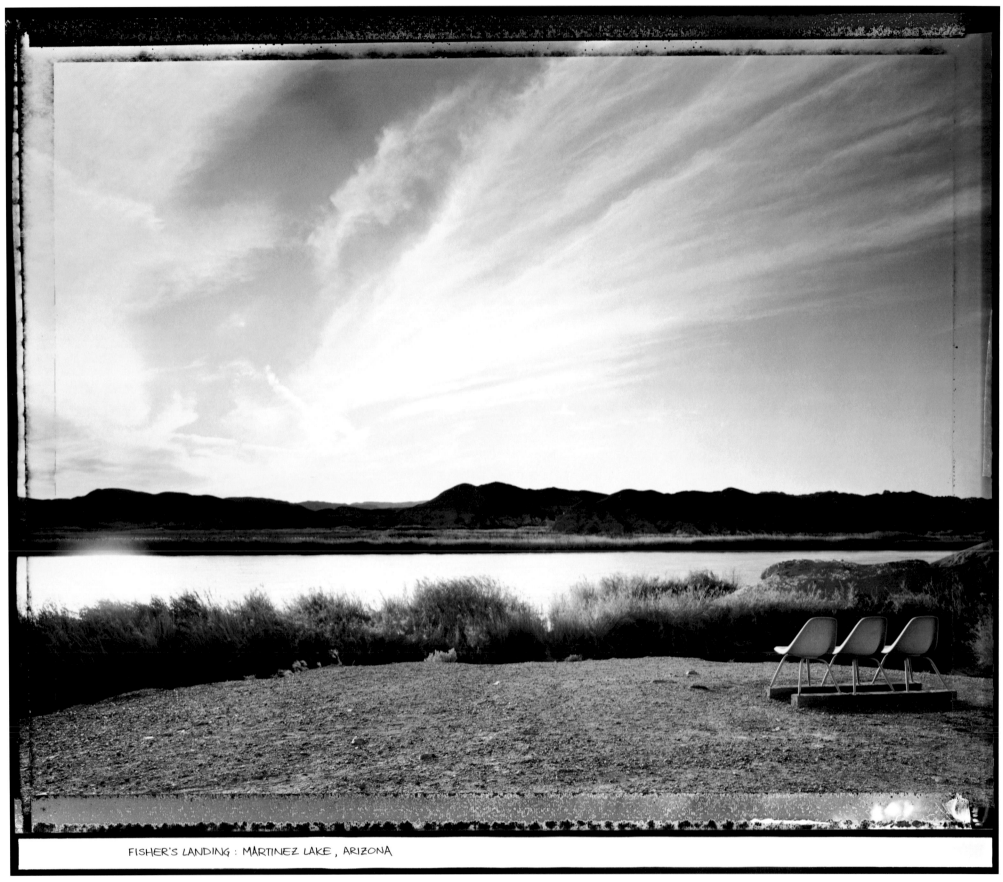

FISHER'S LANDING : MARTINEZ LAKE , ARIZONA

**99. JIM STONE,** FISHER'S LANDING: MARTIINEZ LAKE, AZ, **1988**

# select bibliography

ARENTZ, DICK. *Four Corners Country*. Essay by Ian Thompson. Tucson: University of Arizona Press, 1986.

BRIGHT, DEBORAH. "Once upon a Time in The West." *Afterimage* (October 1984).

———. "Of Mother Nature and Marlboro Men: An Inquiry into the Cultural Meanings of Landscape Photography." *Exposure* 23:1 (1985).

———. "Paradise Recycled: Art, Ecology, and the End of Nature." *Afterimage* (September 1990).

CAHN, ROBERT, and ROBERT KETCHUM. *American Photographers and the National Parks*. New York: Viking Press, 1981.

CONNOR, LINDA. *Solos*. Millertown, New York: Apeiron, 1979.

———. *Linda Connor: Spiral Journey*. Chicago: Museum of Contemporary Photography, Columbia College, 1990.

*Robert Dawson Photographs*. Tokyo: Gallery Min, 1988.

DAWSON, ROBERT, and GERALD HASLAM. *The Great Central Valley Project*. Berkeley: University of California Press, 1989.

DRUKREY, TIMOTHY, and MARNIE GILLETT. *Nuclear Matters*. San Francisco: San Francisco Camerawork, 1991.

ENGLISH, CHRISTOPHER. *The Invented Landscape*. New York: New Museum, 1979.

EVANS, TERRY. *Prairie: Images of Ground and Sky*. Lawrence: University of Kansas Press, 1986.

FLICK, ROBBERT. *Robbert Flick: Sequential Views 1980–1986*. Tokyo: Gallery Min, 1988.

GARNER, GRETCHEN. *Reclaiming Paradise: American Women Photographing the Land*. Duluth: Tweed Museum of Art, University of Minnesota, 1987.

GOIN, PETER. *Nuclear Landscapes*. Baltimore: Johns Hopkins University Press, 1991.

GOUCHER, NANCY. *Deborah Bright: Textural Landscapes*. Binghamton: State University of New York, 1988.

HAGEN, CHARLES, ed. *Beyond Wilderness*. Vol. 120, *Aperture*. New York: Aperture, 1990.

HALES, PETER. "Landscape and Documentary: Questions of RePhotography." *Afterimage* (Summer, 1987).

HILL, ED, and SUZANNE BLOOM. "Landscape Vs. Environment; Or, Thirteen Ways of Coping with Nature." *Spot*. (Houston: Houston Center for Photography, Winter 1990).

JENKINS, WILLIAM. *New Topographics: Photographs of a Man Altered Landscape*. Rochester: International Museum of Photography, 1975.

JUSSIM, ESTELLE, and ELIZABETH LINDQUIST-COCK. *Landscape as Photograph*. New Haven: Yale University Press, 1985.

KETCHUM, CARY D., and ROBERT GLENN KETCHUM. *The Tongass: Alaska's Vanishing Rain Forest*. New York: Aperture, 1987.

KETCHUM, ROBERT GLENN. *Overlooked in America: The Success and Failure of Federal Land Management*. Essay by Charles Callison. New York: Aperture, 1991.

KLETT, MARK. *Traces of Eden: Travels in the Desert Southwest*. Boston: Godine, 1986.

———. *One City/Two Visions: San Francisco Panoramas 1878 and 1990 by Eadweard Muybridge and Mark Klett*. San Francisco: Bedford Arts, 1990.

———. *Revealing Territory: Photographs of the Southwest by Mark Klett*. Albuquerque: University of New Mexico Press: 1992.

MARX, LEO. *The Pilot and the Passenger*. New York: Oxford University Press, 1988.

MISRACH, RICHARD. *Desert Cantos*. Albuquerque: University of New Mexico Press, 1987.

MISRACH, RICHARD, with MYRIAM WEISANG MISRACH. *Bravo 20: The Bombing of the American West*. Baltimore: Johns Hopkins University Press, 1990.

MORTENSON, RAY. *Meadowland*. New York: Lustrum Press, 1983.

OLSEN, SANDRA, and JOHN PFAHL. *Tainted Prospects: Photographers and the Compromised Environment*. New York: Castellani Art Museum, Niagara University, 1991.

PFAHL, JOHN. *Altered Landscapes*. Carmel, California: Friends of Photography, 1981.

———. *Arcadia Revisited: Niagara River and Falls from Lake Erie to Lake Ontario*. Albuquerque: Buscaglia-Castellani Art Gallery of Niagara University and University of New Mexico Press, 1988.

———. *A Distanced Land: The Photographs of John Pfahl*. Albuquerque: Published for the Albright-Knox Gallery and University of New Mexico Press, 1990.

———. *Picture Windows*. Boston: Little, Brown and Co., 1987.

*Polemical Landscapes*. CMP Bulletin 9:3. Riverside: California Museum of Photography, University of California, 1990.

*Second View: The Rephotographic Survey Project*. Albuquerque: University of New Mexico Press, 1984.

SZARKOWSKI, JOHN, ed. *The Photographer and the American Landscape*. New York: Museum of Modern Art and Doubleday and Company, 1963

YATES, STEVE, ed. *The Essential Landscape: The New Mexico Photographic Survey*. Albuquerque: University of New Mexico Press, 1985.

ZUBE, ERVIN H. ed. *Landscape: Selected Writings of J.B. Jackson*. Amherst: The University of Massachusetts Press, 1970.

# checklist of the exhibition

(Note: All works are from the Consolidated Natural Gas Company Foundation Collection unless otherwise indicated.)

1. RICHARD ARENTZ. *Red Maple in Wind*, 1988, platinum-palladium print, 11 1/2 x 19 5/8 in. (pl. 8)

2. RICHARD ARENTZ. *Cumberland Gap*, 1988, platinum-palladium print, 11 3/4 x 19 5/8 in. (pl. 41)

3. RICHARD ARENTZ. *Weeping Crab Apple*, 1988, platinum-palladium print, 11 3/8 x 19 5/8 in.

4. BARBARA BOSWORTH. *National Champion American Elm, Vermillion River, Louisville, Kansas,* 1990, gelatin silver print, 7 11/16 x 19 7/16 in.

5. BARBARA BOSWORTH. *Windmills, Mt. Wachusett,* 1986, gelatin silver print, 7 5/8 x 9 11/16 in. (Gould, fig. 8)

6. BARBARA BOSWORTH. *Niagara Falls,* 1986, gelatin silver print, 7 11/16 x 9 5/8 in. (pl. 73)

7. BARBARA BOSWORTH. *National Champion American Beech, Ashtabula County, Ohio,* 1990, gelatin silver print, 7 5/8 x 9 11/16 in. (pl. 47)

8. BARBARA BOSWORTH. *National Champion Sycamore, Clarence Briggs Farm, Ohio,* 1990, gelatin silver print, 7 5/8 x 9 3/4 in. (pl. 46)

9. DEBORAH BRIGHT. *Bloody Lane: Battle of Antietam,* 1983 (from the series Battlefield Panoramas), 1981–1984, gelatin silver prints, 14 x 133 in. (pl. 88)

10. DREX BROOKS. *Sweet Medicine: Medicine Rock; Sacred Place, North Dakota,* 1989, gelatin silver print, 14 x 20 7/8 in. Gift of the artist. (pl. 13)

11. DREX BROOKS. *Sweet Medicine: Summit Springs Battlefield, Colorado,* 1987, gelatin silver print, 14 x 20 7/8 in. Gift of the artist.

12. DREX BROOKS. *Sweet Medicine: Council Grounds of the Great Treaty at Horse Creek, Nebraska,* 1987, gelatin silver print, 14 x 20 7/8 in. (pl. 42)

13. DREX BROOKS. *Sweet Medicine: Nez Perce Surrender Site, Bear's Paw Mountains, Montana,* 1989, gelatin silver print, 14 x 20 7/8 in.

14. ELLEN BROOKS. *Untitled (Course I),* 1989, laminated cibachrome print, 41 x 109 in. (pl. 12)

15. LOIS CONNER. *Central Park, New York City,* 1988, platinum-palladium print, 6 1/4 x 16 3/4 in. (pl. 10)

16. LOIS CONNER. *Baton Rouge, Louisiana,* 1988, platinum-palladium print, 6 3/8 x 16 3/4 in. (pl. 1)

17. LOIS CONNER. *Central Park, New York City,* 1986, platinum-palladium print, 6 5/16 x 16 7/8 in. (pl. 45)

18. LOIS CONNER. *St. George's Hotel, Brooklyn, New York,* 1991, platinum-palladium print, 6 9/16 x 16 9/16 in. (pl. 37)

19. GREGORY CONNIFF. *Iowa Co., WI, October 1990,* gelatin silver print, 17 7/8 x 22 in.

20. GREGORY CONNIFF. *Iowa Co., WI, October 1990,* gelatin silver print, 17 7/8 x 21 15/16 in.

21. GREGORY CONNIFF. *Iowa Co., WI, October 1990,* gelatin silver print, 18 x 22 in. Gift of Dr. Robert Seder & Deborah Harmon (pl. 44)

22. GREGORY CONNIFF. *Portage Co., WI; Windbreaks, September 1989,* gelatin silver print, 17 7/8 x 22 in.

23. GREGORY CONNIFF. *Oneonta, NY; Freckelton/Beal Garden,* 1987, gelatin silver print, 17 7/8 x 21 15/16 in. (pl. 43)

24. LINDA CONNOR. *Lightning Nevada,* 1976, gold-toned gelatin silver contact print, 7 7/8 x 9 3/8 in. (pl. 19)

25. LINDA CONNOR. *Design Petroglyph, Wupatki, Arizona,* 1989, gold-toned gelatin silver contact print, 7 1/2 x 9 1/2 in. (pl. 18)

26. LINDA CONNOR. *Dots and Hands, Fourteen Window Ruin Bluff, Utah,* 1987, gold-toned gelatin silver contact print, 7 1/2 x 9 5/8 in. (pl. 16)

27. LINDA CONNOR. *Pre-historic Maze, Colorado River, California,* 1986, gold-toned gelatin silver contact print, 7 5/8 x 9 1/2 in. (pl. 17)

28. ROBERT DAWSON. *Polluted New River, Calexico, California* (from the California Toxics project), 1989, gelatin silver print, 13 7/8 x 17 3/4 in. (pl. 33)

29. ROBERT DAWSON. *Glen Canyon Bridge, Page, Arizona* (from the Water in the West project), 1984, gelatin silver print, 13 7/8 x 17 3/4 in.

30. ROBERT DAWSON. *Silverton, Colorado* (from the Water in the West project), 1984, gelatin silver print, 13 7/8 x 17 3/4 in. (pl. 72)

31. ROBERT DAWSON. *Flooded Salt Air Pavilion, Great Salt Lake, Utah* (from the Water in the West project), 1985, gelatin silver print, 13 7/8 x 17 3/4 in. (pl. 90)

32. ROBERT DAWSON. *Delta Farm, Sacramento River, California* (from the Great Central Valley project), 1984, gelatin silver print, 13 7/8 x 17 3/4 in. (pl. 74)

33. ROBERT DAWSON. *Storage Tanks, Corcoran, California* (from the Great Central Valley project), 1984, gelatin silver print, 13 7/8 x 17 3/4 in.

34. ROBERT DAWSON. *San Luis Drain, Kesterson National Wildlife Refuge, California* (from the Great Central Valley project), 1985, gelatin silver print, 13 7/8 x 17 3/4 in.

35. ROBERT DAWSON. *Large Corporate Farm, Near Bakersfield, California* (from the Great Central Valley project), 1983, gelatin silver print, 13 7/8 x 17 3/4 in.

36. ROBERT DAWSON. *Cracked Mud and Vineyard Near Arvin, California* (from the Great Central Valley project), 1985, gelatin silver print, 13 7/8 x 17 3/4 in. (Gould, fig. 3)

37. ROBERT DAWSON. *Friant Dam, Near Fresno, California* (from the Great Central Valley project), 1983, gelatin silver print, 13 7/8 x 17 3/4 in.

38. RICK DINGUS. *Journey Within, Near San Ysidro, NM,* 1986, gelatin silver print with graphite additions, 16 x 20 in. (pl. 26)

39. RICK DINGUS. *Unfinished House in the Woods, Near Taos, NM,* 1985–88, gelatin silver print with graphite additions, 16 x 20 in. (pl. 49)

40. RICK DINGUS. *Black Wash, Near Galisteo Dam, NM,* 1987, gelatin silver print with graphite additions, 16 x 20 in.

41. FRANK DIPERNA. *Makena Field, Maui, Hawaii,* 1988, ektacolor print, 17 3/8 x 21 7/16 in. (pl. 15)

42. FRANK DIPERNA. *Haleakala, Maui, Hawaii,* 1987, ektacolor print, 17 3/8 x 19 1/2 in. (pl. 20)

43. JOHN DIVOLA. *Cyclone on the Beach* 1987, suite of 4 unique Polaroid Polapan prints, 24 x 20 in. each (pl. 38)

44. TERRY EVANS. *Konza Prairie,* 1982, ektacolor print, 19 x 19 in. (pl. 53)

45. TERRY EVANS. *Sage and Scribner's Panic Grass, Fent's Prairie,* 1979, ektacolor print, 14 15/16 x 14 15/16 in. (pl. 55)

46. TERRY EVANS. *Melvern Lake, April 1981*, ektacolor print, 19 x 19 in. (pl. 54)

47. TERRY EVANS. *Fairy Ring #2, Fent's Prairie,* 1979, ektacolor print, 14 15/16 x 14 15/16 in. (pl. 56)

48. TERRY EVANS. *Smoky Hill Bombing Range Target, Tires,* 1990, gelatin silver print, 14 7/8 x 14 3/4 in. Gift of the artist (pl. 76)

49. TERRY EVANS. *Solomon River Oxbow,* 1990, gelatin silver print, 14 7/8 x 14 3/4 in. Gift of the artist (pl. 9)

50. TERRY EVANS. *North Central Kansas, Tracks,* 1990, gelatin silver print, 14 7/8 x 14 3/4 in. Gift of the artist

51. ROBBERT FLICK. *At Pinnacles (SV186),* 1990, 12 gelatin silver prints, 48 x 100 in. overall (approx.) (pl. 35)

52. GUS FOSTER. *Cut Wheat,* 1988, 363-degree panoramic ektacolor print, 18 x 86 1/4 in. (pl. 58)

53. GUS FOSTER. *El Malpais Wilderness*, 1988, 370-degree panoramic ektacolor print, 15 x 83 1/2 in. Gift of the artist

54. PETER GOIN. *The Amistad Reservoir was created by mutual international agreement, flooding a large land area. The original Rio Grande channel was preserved as the permanent border line through the reservoir. Below the Amistad Dam, the water is free of silt and mud and is exceptionally clear. Most of the property in this area is used for recreation, including this screened, river-front picnic area near Del Rio.* 1985–87, toned gelatin silver print, 9 5/8 x 12 1/2 in. (pl. 81)

55. PETER GOIN. *"Best General View" of Rio Grande River Looking West at Pump Canyon,* 1985–87, toned gelatin silver print, 9 5/8 x 12 1/2 in. (pl. 79)

56. PETER GOIN. *According to treaties negotiated between Mexico and the United States, shared waterways must maintain specific water flow. Instead of losing water to evaporation and seepage, hoses may be used to carry the required water across the border. These hoses run through the Alamo Arroyo toward the Rio Grande near Ft. Hancock, east of El Paso and Ciudad Juarez.* 1985–87, toned gelatin silver print, 9 5/8 x 12 1/2 in. (pl. 82)

57. PETER GOIN. *During President Carter's administration, the Immigration and Naturalization Service constructed an "impenetrable" fence at selected areas near El Paso, Calexico, and San Ysidro, among others. It is twelve feet high and constructed of metal webbing (much like chain link) topped with barbed concertina wire. It is called the Tortilla Curtain and does little to stem the flow of illegal crossings into the United States. The metal sections along the fence were installed to repair holes. Mexico is on the left.* 1985–87, toned gelatin silver print, 9 5/8 x 12 1/2 in. (pl. 78)

58. PETER GOIN. *In 1907, by proclamation of President Roosevelt, all federal lands in California, Arizona, and New Mexico within 60 feet of the border line were set apart as a public reservation. Although this frontier is occasionally usurped by ranchers and farmers or for urban development, it represents the formal establishment of a "no-man's land" along the entire length of the Mexican-American border. In principle, this zone provides easy access for monument maintenance; in areas like this near Tecate, it also provides a convenient and expanded fire break. The view is looking east toward Monument No. 244.* 1985–87, toned gelatin silver print, image 9 5/8 x 12 1/2 in. (pl. 80)

59. PETER GOIN. *Trinity Site* (from the Nuclear Landscape series), 1985–87, type C print, 10 5/8 x 13 5/8 in. (Gould, fig. 13)

60. PETER GOIN. *Collapsed Hangar Yucca Flat* (from the Nuclear Landscape series), 1985–87, type C print, 10 5/8 x 13 5/8 in. (pl. 59)

61. PETER GOIN. *Orchard Site* (from the Nuclear Landscape series), 1985–87, type C print, 10 5/8 x 13 5/8 in. (pl. 64)

62. PETER GOIN. *Potential Nuclear Waste Area* (from the Nuclear Landscape series), 1985–87, type C print, 10 5/8 x 13 5/8 in. (pl. 60)

63. PETER GOIN. *Burial Ground* (from the Nuclear Landscape series), 1985–87, type C print, 10 5/8 x 13 5/8 in. (pl. 63)

64. PETER GOIN. *Nuclear Bunker* (from the Nuclear Landscape series), 1985–87, type C print, 10 5/8 x 13 5/8 in. (pl. 61)

65. PETER GOIN. *Burnt Palms* (from the Nuclear Landscape series), 1985–87, type C print, 10 5/8 x 13 5/8 in. (pl. 62)

66. KAREN HALVERSON. *Owens Valley, Near Lone Pine, California,* 1987, ektacolor print, 11 1/2 x 23 in. (pl. 97)

67. KAREN HALVERSON. *Death Valley, California,* 1987, ektacolor print, 11 x 23 in. (pl. 75)

68. KAREN HALVERSON. *Hite Crossing, Lake Powell, Utah,* 1988, ektacolor print, 11 1/2 x 23 in. (pl. 92)

69. DAVID T. HANSON. *California Gulch, Leadville, Colorado: August 1986* (from the series Waste Land), 1986–88, ektacolor print, silver print, modified  U.S. Geological Survey topographic map, triptych, 17 1/4 x 47 in. Lent by the artist (pl. 65)

70. DAVID T. HANSON. *View from First Baptist Church of Colstrip: Company Houses and Power Plant. October, 1984* (from the series Colstrip, Montana), 1982–85, ektacolor print, 8 7/8 x 11 in. (pl. 66)

71. DAVID T. HANSON. *B & R Village Mobile Home Park and Burlington Northern Coal Train. June, 1984* (from the series Colstrip, Montana), 1982–85, ektacolor print, 8 15/16 x 11 in. (pl. 69)

72. DAVID T. HANSON. *Coal Storage Area and Railroad Tipple.  October, 1984* (from the series Colstrip, Montana), 1982–85, ektacolor print, 8 15/16 x 11 in. (pl. 68)

73. DAVID T. HANSON. *Coal Strip Mine, Power Plant and Waste Ponds.  January, 1984* (from the series Colstrip, Montana), 1982–85, ektacolor print, 8 15/16 x 11 in. (pl. 67)

74. ANTHONY LOUIS HERNANDEZ. *"Shooting Sites" Las Vegas,* 1987/printed 1989, cibachrome print, 29 1/2 in. x 29 1/2 in. Gift of the artist (Gould, fig. 9)

75. ANTHONY LOUIS HERNANDEZ. *"Shooting Sites" Angeles National Forest,* 1988/printed 1989, cibachrome print, 29 1/8 x 29 in. (pl. 32)

76. ALLEN HESS. *The New Mississippi River Bridge, Luling, Louisiana,* 1982, selenium-toned contact print, 7 9/16 x 19 1/2 in. (pl. 71)

77. ALLEN HESS. *Oak Alley Plantation, River Road, Louisiana,* 1983, selenium-toned contact print, 7 9/16 x 19 1/2 in. (pl. 39)

78. ALLEN HESS. *Railroad Ferry Incline, Mississippi River, Low Water July 1988 Ste. Genevieve, Missouri,* 1988, selenium-toned contact print, 7 9/16 x 19 1/2 in. (Gould, fig. 12)

79. ALLEN HESS. *Cypress Logging Slough and Boat, Louisiana,* 1985, selenium-toned contact print, 7 9/16 x 19 1/2 in. (pl. 40)

80. ALLEN HESS. *Julia Belle Swain, Mississippi River,* 1975, selenium-toned contact print, 8 x 20 in. Lent by the Consolidated Natural Gas Company

81. LEN JENSHEL. *Monument Valley, Navajo Tribal Park, Arizona,* 1985, ektacolor print, 14 3/4 x 22 in. (Gould, fig. 11)

82. LEN JENSHEL. *Gouldings Lodge, Monument Valley, Utah,* 1987, ektacolor print, 14 3/4 x 22 in. (pl. 23)

83. LEN JENSHEL. *State Highway 128 Near Fisher Tower, Utah,* 1985, ektacolor print, 14 3/4 x 22 in. (pl. 4)

84. LEN JENSHEL. *Great Basin National Park, Nevada,* 1987, ektacolor print, 14 3/4 x 22 1/8 in. (pl. 7)

85. ROBERT GLENN KETCHUM. *Things Have a Life of Their Own* (Order from Chaos series), 1982, cibachrome print, 29 7/8 x 37 3/4 in. Anonymous gift (Gould, fig. 2)

86. ROBERT GLENN KETCHUM. *Trying to "stop the world"* (Order from Chaos series), 1984, cibachrome print, 29 7/8 x 38 5/8 in. Anonymous gift

87. ROBERT GLENN KETCHUM. *"The Voyage of Life"/Homage to Thomas Cole,* 1984, cibachrome print, 29 1/2 x 37 1/2 in. Anonymous gift (pl. 11)

88. MARK KLETT. *Around Toroweap Point, Just Before and After Sundown, Beginning and Ending with Views by J.K. Hillers, Over 100 Years Ago, Grand Canyon,* 1986, gelatin silver prints, 19 3/16 x 15 15/16 in. each (pl. 21)

89. STUART D. KLIPPER. *Road to Bonneville Raceway, Utah, 1990*  (from the ongoing series The World in a Few States), type C print, 12 x 38 in. (pl. 98)

90. STUART D. KLIPPER. *Storm Over Bonneville Raceway, Utah 1990*  (from the ongoing series The World in a Few States), type C print, 12 x 38 in. (pl. 6)

91. STUART D. KLIPPER. *Snake River Gorge Bridge, Twin Falls, Idaho, 1990* (from the ongoing series The World in a Few States), type C print, 11 15/16 x 38 1/8 in. (pl. 70)

92. VICTOR LANDWEBER.  *Keane Wonder Mine, Death Valley, CA—Richest Site of the Western Funeral Range, Producing $1,000,000 in Gold and Silver Between 1908 and 1916,* 1987/printed 1991, gelatin silver prints, 36 x 83 3/4 in. (pl. 22)

93. JOE MALONEY. *Dark Eddy, Delaware River,* 1986, ektacolor print, 12 3/8 x 15 5/8 in. (pl. 3)

94. JOE MALONEY. *East Branch, Delaware River, New York,* 1979, ektacolor print, 12 3/8 x15 5/8 in. (pl. 52)

95. JOE MALONEY. *Camp Delaware, New York State,* 1986, ektacolor print, 12 3/8 x 15 5/8 in. (pl. 5)

96. SKEET MCAULEY. *Alaska Pipeline,* 1990, Fujichrome print, 28 in. x 84 in. (pl. 36)

97. ROGER MERTIN. *Liberty Island; Centennial Observation, October 28, 1986*, contact print on chromogenic paper, 9 11/16 x 7 11/16 in. (pl. 86)

98. ROGER MERTIN. *View; Looking Northeast, Ellis Island,* 1988, contact print on chromogenic paper, 9 5/8 x 7 11/16 in.

99. ROGER MERTIN. *View; Looking Southwest, Ellis Island, Island #3,* 1988, contact print on chromogenic paper, 9 11/16 x 7 11/16 in. (pl. 87)

100. RICHARD MISRACH. *Dead Animals #327,* 1987, ektacolor plus print, 28 x 35 1/4 in. (pl. 14)

101. RICHARD MISRACH. *Bomb, Destroyed Vehicle and Lone Rock,* 1987, ektacolor plus print, 18 5/6 x 23 3/16 in. (pl. 57)

102. RAY MORTENSON. *Amtrak, Hudson Generating Station, Jersey City and Manhattan from Laurel Hill,* 1982, gelatin silver print, 23 7/8 x 30 in. (pl. 83)

103. KENDA NORTH. *Untitled* (Marks on the Landscape series), 1987, dye transfer print, 14 1/8 x 17 11/16 in. (pl. 29)

104. KENDA NORTH. *Untitled* (Marks on the Landscape series), 1986, dye transfer print, 14 x 17 1/2 in. (pl. 27)

105. KENDA NORTH. *Untitled* (Marks on the Landscape series), 1985, dye transfer print, 14 1/8 x 17 5/8 in. (pl. 30)

106. KENDA NORTH. *Untitled* (Marks on the Landscape series), 1987, dye transfer print, 14 3/16 x 17 11/16 in. (pl. 28)

107. MARY PECK. *Everglades 40 #1,* 1986, toned gelatin silver print, 10 1/4 x 31 in. (pl. 48)

108. MARY PECK. *Everglades 88-2 #4,* 1988, toned gelatin silver print, 10 5/16 x 30 7/8 in. (Gould, fig. 1)

109. MARY PECK. *Everglades 49 #1,* 1986, toned gelatin silver print, 10 1/8 x 30 3/4 in.

110. JOHN PFAHL. *Goodyear #5, Niagara Falls, NY, 1989*, ektacolor plus print, 18 1/2 x 18 1/2 in. (pl. 34)

111. JOHN PFAHL. *Niagara Power Project, Niagara Falls, New York,* 1981, ektacolor plus print, 13 1/4 x 18 3/8 in. (pl. 31)

112. JOHN PFAHL. *Three Mile Island Nuclear Plant, Susquehanna River, PA,* 1982, ektacolor plus print, 13 1/4 x 18 1/4 in. (pl. 91)

113. MERIDEL RUBENSTEIN. *Untitled (Good Luck),* 1982/printed 1989, palladium print, 13 7/8 x 17 11/16 in. (pl. 24)

114. MERIDEL RUBENSTEIN. *Penitente,* 1982/printed 1989, palladium print, 12 3/4 x 16 5/8 in. (pl. 25)

115. LARRY SCHWARM. *Snow, Near Greenburg, Kansas,* 1989, ektacolor print, 13 1/4 x 13 1/4 in. (pl. 96)

116. LARRY SCHWARM. *Near Cottonwood Falls, Kansas,* 1988, ektacolor print, 13 1/4 x 13 3/16 in. (pl. 93)

117. LARRY SCHWARM. *Southeastern Washington State,* 1989, ektacolor print, 13 1/4 x 13 1/4 in. (Gould, fig. 6)

118. LARRY SCHWARM. *Flint Hills Prairie Fire Near Cassoday, Kansas,* 1990, ektacolor print, 13 1/4 x 13 1/4 in. Gift of the artist (pl. 94)

119. LARRY SCHWARM. *Grass Fire Near Cassoday, Kansas,* 1990, ektacolor print, 13 1/4 x 13 1/4 in. Gift of the artist (pl. 95)

120. LARRY SCHWARM. *Fire, Easter Night, Chase County, Kansas,* 1991, ektacolor print, 13 1/4 x 13 1/4 in. Gift of the artist

121. STEEL STILLMAN. *Plane Tree,* 1990, cibachrome print, 14 x 11 in. (pl. 50)

122. STEEL STILLMAN. *Red Plane Tree,* 1990, cibachrome print, 14 x 11 in. (pl. 51)

123. STEEL STILLMAN. *Where The Fish Bite Best,* 1990, cibachrome print, 11 x 14 in.

124. STEEL STILLMAN. *Lower Ausable Lake,* 1990, cibachrome print, 11 x 14 in.

125. JIM STONE. *Fisher's Landing: Martinez Lake, AZ,* 1988, gelatin silver print, 18 7/8 x 22 in. (pl. 99)

126. JIM STONE. *Desert Home: Ferguson Lake, AZ,* 1988, gelatin silver print, 19 x 21 7/8 in. (pl. 77)

127. MADOKA TAKAGI. *North View from Municipal Building, Manhattan* (New York series #145), 1990/ printed 1991, platinum print, 9 1/2 x 7 1/2 in. (pl. 84)

128. MADOKA TAKAGI. *Long Island City, Queens* (New York series #90), 1990/ printed 1991, platinum print, 9 1/2 x 7 1/2 in. (pl. 85)

129. MADOKA TAKAGI. *110th St. and Manhattan Ave., Manhattan* (New York series #40), 1990/ printed 1991, platinum print, 9 1/2 x 7 1/2 in.

130. TERRY TOEDTEMEIER. *Spearfish (Site), Klickitat County, Washington,* 1988, gelatin silver print, 8 3/4 x 18 3/8 in.

131. TERRY TOEDTEMEIER. *Burning Railroad Tie, Burlington Cut Near Catherine Creek, Klickitat County, Washington,* 1987, gelatin silver print, 8 5/8 x 18 1/4 in. (pl. 2)

132. JOHN YANG. *Somerset Hills Country Club Golf Course,* 1987, gelatin silver print, 8 x 77 in. (pl. 89)

# biographies

ARTISTS

(Note: Unless otherwise indicated, quotations by artists are from correspondence with Merry A. Foresta.)

**RICHARD ARENTZ** Born in Detroit, Michigan, 1935. Currently lives in Flagstaff, Arizona, where he is an instructor in photography at Northern Arizona University. An exhibition featuring Arentz's work was organized by the Huntington Museum of Art, Huntington, West Virginia, in 1990. His book *Four Corners Country* was published in 1986.

**BARBARA BOSWORTH** Born in Cleveland, Ohio, 1953. Now resides in Cambridge, Massachusetts. She has taught at the Massachusetts College of Art since 1984.

Bosworth writes: "Most of my work now centers on the idea that we are an interactive part of our environment. We are not separate and removed from the land and nature. We are an integral part of it. Sometimes this interaction is ironic.... But often my pictures are [taken] simply because I love the way the land looks."

**DEBORAH BRIGHT** Born in Washington, D.C., 1950. Currently resides in Somerville, Massachusetts. Bright has taught art and art history at the Rhode Island School of Design since 1989. An exhibition of her photographs, "Deborah Bright: Textual Landscapes," was held at University Art Museum, SUNY Binghamton, New York, in 1988. Her work was included in "Polemical Landscapes," California Museum of Photography, University of California, Riverside.

Bright writes: "My involvement with landscape photography is a very complex one.... In addition to my own work as an artist I also write critical articles on the history and criticism of landscape photography.... I think that a critical perspective on these issues is warranted at this moment when our culture's industrial and post-industrial relationship to nature is being so extensively revised."

**DREX BROOKS** Born in Oregon, 1952. Currently resides in Ogden, Utah. Since 1988 Brooks has been assistant professor and photography program coordinator at Weber State College, Ogden, Utah. A monograph, *Sweet Medicine,* will be published in 1992.

**ELLEN BROOKS** Born in Los Angeles, California, 1947. Currently lives in New York City. Brooks's work has been included in several recent contemporary photography exhibitions in the United States and Europe.

**LOIS CONNER** Born in 1951 in New York City, where she currently resides. Conner has received two John Simon Guggenheim Memorial Fellowships (1984 and 1985), which she spent photographing in China.

**GREGORY CONNIFF** Born in 1944, Jersey City, New Jersey. Presently lives in Madison, Wisconsin. A recipient of a John Simon Guggenheim Fellowship in 1989, Conniff published *Common Ground*, Vol. I of *An American Field Guide* (New Haven: Yale University Press, 1985).

**LINDA CONNOR** Born in New York City, 1944. Lives in San Anselmo, California. Connor has taught at San Francisco Art Institute since 1969. She has received two grants from the National Endowment for the Arts (1976 and 1981) and a Guggenheim Fellowship in 1979. Widely exhibited, her publications include *Solos* (1979), and, most recently, *Spiral Journey: Photographs 1967–1990*, published in conjunction with the 1990 retrospective exhibition of her photographs.

**ROBERT DAWSON** Born in Sacramento, California, 1950. Currently resides in San Francisco. Dawson teaches at San Francisco State University and San Jose State University. He received a National Endowment for the Arts Fellowship in 1984 and 1988. Recent solo exhibitions of his work include a show at the Gallery Min, Tokyo, Japan (1988). Since 1983 he has been co-director of the Water in the West Project, a collaborative photographic exploration of our culture's relationship to, and use of, water in the arid lands of the American West. Recent publications include *The Great Central Valley Project* (University of California Press, 1989) and *Robert Dawson Photographs* (Gallery Min, Tokyo, Japan, 1988).

**RICK DINGUS** Born in Appleton City, Missouri, 1951. Currently lives in Lubbock, Texas. Since 1982 Dingus has been associate professor of photography, photo history, and drawing at Texas Tech University. He received a National Endowment for the Arts/Mid-America Art Alliance Regional Fellowship in 1987. He was also a member of the Rephotographic Survey Project (1978–79) and more recently he worked on "Navajo Sacred Places," in conjunction with a Navajo oral history project. He writes extensively on contemporary photography. His publications include *Second View: The Rephotographic Survey* (University of New Mexico Press, 1984).

**FRANK DIPERNA** Born in Pittsburgh, Pennsylvania, 1947. Now resides in Great Falls, Virginia. DiPerna teaches photography at the Corcoran School of Art, Washington, D.C. His novel, *The Tale of the Lizard*, was published in 1989.

**JOHN DIVOLA** Born in Santa Monica, California, 1949. Currently resides in Venice, California. Divola teaches at University of California, Riverside. Solo exhibitions of his work have been held at The California Museum of Photography, University of California, Riverside (1991) and Jayne H. Baum Gallery, New York City (1990). He has received several National Endowment for the Arts Fellowships (1973, 1976, 1979, 1990) and a John Simon Guggenheim Memorial Fellowship (1986).

**TERRY EVANS** Born in Kansas City, Missouri, 1944. Currently resides in Salina, Kansas. Evans serves on the board of directors of The Land Institute in Salina. Recent publications include *Prairie: Images of Ground and Sky* (University Press of Kansas, 1986).

"How did our good intentions and values based on productivity lead us to exhaust the land we thought we loved?" asks Evans. "Part of the answer lies in the beauty of the destruction; the machine-made patterns I photograph are well-ordered visual harmony. But seeing is not observing. Where is the balance for humanity between the heedlessness of ordered domesticity and the wisdom of chaotic wilderness?"

**ROBBERT FLICK** Born in Amersfoort, Holland, 1939. Currently resides in Claremont, California. Flick is professor of studio arts at the University of Southern California, Los Angeles. He received a National Endowment for the Arts Fellowship in 1982 and 1984. Recent publications include *Robbert Flick: Sequential Views 1980–1986*, (Gallery Min, Tokyo, Japan 1987).

Flick writes: "The sequential landscape is an alternative to lived experience, balancing an awareness of rhythms and evolving processes in a landscape with an art practiced over a period of time."

**GUS FOSTER** Born in Wausau, Wisconsin, 1940. Currently resides in Taos, New Mexico. Recent solo exhibitions of his work include "Panoramic Photographs by Gus Foster," the Albuquerque Museum, New Mexico (1990).

**PETER GOIN** Born in Madison, Wisconsin, 1951. Now lives in Reno, Nevada. An associate professor of art at the University of Nevada at Reno, Goin spent 1991–92 as artist-in-residence at the Center for Documentary Studies, Duke University, Durham, North Carolina. Goin's recent publications include *Tracing the Line: A Photographic Survey of the Mexican-American Border* (1987), *Nuclear Landscapes* (1991), and *Stopping Time: A Rephotographic Survey of Lake Tahoe* (1992). His work was included in "Polemical Landscapes," California Museum of Photography, University of California, Riverside. An exhibition of his called "Peter Goin: The Land as Witness," was shown at the Baltimore Museum of Art (1991).

**KAREN HALVERSON** Born in Syracuse, New York, 1941. Currently resides in Studio City, California. She is presently teaching at the Art Center College of Design in Pasadena, California. Halverson's work was included in *Woman Photographers* (New York: Abrams, 1990).

Halverson writes: "The car is part of the contemporary desert landscape. It is the usual means of access. For me, it is also companion and protector, although it appears small and vulnerable set against the vast space. Even the light it casts at night is shallow and emphasizes how very dark and vast is the space which stretches beyond. Yet because the car is the definitive symbol of our access to the desert, by extension it also implies our incursion upon it."

**DAVID T. HANSON** Born in Billings, Montana, 1948. Currently resides in Providence, Rhode Island. Hanson teaches at the Rhode Island School of Design. His work was included in "Polemical Landscapes," California Museum of Photography, University of California, Riverside (1990). Solo exhibitions of his work include shows at the Yellowstone Art Center, Billings, Montana (1988) and the Institute for Policy Studies, Washington, D.C. (1987). A recipient of a John Simon Guggenheim Memorial Fellowship in 1985, he also received a National Endowment for the Arts Fellowship in 1986 and 1990. *Waste Land*, a book of photographs by Hanson, will be published by the National Museum of American Art in 1993.

**ANTHONY LOUIS HERNANDEZ** Born in Los Angeles, California, 1947. Currently resides in Los Angeles. Hernandez received a National Endowment for the Arts Fellowship in 1975, 1978, and 1980. He was artist-in-residence at the University of Nevada, Las Vegas, in 1986 and at Ucross Foundation, Ucross, Wyoming, in 1989. He has had solo exhibitions at the Burden Gallery, New York, Northlight Gallery, Arizona State University (1985), and The Opsis Foundation, New York City (1990).

**ALLEN HESS** Born in Dayton, Ohio, 1950. Currently resides in Pittsford, New York. Hess's work has been exhibited at the International Museum of Photography at George Eastman House in Rochester, New York, the Contemporary Arts Center in New Orleans, Louisiana, and in Boston's Institute of Contemporary Art. He has received a National Endowment for the Arts Fellowship.

Hess writes: "My work is based in the tradition of documentary photography. In particular, it has references in 19th-century photography, from the use of a large turn-of-the-century camera to the subject matter itself."

**LEN JENSHEL** Born in New York City, 1949. Currently resides in New York City. Jenshel received a National Endowment for the Arts fellowship in 1978 and a John Simon Guggenheim Memorial Fellowship in 1980. A solo exhibition of his work was held at the Chrysler Museum, Norfolk, Virginia, in 1987. *Desert Places*, a monograph, was published in 1991.

**ROBERT GLENN KETCHUM** Born in Los Angeles, California, 1947. Currently lives in Los Angeles. Ketchum's most recent publications include *The Hudson River and the Highlands* (1985), *The Tongass: Alaska's Vanishing Rainforest* (1987), and *Overlooked in America: The Success and Failure of Federal Land Management* (1991). He received the Ansel Adams Award for Conservation Photography from the Sierra Club in 1989.

**MARK KLETT** Born in Albany, New York, 1952. Currently resides in Tempe, Arizona. Klett manages the Photography Collaborative Facility at the School of Art at Arizona State University. Recent solo exhibitions of his work were organized by the Oklahoma City Art Museum (1991), the Pace/MacGill Gallery (New York, 1990), the Afterimage Gallery (Dallas, Texas, 1988), and the Phoenix Art Museum, (Phoenix, Arizona, 1987). He was a member of the Rephotographic Survey Project, 1978–79. He has received three National Endowment for the Arts Fellowships (1979, 1982, 1984). Klett's publications include *Second View: The Rephotographic Survey Project* (University of New Mexico Press, 1984); *Traces of Eden: Travels in the Desert Southwest* (David Godine, 1986); *One City/Two Visions* (Bedford Arts Press, 1990); *Revealing Territory: Photographs of the Southwest by Mark Klett* (University of New Mexico Press, 1992). An exhibition is planned by the Amon Carter Museum in Fort Worth, Texas, for 1992.

Klett writes: "The landscape is not so much a paradise to long for...as it is a mirror that reflects our own cultural image. We now view landscape photographs, both past and present, much like the shadows on the walls of Plato's cave. They are artifacts of what we think we know about the land, and how we have come to know it—the language of an individual's experience in his or her time, and at their best a form of commentary" ("The Legacy of Ansel Adams: Debts and Burdens," *Aperture* 120 [Late Summer, 1990]).

**STUART D. KLIPPER** Born in the Bronx, New York, 1941. Currently resides in Minneapolis, Minnesota. Recent solo exhibitions of his work were organized by the Museum of Modern Art (1991), The San Francisco Museum of Modern Art (1989), and The Jewish Museum, New York City (1988). He received a National Endowment for the Arts Fellowship (1980) and two John Simon Guggenheim Memorial Fellowships (1980, 1989). Klipper was also awarded the Antarctic Service Medal, U.S. Navy, 1989.

**VICTOR LANDWEBER** Born in Washington, D.C., 1943. Now resides in Berkeley, California. Recent solo exhibitions include "Victor Landweber Photographs, 1967–1984," the Museum of Photographic Arts, San Diego, California, 1985.

Landweber writes: "I've collected historical and apocryphal information about many of the old mines and am interested in the economic, psychological, political, and ecological forces that sustain the mythology of the Old West and which, along with literature, music, art, and movies, have directed our perception about it and what it's now become."

**JOE MALONEY** Born in Worcester, Massachusetts, in 1949. Presently lives in Hancock, New York. Maloney has had recent solo exhibitions at the Laurence Miller Gallery, New York (1990), the University of Illinois at Carbondale (1984), and the Northlight Gallery at the University of Arizona at Tempe (1980). He received a National Endowment for the Arts Fellowship in 1979.

**SKEET MCAULEY** Born in Monahans, Texas, 1951. Currently resides in Dallas, Texas. Recent solo exhibitions of his work have been held at the Mead Museum in Amherst, Massachusetts (1990), The Amon Carter Museum, Fort Worth, Texas (1990), and the Museum of Contemporary Photography, Chicago, Illinois (1985). *Sign Language: Contemporary Southwest Native America, Photographs by Skeet McAuley* was

published by Aperture Press in 1989. McAuley has received two National Endowment for the Arts Fellowships (1984, 1986).

**ROGER MERTIN** Born in Bridgeport, Connecticut, 1942. Currently lives in Rochester, New York. Since 1980 he has been associate professor of art at the University of Rochester. Mertin received a John Simon Guggenheim Memorial Fellowship in 1974 and National Endowment for the Arts grants in 1976 and 1978. Solo exhibitions of his work include "1984: Rochester," Hartnett Gallery of the University of Rochester, and "Roger Mertin: 15 October–30 November, 1985," Robert B. Menschel Photography, Syracuse University, New York (both in 1985).

**RICHARD MISRACH** Born in Los Angeles, California, 1949. Presently lives in Emeryville, California. Misrach has received a John Simon Guggenheim Memorial Fellowship (1979) and three National Endowment for the Arts Fellowships (1973, 1977, 1984). A book of his photographs, *Desert Cantos,* was published in 1987 (University of New Mexico Press); another, *Bravo 20: The Bombing of the American West,* with text by Myriam Weisang Misrach, was published in 1990 (John Hopkins University Press).

Misrach writes: "The issues of landscape photography extend beyond the frame. A few years ago, we were all content to decode a picture based on the information contained from edge to edge.... The landscape photograph is not an autonomous aesthetic object to be understood on the basis of formal innovation, visceral power or conceptual insight—it also carries weighty cultural baggage that can no longer be ignored."

**RAY MORTENSON** Born in Wilmington, Delaware, 1944. Currently lives in New York City. Mortenson's work was included in "The New Pastoral," International Museum of Photography at George Eastman House, Rochester, New York (1990). A monograph of his work, *Meadowland,* was published in 1983 (Listrum Press).

**KENDA NORTH** Born in Chicago, Illinois, 1951. Currently lives in Dallas, Texas. She is chairperson of the art department of the University of Texas at Arlington. North received a National Endowment for the Arts Fellowship in 1977. Solo exhibitions of her work have been organized by the California Museum of Photography, University of California, Riverside (1985), Orange Coast College, Costa Mesa, California (1980), and the International Museum of Photography at the George Eastman House, Rochester, New York (1977).

**MARY PECK** Born in Minneapolis, Minnesota, 1952. Now lives in Seattle, Washington. Her photographs were featured in "Everglades," a solo exhibition at the Miami-Dade Community College South Campus Art Gallery (1987). Peck's work was included in "The Essential Landscape" (Museum of Fine Arts, Santa Fe, 1985). She received a National Endowment for the Arts Fellowship in 1982.

**JOHN PFAHL** Born in New York City in 1939. Presently resides in Buffalo, New York. Pfahl teaches at the School of Photographic Arts and Science, Rochester Institute of Technology, New York. A retrospective of his work was organized by the Albright-Knox Gallery, Buffalo (1990). Publications of his work include *Altered Landscapes* (The Friends of Photography, 1981) and *A Distanced Land* (University of New Mexico Press, 1990). Pfahl recently curated the exhibition, "Tainted Prospects: Photographers and the Compromised Environment," Castellani Art Museum, Niagara University, New York (1991).

**MERIDEL RUBENSTEIN** Born in Detroit, Michigan, in 1948. Lives in Santa Fe, New Mexico, and San Francisco, California. She has received a National Endowment for the Arts Fellowship (1983) and a John Simon Guggenheim Memorial Fellowship (1981). Rubenstein's work was included in *The Essential Landscape: The New Mexico Photographic Survey* (University of New Mexico Press, 1985).

**LARRY SCHWARM** Born in Greensburg, Kansas, in 1941. Resides in Emporia, Kansas, where he teaches at Emporia State University. Schwarm's work has been shown in recent solo exhibitions at the Society for Contemporary Photography Gallery, Kansas City, Missouri, and the Tulsa Center for Photography, Tulsa, Oklahoma (1992). He has received a Mid-America Arts Alliance/National Endowment for the Arts Fellowship (1991) and a National Endowment for the Arts Survey Grant (1974).

**STEEL STILLMAN** Born in 1955 New York City, where he currently resides. Stillman's work has been represented in *The Photography of Invention: American Pictures of the 1980s* (National Museum of American Art, Washington, D.C., and MIT Press, 1989).

**JIM STONE** Born in 1947, Los Angeles, California. He currently resides in Dorchester, Massachusetts. His work has been shown recently in West Virginia, at the Huntington Art Museum (1990), and in Cracow, Poland (1989). Stone's publications include *A User's Guide to the View Camera* (Prentice-Hall, 1986) and *Darkroom Dynamics: A Guide to Creative Photography* (Van Nostrand Reinhold, 1979).

**MADOKA TAKAGI** Born in 1956, Obihiro, Hokkaido, Japan. Currently lives in New York City. Recent exhibitions of Takagi's work have been held at The Midtown Y Photography Gallery, New York (1987) and Simon Lowinsky Gallery, New York (1991).

**TERRY TOEDTEMEIER** Born in 1947, Portland, Oregon, where he still lives. He teaches at the Pacific Northwest College of Art and is curator for photography, Portland Art Museum. Toedtemeier received an Oregon Arts Commission Fellowship (1987). His solo exhibitions include shows at the Maryhill Museum of Art, Maryhill, Washington (1989) and the Portland School of Art, Portland, Maine (1988).

Toedtemeier writes: "My photographs are not made in an effort to mimic the style of earlier work or to make a transient political comment on the ironies of our time. I am concerned with the rigor of the landscape and the visual evidence of our presence on it."

**JOHN YANG** Born in China, 1933. Now lives in New York City. A recent exhibition of Yang's work, "Long Island Golf Courses: Panoramic Photographs, 1991," was shown at the Vered Gallery, East Hampton, New York.

## AUTHORS

**MERRY A. FORESTA** has curated several major exhibitions at the National Museum of American Art, Smithsonian Institution, including *The Photography of Invention: American Pictures of the 1980s* and *Perpetual Motif: The Art of Man Ray.* Foresta is curator for *Between Home and Heaven.*

**STEPHEN JAY GOULD** is a professor of geology at the Museum of Comparative Zoology, Harvard University. A former president of the American Society of Naturalists, Gould has written many books, most recently *Bully for Brontosaurus: Reflections in Natural History* (1991). Gould is the winner of the 1981 National Book Critics Circle Award in general nonfiction for *The Mismeasure of Man.*

**KARAL ANN MARLING** is a professor of art history and American studies at the University of Minnesota. Her most recent work is *Iwo Jima: Monuments, Memories and the American Hero.* She has also written *Blue Ribbon: A Social and Pictorial History of the Minnesota State Fair, Tom Benton and His Drawings, Wall-to-Wall America: A Cultural History of Post-Office Murals in the Great Depression,* and *The Colossus of Roads: Myth and Symbol Along the American Highway.*